LIGHT FROM THE VOID

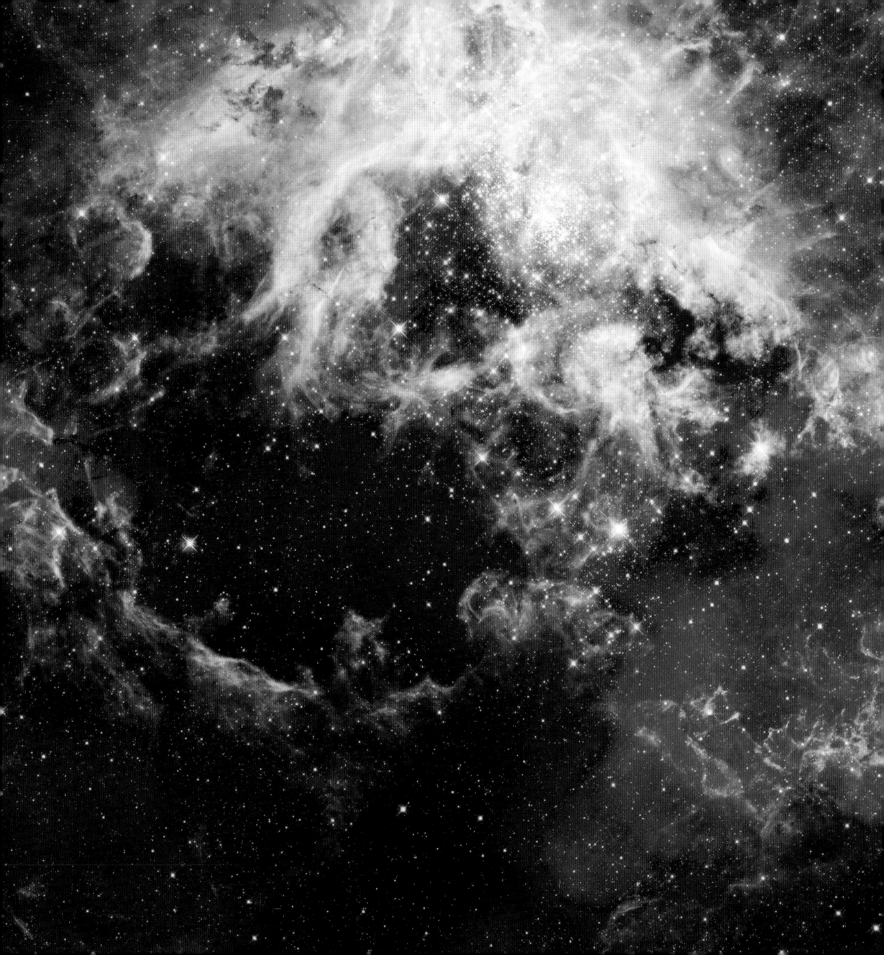

LIGHT FROM THE VOID

TWENTY YEARS OF DISCOVERY WITH NASA'S CHANDRA X-RAY OBSERVATORY

Kimberly Arcand, Grant Tremblay, Megan Watzke,
Martin C. Weisskopf, and Belinda J. Wilkes

Smithsonian Books

Smithsonian Books in Association with the Smithsonian Astrophysical Observatory

WASHINGTON, DC

Other titles: Twenty years of discovery with NASA's Chandra X-ray Observatory
 | Chandra X-ray Observatory
Description: Washington, DC : Smithsonian Books, [2019] | Includes index.
Identifiers: LCCN 2019021938 (print) | LCCN 2019019663 (ebook) | ISBN
 9781588346698 | ISBN 9781588346780 ()
Subjects: LCSH: Chandra X-ray Observatory (U.S.) | X-ray astronomy.
Classification: LCC QB472 .T74 2019 (ebook) | LCC QB472 (print) | DDC
 522/.6863--dc23
LC record available at https://lccn.loc.gov/2019021938

Manufactured in China, not at government expense

23 22 21 20 19 5 4 3 2 1

Title pages: 30 Doradus (the Tarantula Nebula), page 38
Dedication page: SN 1006, page 88
Table of contents: Perseus A, page 166

THIS BOOK, LIKE CHANDRA'S LEGACY,
IS DEDICATED TO THE MEMORY OF
RICCARDO GIACCONI

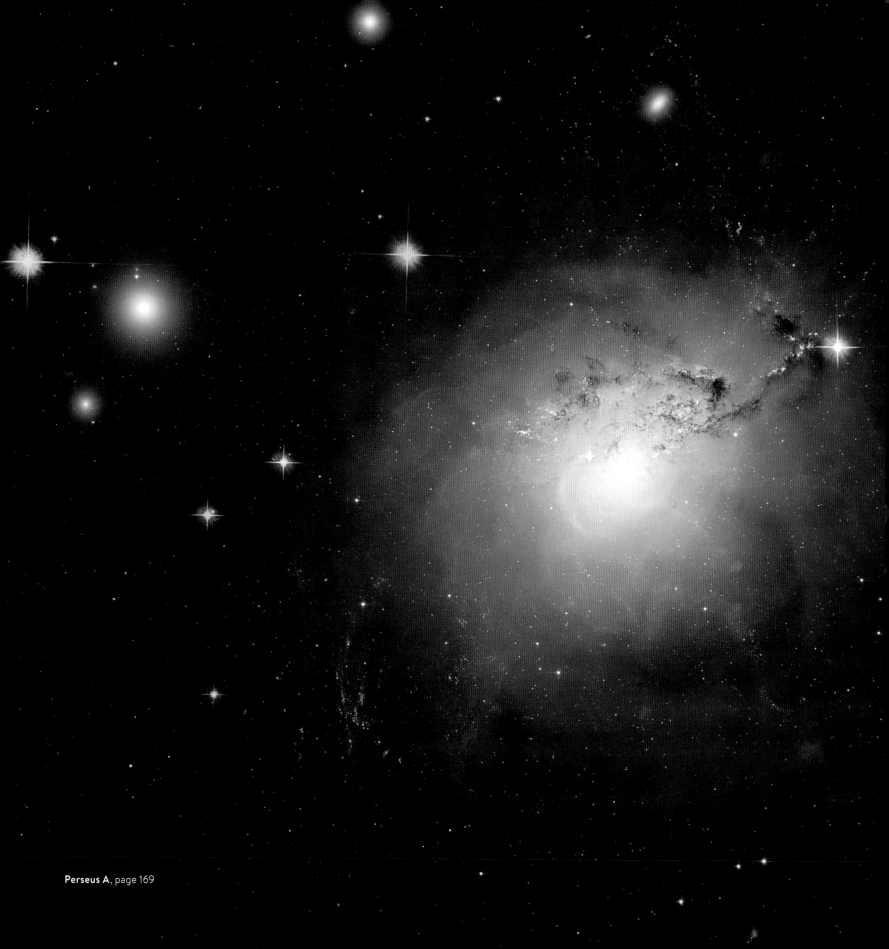

Perseus A, page 169

CONTENTS

MARTIN C. WEISSKOPF

Chief Scientist for X-ray Astronomy, NASA Marshall Space Flight Center

Project Scientist for the Chandra X-ray Observatory

THE CHANDRA X-RAY OBSERVATORY, one of four members of NASA's Great Observatory cohort, celebrates its twentieth year of operation in 2019. This book shares highlights of Chandra's scientific results: X-ray and multi-wavelength pictures of the hottest and most violent celestial sources for which the X-ray emission reveals new information, often revolutionizing our understanding of the Universe.

Chandra remains without peer in its capabilities for producing sub-arcsecond X-ray images, precisely locating X-ray sources, detecting them to extremely faint levels, measuring their structure in detail, and obtaining high-resolution, spatially resolved spectra. It is the world's greatest X-ray observatory, and it will remain so in the years to come—indeed, eight to ten years of further operation are currently expected.

Chandra's unique capabilities enable it to play a key role in the investigation of the extreme physics involved in spectacular phenomena such as the merger of neutron stars and tidal disruptions of stars by supermassive black holes. It enables astronomers to employ cosmic laboratories to study a wide range of otherwise inaccessible physical phenomena: the behavior of matter at extremely high densities, the effects of ultra-strong magnetic fields, the physics of matter swirling into black holes, and the ability of supermassive black holes to affect the evolution of entire galaxies, even clusters of galaxies. Chandra has added new dimensions to our knowledge of celestial sources from planets and exoplanets to galaxies and galaxy clusters, the largest structures in the universe, and everything in between.

Since X-rays are produced by practically every kind of astronomical object, it takes the high-precision and high-quality data that Chandra provides to study and understand them. Chandra has brought X-ray astronomy into the mainstream of astronomy and astrophysics, and thousands of astronomers and astrophysicists worldwide have used the Observatory. Discoveries include the ubiquity of X-ray emitting jets from quasars, the discovery of X-ray emission from a source of gravitational waves, and the hostile environment for forming plantes provided by X-ray emisssion from their stars.

Chandra's outstanding success, not only scientifically but also programmatically and financially, has been the result of a highly integrated team effort between NASA; its lead center for Chandra, the Marshall Space Flight Center; and the prime contractor for the Chandra X-ray Center (CXC), the Smithsonian Astrophysical Observatory. The CXC carries out all aspects of the mission from its facilities in Massachusetts, with managerial and scientific oversight from the MSFC Project Office. The CXC subcontracts with several organizations, including the instrument Principal Investigators and their teams at Penn State University, MIT, and SAO, as well as Northrup Grumman Corporation (formerly TRW), the prime contractor for the mission, which, along with its subcontractors, provides the operations team and engineering support.

It is an honor and a privilege to have participated in the building and in the continuing operations of this scientific cathedral and to share some of its wonders in this book. In closing, we acknowledge the contributions of the Chandra Telescope Scientist, Leon Van Speybroeck, for the critical role he played in delivering the optics, and of Riccardo Giacconi, whose leadership and vision inspired this Great Observatory.

With this one experiment it is impossible to completely define the nature and origin of the radiation we have observed.... However, we believe that the data can best be explained by identifying the bulk of the radiation as soft X-rays from sources outside the solar system.

RICCARDO GIACCONI
From his 1962 paper describing the first detection of X-rays from beyond the Solar System

Crab Nebula, page 106

LIFTING
CHANDRA INTO SPACE

COLONEL EILEEN M. COLLINS, USAF (Ret.)
Commander, Space Shuttle *Columbia*, STS-93

On July 23, 1999 *Columbia* lifts Chandra into the void. STS-93 Commander Eileen Collins, Pilot Jeffrey Ashby, and Mission Specialists Michel Togini, Steven Hawley, and Cady Coleman become the last humans to see Chandra with their naked eyes.

AS A CHILD IN RURAL upstate New York, I was inspired by the stars in the night sky. When I joined the Air Force, I was stationed in Oklahoma, where my growing passion for astronomy was rewarded with vast, clear, dark nights lit up with beautiful stars.

I subscribed to magazines and book clubs. I bought my first two telescopes. I memorized the names and locations of stars and constellations. I marveled at the unknown objects in deep space and eventually became more fascinated with what we did not know than what we knew. I yearned to learn more about the origin, structure, and destiny of our Universe. And I became a NASA astronaut, which allowed me to combine my love of flying with my love of astronomy and cosmology.

In March 1998, the Chief of the Astronaut Office called me in for a one-on-one meeting. He told me that he had me in mind for a great flight. He then sent me over to the Chief of Flight Operations and the director of Johnson Space Center, who notified me I was chosen as the commander of the AXAF (Advanced X-ray Astrophysics Facility) mission. I would be the first woman to command a Shuttle mission: *Columbia*.

Going into this flight, I focused on *Columbia*'s astronomy payload. I began a journey of training, understanding, leading, and focusing on the safe and successful deployment of what eventually became known as the Chandra X-ray Observatory.

My crew was just as dedicated as I was to our mission—*our* observatory, we thought. Our pilot, Jeff Ashby, was to fly his first mission to space. Steve Hawley would be our flight engineer and astronomy expert. Cady Coleman and Michel Tognini became experts on the inertial upper stage, the rocket that lifted Chandra

AN ASTRONAUT'S PERSPECTIVE

to its full elevation. Our lead flight director, Bryan Austin, and lead payload director, David Brady, with whom we worked daily, were similarly committed to the safe and successful deployment of Chandra.

There were struggles getting to the launchpad. We experienced development glitches throughout the last year. We had to undergo extra testing and tolerate numerous launch delays, even though we were eager to go. As hard as it was at the time, the attention to detail paid off. If NASA had accepted anything less than perfection or overlooked any testing, Chandra might not still be in operation today.

Even during the launch countdown there were delays. Our first launch attempt was on July 20, 1999, the thirtieth anniversary of the Apollo 11 mission. All three Apollo 11 astronauts—Neil Armstrong, Buzz Aldrin, and Michael Collins—attended. We scrubbed at T-8 seconds for a sensor failure in the main propulsion system. Two days later, on our second attempt, we delayed for thunderstorms despite a forecast of 100 percent "go." On July 23, there were delays in the last hour of the countdown because of communication problems, but in a flurry of confusion followed by timely decisiveness, we managed to launch within the predetermined forty-minute window. Our ascent was exciting, and excitement is not a good thing: At T+ 8 seconds there was an electrical short in the AC1 Phase A bus, which caused alarms to go off in the cockpit. We lost a main engine controller on each of two main engines. Fortunately, each engine has its own backup controller; otherwise we could have experienced one or two engine failures. The thought of doing an abort with the heaviest payload ever to fly on a space shuttle was not pretty. Unknown to us, we also leaked hydrogen fuel all the way from prelaunch to main engine cutoff. We were under speed by 15 feet per second, which put us in a slightly lower orbit than planned. Our orbital engines were capable of raising *Columbia* to the proper altitude for deployment, however, and things went well from there.

Some people have wondered why Chandra went up on a Shuttle rather than on an "expendable" rocket. The answer is that one of the advantages to having a crew present is the ability to repair problems once in space and before deployment. Cady and Michel were trained to perform a spacewalk in the event of a mechanical or electrical problem. In 1991, the Gamma Ray Observatory had had a deployment problem with the high-gain antenna. Astronaut Jerry Ross took a short spacewalk and shook the antenna, which easily fixed the problem. We were ready to respond in the event that a similar malfunction occurred on our flight.

Today, I am happy to look back upon the entire team's contribution to such a successful mission. I brag that Chandra was designed to work for five years but is performing beautifully twenty years on. Through it, we are learning about our Universe—about how it began, what the mysterious objects are so far away from us, and how it will end. I tell young people that there is enough data from Chandra to keep all of them busy long into the future, everywhere in the world, searching for answers to these questions.

My thanks still go out to the designers, managers, operators, scientists, and many others who contributed to *Columbia*'s mission. It gives me great joy to reflect on Chandra's accomplishment, and I hope that it continues to send us information for years to come.

Earth's atmosphere, known as the "thin blue line," is all that stands between life on Earth and the cold, dark void of space.

SOME OF THE EARLIEST known stone tools, at least 3.3 million years old, were recently discovered near an ancient lake in Kenya. Sitting on its shores at night, the protohominids who made those tools, our ancient and distant ancestors, would have surely been aware of the crystalline cosmos that traced arcs in the sky above them—the stars in their billions, the pale cyclical crescent, the disk of the Milky Way reflecting in the waters of the lake.

Although the precursors of our species were advanced enough to craft hunting weapons over three million years ago, the earliest known depiction of anything beyond the Earth—an ancient eagle's bone carved with the phases of the Moon—is little more than 30,000 years old. The recorded history of astronomy, often called the oldest science, is but a short sentence in the book of life on Earth.

As with the quickening drumbeat of technological progress, advancement in our understanding of the Universe has been exponential, the growth of knowledge spreading like wildfire. More than 20,000 years passed between the carving of lunar phases on that eagle's bone and the emergence of the first accurate star charts. It would be another thousand years before the first recorded observation of what we would eventually understand to be a galaxy beyond our own. Another 600 years would pass before Galileo first turned his telescope skyward.

Just three centuries years later, in 1946, an astronomer named Lyman Spitzer wrote a speculative paper proposing the idea of a telescope in space. Sixteen years later, in 1962, thirty-year-old Riccardo Giacconi, the future father of X-ray astronomy, and his young team launched a small rocket that, during a flight that lasted less than six minutes, detected for the time an X-ray signal shining from somewhere outside of our Solar System: Scorpius X-1, a binary system 9,000 light-years away, in which a small sun is being shredded and consumed by a nearby neutron star. That 1962 discovery sparked a chain of events that would lead to the launch of an ever-greater series of X-ray observatories cast into space, and in a sense it was then that NASA's Chandra X-ray Observatory came to life, even though it would not launch until thirty-seven years later.

A platform of discovery shot into the dark, Chandra was named in honor of Subrahmanyan Chandrasekhar, an Indian-born American astronomer who developed a theory of white dwarf stars that would prove critical to our understanding of how the Universe works. Chandra's ongoing mission, now two decades long, has transformed our comprehension of the furnaces of cosmic change, the birth and death of stars, and the origin of all there is. With discoveries from the shining poles of Jupiter to black holes at the edge of time, Chandra reigns as one of the truly great engines of scientific progress. It is an essential tool, a catalyst for the accelerated expansion of discovery.

This book serves as a celebration of Chandra's everlasting legacy. Each image on the following pages is a consequence of the laws of nature, a note in the symphony of the cosmos, a glimpse of light from the void.

1949

A V-2 rocket, launched by the Naval Research laboratory, detects X-ray emission from the Solar Corona.

1962

Riccardo Giacconi and his team launch a small Aerobee Rocket carrying a proportional counter X-ray detector. During the rocket's 350-second flight, the team becomes the first to discover X-rays from outside the solar system.

The results were published in a landmark 1962 paper. Giacconi didn't know it at the time, but his team had detected X-rays from Scorpius X-1, a low-mass X-ray binary system wherein a dwarf star is being shredded apart by an orbiting neutron star. Because Sco X-1 is relatively nearby (9,000 light-years away), it is the brightest persistent X-ray source in the sky (with the exception of our Sun).

1963

Nine months later, Giacconi and team submit a proposal to NASA for "An Experimental Program of Extra-Solar X-ray Astronomy."

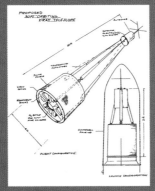

A figure from the 1963 proposal submitted to NASA by Giacconi and colleagues. Though it predated Chandra by more than thirty years, its content was so forward-looking that Chandra closely resembles the notional spacecraft and instrument design proposed amid the nacent days of X-ray astronomy.

1970

Uhuru, the first satellite dedicated to the observation of cosmic X-ray sources, is launched. Equipped with a sensitive proportional counter attached to a viewing pipe, it expanded the number of known extrasolar X-ray sources to more than 400, showed that "X-ray stars" are actually neutron stars or black holes accreting matter from companions in binary systems, and discovered X-rays from hot gas in galaxy clusters.

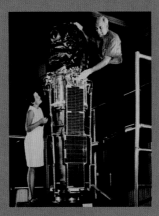

Uhuru, the first satellite dedicated to high energy astrophysics. In the photo, Bruno Rossi (Giacconi's colleague and one of the great figures of X-ray astronomy) performs a preflight test with Marjorie Townsend, the first woman to receive an engineering degree from the George Washington University. She would eventually become the project manager for the Small Astronomy Satellite (SAS) program, of which Uhuru was the first.

1976

Riccardo Giacconi and Harvey Tananbaum submit the initial (unsolicited) proposal "For the Study of the 1.2 Meter X-ray Telescope National Space Observatory." This was the birth of Chandra. The proposal called for the creation of a subarcsecond imaging X-ray telescope, which at the time nobody knew how to do.

1977

The proposal submitted by Giacconi and Tananbaum drew great interest at NASA headquarters, which initiated a competitive process regarding what centers or institutions might lead development of what would soon be called AXAF—the Advanced X-ray Astrophysics Facility. Given its groundbreaking leadership across the entire short history of X-ray astronomy, the Smithsonian Astrophysical Observatory (SAO) won the bid, in partnership with NASA's Marshall Space Flight Center. Riccardo Giacconi took charge of the first AXAF Science Working Group at SAO.

1978

The Einstein X-ray Observatory is launched. It was the first satellite with X-ray grazing incidence mirrors, and therefore the first that could create actual images of extended X-ray sources, both within our galaxy and beyond. Even during its three-year mission, it enabled extraordinary advances in our understanding of the cosmos.

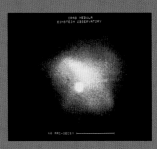

Einstein's image of the Crab Nebula and the pulsar at the heart of M1.

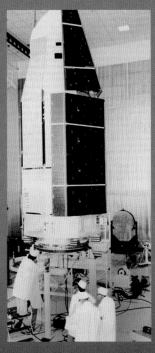

The Einstein Observatory as it is being prepared for its launch on November 13, 1978, from Cape Canaveral, Florida.

1980–1982

Just as it had done for the two decades prior, the National Academy of Science commissions the 1980 Decadal Survey in Astronomy and Astrophysics. They release their report—regarded as a sacred document guiding the future course of U.S. space science funding prioritization—in 1982. Its top recommendation: build and fly AXAF.

1983–1989

A period of extraordinary advancement and frustrating setbacks for the AXAF mission. When the mission was selected, it was not obvious if it was even possible that X-ray mirrors so pristine and sharp could ever be made, but the late 1980s saw remarkable results from the prototype mirrors under development. Budget cuts, however, along with delays to the still-in-construction Hubble Space Telescope, would forecast a measure of turmoil for AXAF in the early 1990s.

1989

The second of two AXAF mirror prototypes, the "Technology Mirror Assembly" (TMA-2), delivers record-setting results in excess of the AXAF requirements.

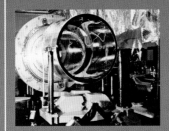

The TMA-2, the second of Chandra's prototype mirrors. Although they are merely a scaled ⅔ version of its innermost mirrors, the TMA-2 remains one of the finest X-ray mirrors ever created.

1992

Amid NASA programmatic uncertainty and budget constraints, the AXAF mission is restructured into two separate spacecraft. "AXAF-I" would fly four nested mirror pairs instead of the originally planned six, and the heavy microcalorimeter instrument would be removed to fly on "AXAF-S," a smaller-scale companion mission dedicated to spectroscopy.

1993

The U.S. Congress cancels the AXAF-S mission. The descoped AXAF-I, now with four nested mirror pairs and two imaging instruments, would be the baseline design moving forward. Around this time, the plan for AXAF-I's orbit was changed from low-Earth to high-Earth, reaching nearly a third of the way to the moon. This led to large improvements in observing efficiency, but made impossible any notional future servicing mission by astronauts. Once cast into the void, AXAF would remain there alone.

1996

Chandra's flight mirrors are completed and testing and calibration studies begin. The mirrors perform better than the specifications.

1999

The fully complete observatory is delivered to Kennedy Space Flight Center for integration with the Inertial Upper Stage (IUS) and insertion into the *Columbia*'s payload bay. The combined Chandra-IUS assembly became the heaviest payload ever launched by the Space Shuttle.

July 23, 1999

Columbia lifts Chandra into space. STS-93 Commander Eileen Collins, Pilot Jeffrey Ashby, and Mission Specialists Michel Togini, Steven Hawley, and Cady Coleman become the last humans to see Chandra with their naked eyes. Eight hours later, its Intertial Upper Stage fires, carrying the third Great Observatory to a high-Earth orbit.

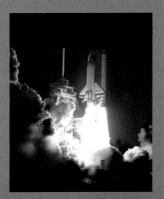

The launch of Chandra aboard the Space Shuttle *Columbia*.

August 26, 1999

Chandra opens its eyes and looks first toward the ghostly remains of the Cassiopeia A supernova remnant. It is the first true scientific observation for a mission that is, twenty years later, still working to transform our understanding of the Universe.

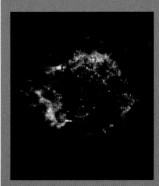

Chandra's "first light" image of Cassiopeia A.

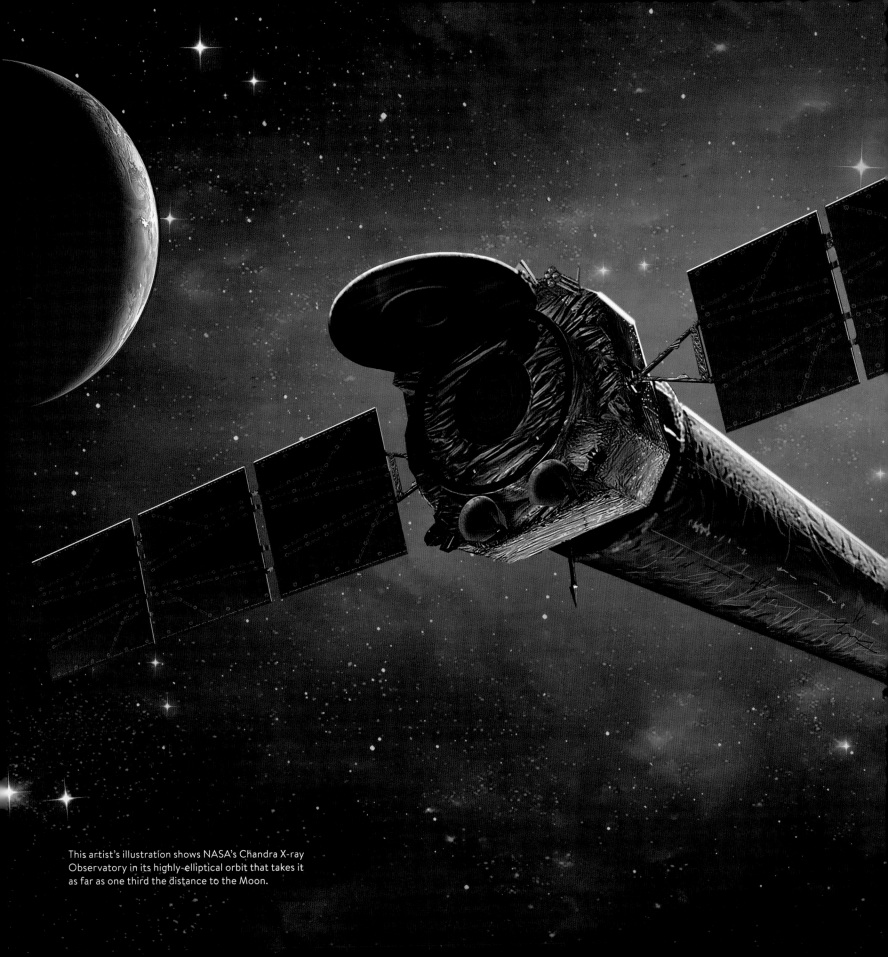

This artist's illustration shows NASA's Chandra X-ray Observatory in its highly-elliptical orbit that takes it as far as one third the distance to the Moon.

THE CHANDRA X-RAY OBSERVATORY:
TWO DECADES OF FLIGHT, A CENTURY OF DREAMS

EARTH IS TETHERED to the cosmos by light, particles, and waves from an infinite ocean that crashes upon our tiny shore. Our probes have visited other worlds and traveled for decades to the edge of our Solar System. In the boundless expanse that is the Universe, even worlds as distant as Pluto are mere rocks that dot our shoreline, a footstep into infinity. The fastest spacecraft we have ever launched would take tens of thousands of years to reach Proxima Centauri, the nearest star to our Sun, at 4.2 light-years away.

It is a humbling but important reminder that, while we might explore our Solar System in fits and starts, we will almost certainly never *leave* it. We will likely never feel the warmth of another sun or fly through the gaseous ribbons of a stellar nursery, and we will certainly never travel a hundred million light-years to a galaxy beyond our own. The distances involved are too vast, the timescales too great. Our eyes gather photons, particles of light, that were born billions of years ago and have crossed the Universe.

Here we are, then, forever bound to our tiny island in the expanse. We can only stand on its shore and collect light from the darkness. We can do so only to a limited extent with our naked eyes, but we have long known that putting mirrors and lenses to work can enable us to collect more light from the Universe. Over the centuries we have built ever larger telescopes, great collectors that dot the surface of the Earth and circle its skies, a sensory network that connects humankind to the Cosmos.

Light is fast—but not infinitely so. It takes time for a photon to travel from its birthplace and arrive at our doorstep. That the sun is "8 light-minutes away" means that it takes photons, traveling at the speed of light (186,282 miles *per second*), 8 minutes to travel from the Sun to the Earth. It takes 26,000 years for light from the very

center of the Milky Way galaxy, and hundreds of millions to billions of years for light from other galaxies to reach us.

Looking deeper into space, therefore, is looking deeper into the past. Time travel is not science fiction. It is everyday reality. You are always looking back in time, because your eye collects light that takes time to travel through space. You have never witnessed the present in your entire life. The more distant an object is away from you, the farther into the past you are looking. If an object is a foot away from you, you are seeing it as it was approximately one nanosecond (one billionth of a second) in the past. Ten feet? Ten nanoseconds in the past. A thousand light-years? A thousand years in the past. And so on.

Telescopes are powerful time machines. To collect light from the Cosmos gives the power not only to dissect its chemistries and processes but also to watch how its constituent parts evolve through time. By sorting and mapping populations of galaxies at ever greater distances, we learn, even if slowly and arduously, how those galaxies grow and evolve through time.

One of the biggest scientific realizations of the past century is that light extends far beyond what humans can detect with our eyes. The light that we are most familiar with is what astronomers refer to as "optical" or "visible" light, and it represents only a mere fraction of all the light that exists. Light is a continuum, ranging from radio waves through microwaves, infrared to optical light and ultraviolet, and finally to X-rays and gamma rays, most of which our eyes cannot detect.

Scientists have therefore had to construct telescopes with superhuman vision to observe the Universe. Every photon that our telescopes collect has a specific wavelength that encodes the energy it carries. Like a bookkeeping currency, photons are one of the ways in which nature ensures that energy is conserved and symmetries are obeyed; they are agents of nature's elegance and simplicity. Those photons born in the quiet majesty of cold, dense gas clouds that will become the wombs of future stars have wavelengths of a few millimeters, observable by powerful ground-based telescopes, like the Very Large Array (VLA) in the high desert of New Mexico. The stellar component of galaxies shines brightly in the optical regime, which is why many are visible even to the naked eye on a pristinely clear night. Stars more massive and far younger than our sun can be extremely bright in the ultraviolet (UV) regime, emitting photons with a characteristic wavelength of just a few hundred nanometers. For the most energetic events in our Universe, like the scattering of electrons in the vortex of plasma around a supermassive black hole, a photon's wavelength is extremely short (as short as a billionth of a meter long), and therefore it belongs to the X-ray regime.

NASA's four Great Observatories, of which Chandra is one, were designed to collect light from four major wavelength regimes. Each was a revolution, and together they are among our greatest time machines to date. The Hubble Space Telescope, launched in 1990, transformed our ability to observe in the UV, optical, and near-Infrared wavelengths. Its exquisitely sharp angular resolution, which partly owes to its being the first telescope to observe above the blurry screen of Earth's turbulent atmosphere, revolutionized imaging techniques, and many of the images shown in this book are composites of those taken from Chandra and Hubble. A year later, in 1991, the Compton Gamma Ray Observatory opened new eyes on the most powerful explosions in the Universe. The Spitzer Space Telescope, launched in 2003, pushed imaging and spectral capabilities into the mid-infrared, lifting the veil of dust and revealing stellar nurseries in stunning detail.

X-rays do not penetrate Earth's atmosphere, and so all X-ray observatories must be launched into space. X-ray photons are so energetic that they must be collected in a manner similar to skipping stones off the surface of a pond. With optical telescopes, the incoming rain of photons is nearly perpendicular to the mirror, the surface they bounce off like rubber balls. Unlike them, X-ray photons must be reflected at an extremely narrow incidence angle

(one to two degrees), so that the incoming photons are nearly parallel to the "grazing incidence" mirrors off of which they bounce. Those X-ray observatories capable of imaging, therefore, look highly unusual as compared to the optical telescopes with which we are familiar. Their mirrors are nested cylindrical shells of glass, portals in which light from the most extreme and energetic events in our universe is focused toward detectors that often sit more than 30 feet away from the mirror assembly.

When the Chandra X-ray Observatory was packed into *Columbia*'s payload bay in the summer of 1999, it became the largest and heaviest satellite that would ever be launched by a Space Shuttle. In the dark of night on July 23, 1999, a crew of five commanded by Colonel Eileen Collins, the first woman ever to lead a Shuttle mission, ascended to the outer reaches of the Earth's atmosphere and set Chandra free. Soon afterward, an attached rocket called an inertial upper stage initiated a series of burns, lifting Chandra to sixty-three-hour orbit that reaches nearly a third of the distance to the Moon.

There Chandra reigns, twenty years into what was supposed to be a five-year mission, still the most powerful X-ray telescope in history. Its legacy grows with every photon it collects, watching, mapping, timing the heartbeat of nature, hearing the music of the cosmos. Join us in celebrating Chandra's two decades of discovery.

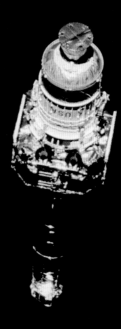

This 70mm frame shows the Chandra X-ray Observatory backdropped against the darkness of space not long after its release from *Columbia*'s payload bay.

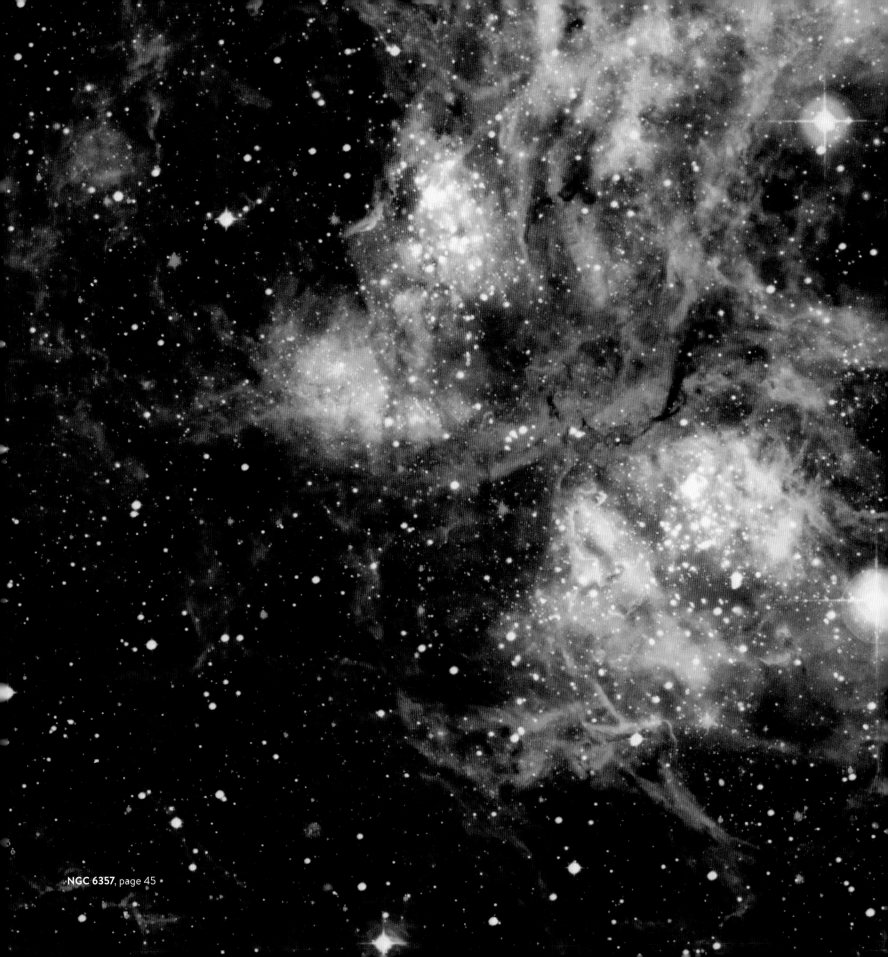

NGC 6357, page 45

1

THE LIGHT OF
INFANT SUNS

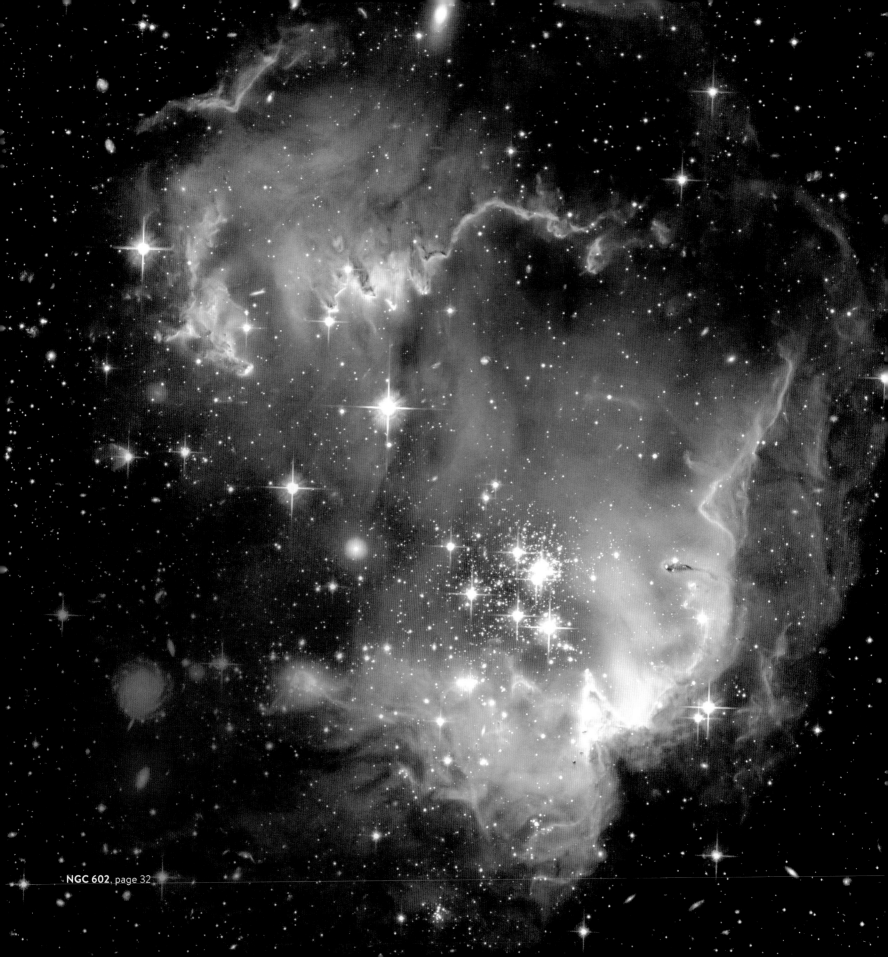

STELLAR
BIRTH

THE EARTH IS AWASH IN THE LIGHT of near and distant suns, more than 200 billion of which can be found in our Galaxy, the Milky Way. Those stars are born in giant, dense, cold clouds of gas that collapse under their own gravity. It is here, in the darkest places of our Universe, that the light of an infant sun first begins to shine.

The Chandra X-ray Observatory watches. As a time machine, it is our sharpest set of X-ray eyes on the stars in their infancy.

Young stars spin rapidly for a few hundred million years after their birth, powering intense magnetic fields that in turn give rise to bright X-ray emissions. Chandra's unusual and innovative mirrors and sensitive detectors focus on these high-energy photons, particles and waves of X-ray light.

Stars do not form in isolation but in clusters, which can have thousands of members. Because the stars in a cluster were all born at roughly the same time and are at roughly the same distance, a star cluster provides an ideal laboratory for testing theories of how the behavior of stars depends on their mass. Since most star clusters eventually disperse, we see them when the stars are relatively young, born less than a few hundred million years ago.

Normal, middle-aged stars such as our Sun, the star nearest to us, have hot, X-ray-emitting outer atmospheres. X-ray observations have proven to be a useful tool for studying how the turbulent heating near the surface of stars depends on the age, rotation, and type of the star and how the flaring activity of stars changes as stars evolve. Such studies may also give us clues to how the Sun will behave in the future. Chandra has also emerged as a powerful tool for understanding how X-rays from young stars can affect their planet-forming disk and how more mature stars can affect their planets. Chandra studies have revealed as well that massive planets might affect their host stars in turn.

The pages that follow contain some of Chandra's legacy-class images of young stellar objects embedded in their dusty, cold nurseries. These images are often shown as multi-wavelength composites with views from the Hubble Space Telescope, revealing the structure of the stellar nursery in its stunning glory. Most of the images are a few light-years across, and all show regions found within our home Galaxy.

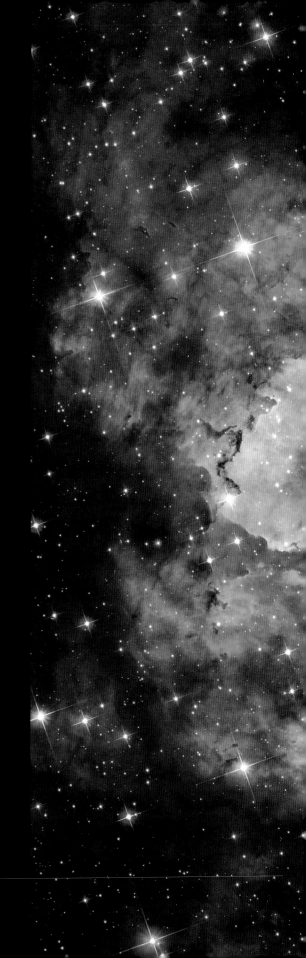

WESTERLUND 2

Westerlund 2 is a cluster of young stars, each of which is about one to two million years old. Data in visible light from Hubble reveal thick clouds where the stars are forming. High-energy radiation in the form of X-rays, however, can penetrate this cosmic haze, enabling Chandra to detect it. Westerlund 2 contains some of the hottest, brightest, and massive stars in the Milky Way galaxy.

Scale and distance: Image is about 44 light-years across; object is about 20,000 light-years from Earth.

Wavelength/color: X-ray: purple; Optical: red, green, blue.

ARCHES CLUSTER

The Arches is a cluster of young stars in our Milky Way galaxy. This cluster contains hot, massive stars that live short, furious lives lasting only a few million years. During this period, gas evaporates from these stars and blows out as intense winds from the stars' surfaces. Astronomers think the envelope of hot gas observed by Chandra comes from the collisions of the winds from numerous stars. Chandra X-ray data are shown with infrared observations in the inset. The larger field shows spectacular filamentary structures in radio wavelengths.

Scale and distance: Image is 4.4 light-years across; object is about 25,000 light-years from Earth.

Wavelength/color: X-ray: blue; Radio: red; Infrared: green.

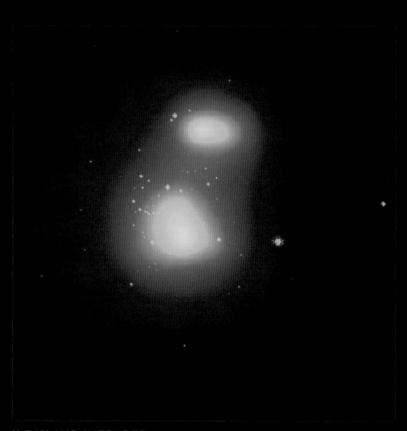

X-RAY AND INFRARED

RADIO

Trumpler 14 is home to about 1,600 stars amid a diffuse glow from hot X-ray-producing gas. The cluster has an unusually high concentration of massive, luminous, young (about 1 million years old) stars. X-rays can be produced by shock waves—akin to sonic booms produced by high-speed planes—in unstable winds flowing away from massive young stars. The diffuse X-ray glow seen by Chandra is likely caused by the combined action of many such winds on a scale of several light-years.

Scale and distance: Image is about 47 light-years across; object is about 9,000 light-years from Earth.

Wavelength/color: X-ray: red, blue.

ORION NEBULA

The Orion Nebula is one of the star formation regions closest to Earth. Wispy filaments seen in optical light are clouds of gas and dust that provide the material used as fuel by young stars. The bright point-like sources are newly formed stars that Chandra has captured in X-ray light. These fledgling stars are seen to flare in their X-ray intensity, which suggests that our Sun had many violent and energetic outbursts when it was much younger.

Scale and distance: Image is 24 light-years across; object is about 1,500 light-years from Earth.

Wavelength/color: X-ray: blue, yellow, orange; Optical: red-purple.

CORONA AUSTRALIS

The Corona Australis region is one of the most active regions of ongoing star formation in our Galaxy. At its heart, the Coronet cluster contains a loose cluster of a few dozen known young stars with a wide range of masses at various stages of evolution. This gives researchers an opportunity to study stars that are forming simultaneously in several kinds of light, such as the X-ray and infrared data shown in this image.

Scale and distance: Image is 2 light-years across; object is about 420 light-years from Earth.

Wavelength/color: X-ray: purple; Infrared: orange, green, cyan.

NGC 602

Located in the Small Magellanic Cloud (SMC), NGC 602 contains a spectacular star-forming region. The SMC is one of the Milky Way's closest galactic neighbors and offers an opportunity to study phenomena that are difficult to examine in more distant galaxies. Chandra data of NGC 602 provided the first detection of X-ray emission from young stars with masses similar to our Sun outside our Milky Way galaxy. NGC 602 is an excellent place to study the life cycle of stars and in different kinds of light, such as X-ray, optical, and infrared as seen in this image.

Scale and distance: Image is about 160 light-years across; object is about 180,000 light-years from Earth.

Wavelength/color: X-ray: purple; Optical: red, green, blue; Infrared: red.

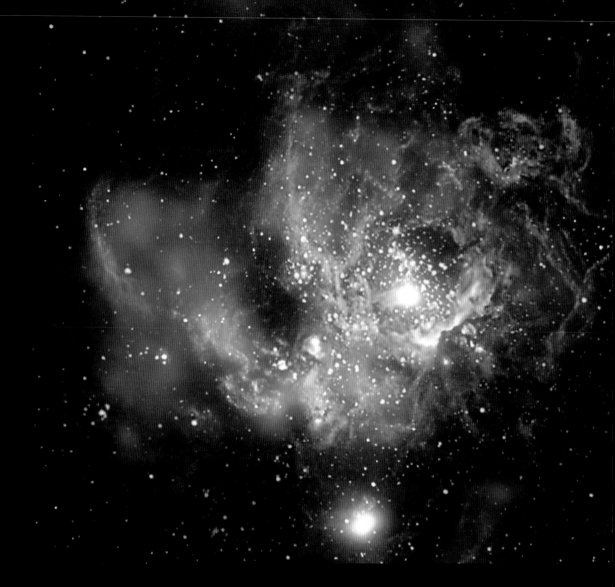

NGC 604

NGC 604 is the largest region of star formation
in the nearby Triangulum galaxy, also called
Messier 33. This image of Chandra X-ray and
Hubble optical data shows an area where some
hundreds of hot, young, massive stars reside.
Giant bubbles in the cooler gas and dust in
the field have been generated by powerful
stellar winds, which are then filled with hot,
X-ray-emitting gas.

Scale and distance: Image is 895 light-years
across; object is about 2.7 million light-years
from Earth.

Wavelength/color: X-ray: blue; Optical: red,
green, yellow.

ROSETTE NEBULA

Chandra's view of the Rosette Nebula (shown over an optical image of the wider nebula) reveals hundreds of young stars in the central cluster and fainter clusters on either side. The central cluster appears to have formed first, producing a burst of radiation and stellar winds that caused the surrounding nebula to expand, triggering formation of two neighboring clusters.

Scale and distance: Image is about 87 light-years across; object is about 5,000 light-years away from Earth.

Wavelength/color: X-ray: red; Optical: purple, orange, green, blue.

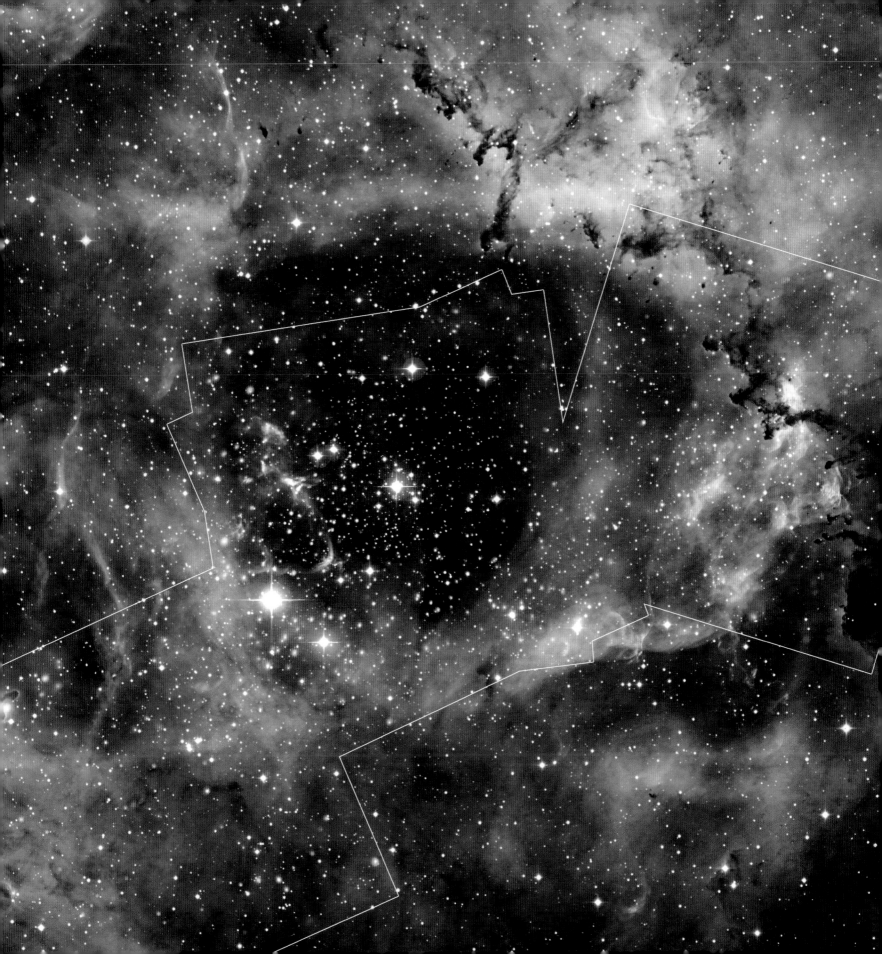

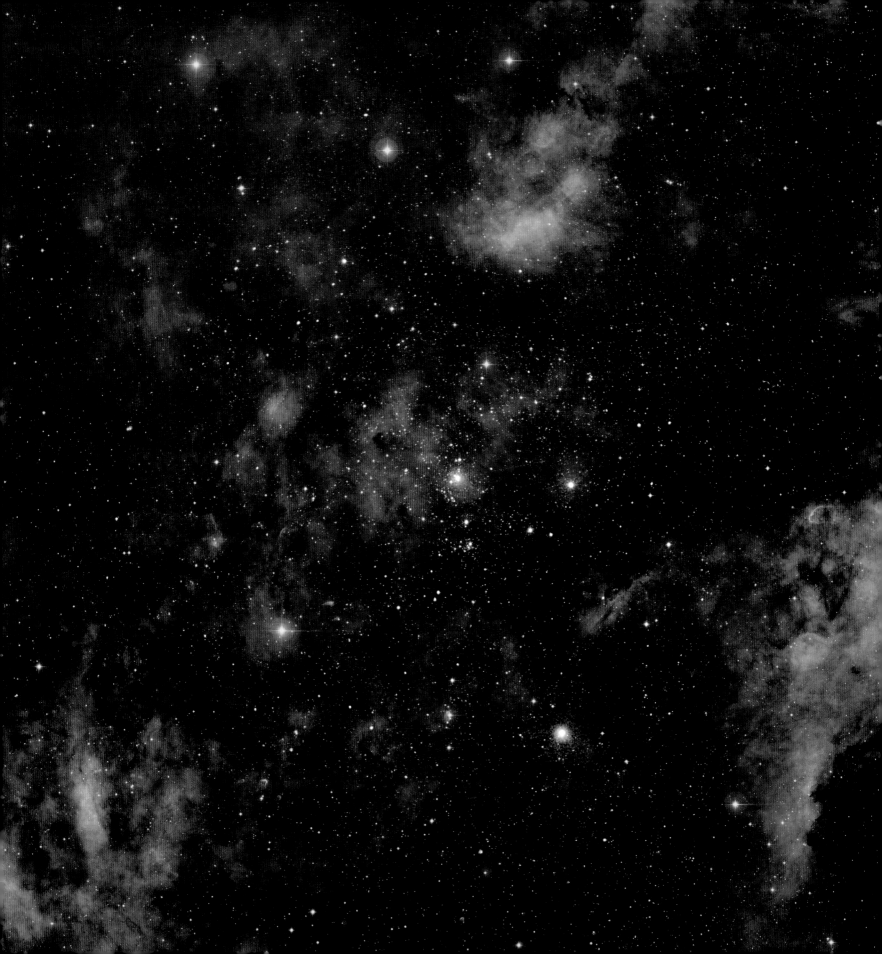

CYGNUS OB2

Cygnus OB2 is the closest massive star cluster to Earth. It contains 1,500 young stars shimmering brightly with X-ray light. These infant suns range in age from one million to seven million years old. Long observations with Chandra reveal how the outer atmospheres of these young stars behave. The image also shows optical and infrared light. Astronomers study objects like Cygnus OB2 to better understand how star factories like it form and evolve.

Scale and distance: Image is 16 light-years across; object is about 4,700 light-years from Earth.

Wavelength/color: X-ray: blue; Optical: yellow; Infrared: red.

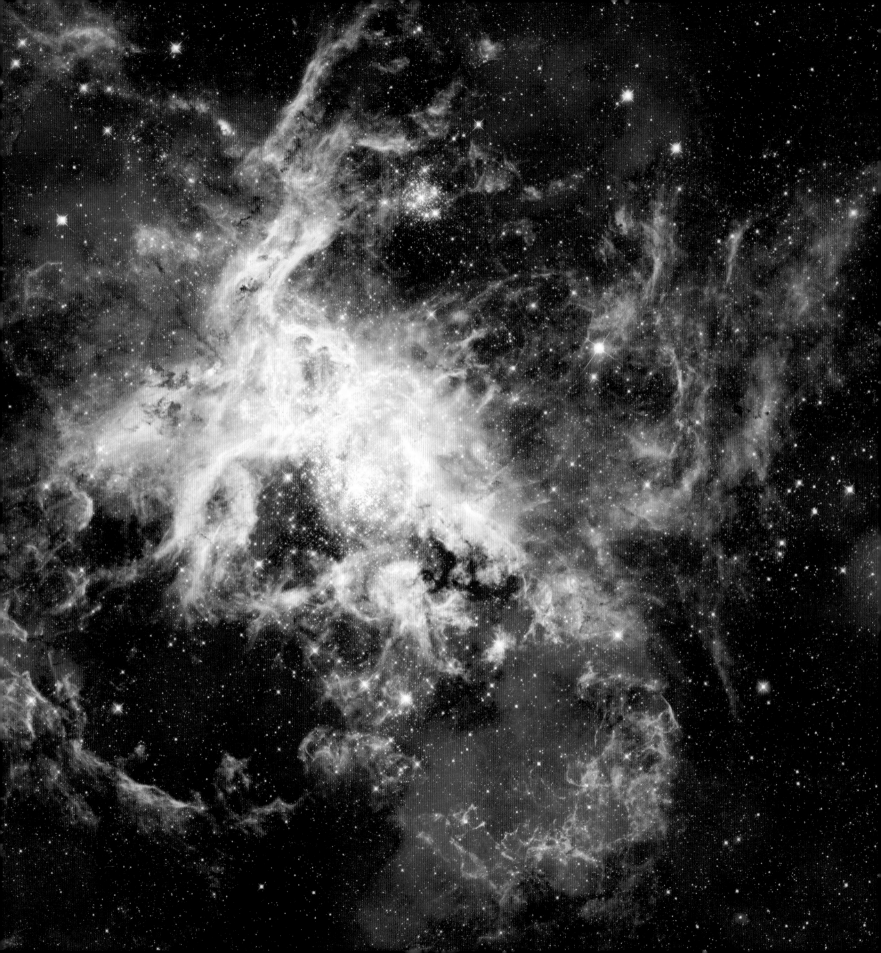

30 DORADUS (THE TARANTULA NEBULA)

30 Doradus (the Tarantula Nebula) is located in the Large Magellanic Cloud, a galaxy near our Milky Way. Chandra reveals gas that has been heated to millions of degrees by winds from stars and supernova explosions. This high-energy stellar activity creates shock fronts, similar to sonic booms. Optical data reveal light from massive stars at various stages of their birth, while infrared emission maps show cooler gas and dust.

Scale and distance: Image is about 600 light-years across; object is about 160,000 light-years from Earth.

Wavelength/color: X-ray: blue; Optical: green; Infrared: red.

47 TUCANAE

47 Tucanae is a globular cluster. As the oldest stellar systems in the Milky Way galaxy, globular clusters are laboratories for stellar and dynamical evolution. Many of the objects in the Chandra image are binary systems, in which a normal, Sun-like star companion orbits a collapsed star, either a white dwarf or neutron star. In fact, scientists using Chandra may have found the closest orbit between a star and black hole ever to date in this system.

Scale and distance: Image is about 10 light-years across; object is about 15,000 light-years from Earth.

Wavelength/color: X-ray: red, green, blue.

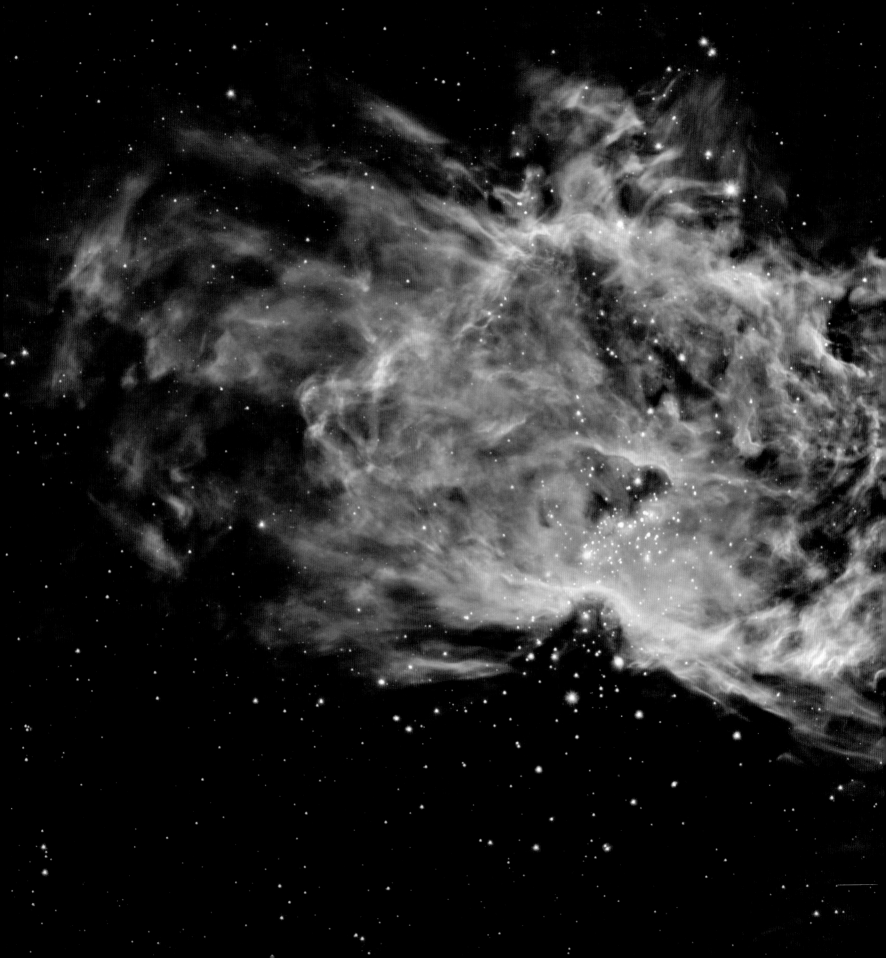

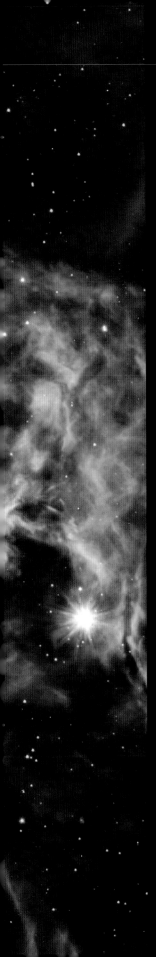

FLAME NEBULA

The Flame Nebula, also known as NGC 2024, is ablaze with star formation. Chandra's observation of this system reveals that the stars on its outer edges are about 1.5 million years old, while those in its central regions are about 200,000 years old. This finding contrasts with prior expectations that stars in the center should have been born first (and therefore be older). The combination of X-rays and infrared data is very powerful for studying populations of young stars.

Scale and distance: Image is about 15 light-years across; object is about 1,400 light-years from Earth.

Wavelength/color: X-ray: purple; Infrared: red, green, blue.

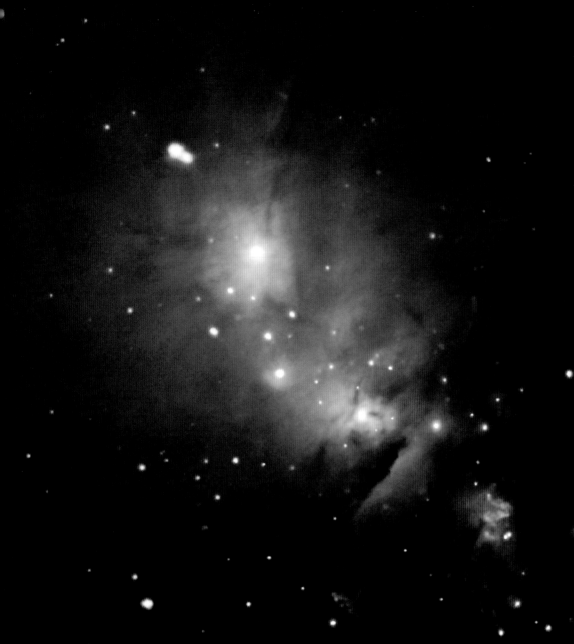

NGC 1333

NGC 1333 is a cluster containing many stars less than two million years old, which is very young in astronomical terms. Chandra data reveal 95 young stars glowing in X-ray light, 41 of which had not been identified in other wavebands. X-ray observations, combined here with infrared and optical data, can reveal information about the physical properties and behaviors of these very young stars.

Scale and distance: Image is about 4 light-years across; object is about 770 light-years from Earth.

Wavelength/color: X-ray: pink; Optical: red, green, blue; Infrared: red.

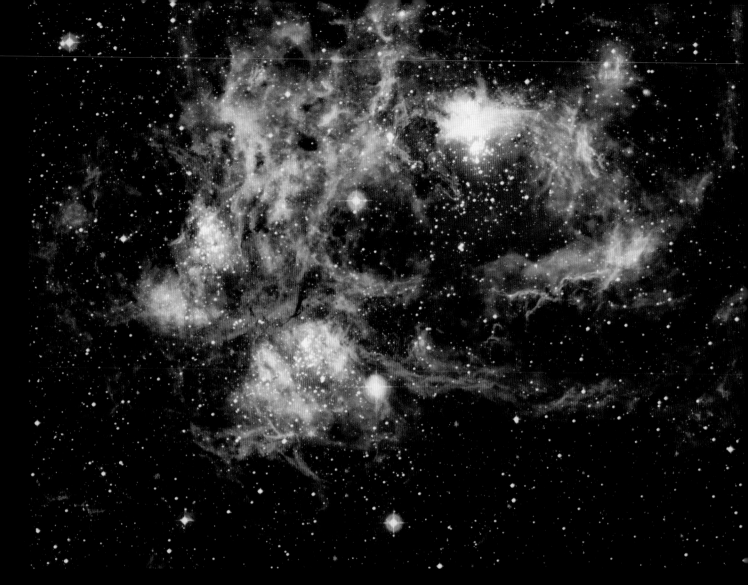

NGC 6357

NGC 6357 is a star formation region in our Milky Way. NGC 6357 contains at least three clusters of young stars, including many hot, massive, luminous stars. X-rays from Chandra and a German X-ray satellite called ROSAT reveal hundreds of young stars, as well as diffuse X-ray emission from hot gas. There are bubbles, or cavities, that have been created by radiation and material blowing away from the surfaces of massive stars, plus supernova explosions. X-rays have been combined with infrared and optical data to complete this cosmic vista.

Scale and distance: Image is about 70 light-years across; object is about 5,500 light-years from Earth.

Wavelength/color: X-ray: purple; Optical: blue; Infrared: orange.

THE EAGLE NEBULA (M16)

The Eagle Nebula is a star-forming region more commonly known as the Pillars of Creation. Chandra's unique ability to resolve and locate X-ray sources made it possible to discover and identify hundreds of very young stars and those still in the process of forming, known as protostars. The Chandra data were added to Hubble's data to create this spectacular image of stellar birth.

Scale and distance: Image is about 5.13 light-years across; object is about 5,700 light-years from Earth.

Wavelength/color: X-ray (larger point sources): red, green, blue; Optical (diffuse emission and smaller point sources): red, green, blue.

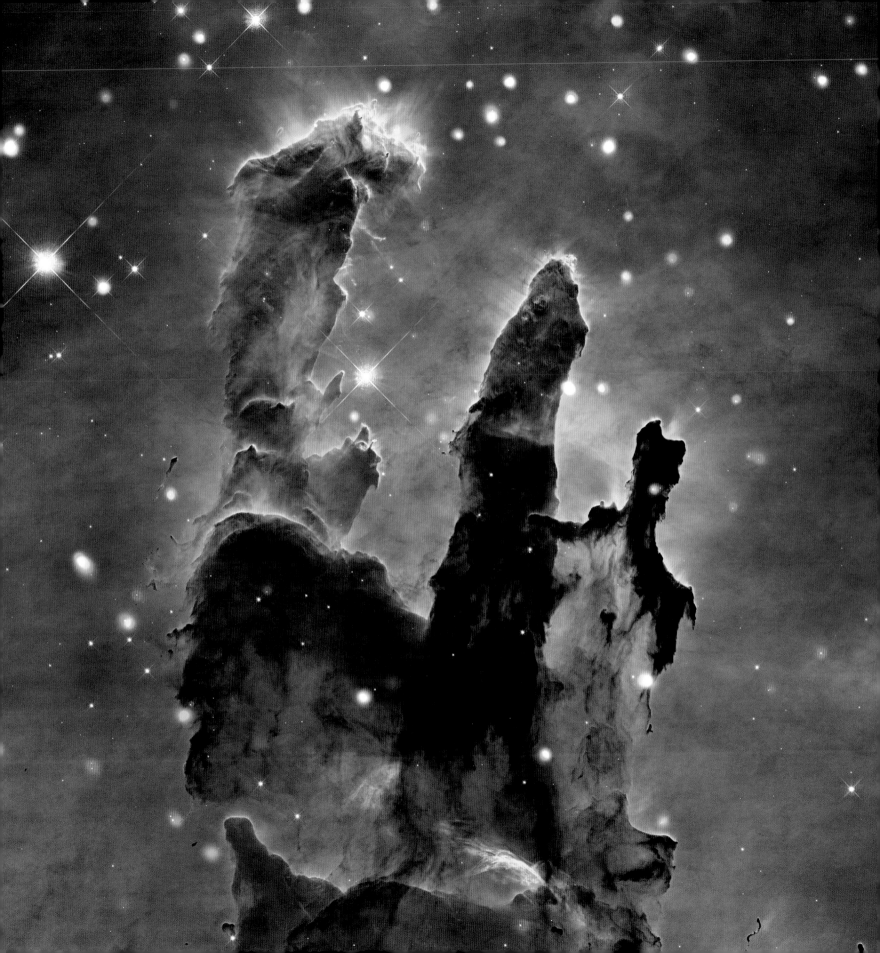

INFRARED

N G C 6 2 3 1

NGC 6231 is an ideal test bed for studying a
stellar cluster not long after star formation has
stopped. Stars in clusters come from the same
origins—a common cloud of gas and dust—
and are bound together by gravity. Chandra
identified young Sun-like stars (close-up
outlined in inset) that have been hiding in plain
sight in optical and infrared images. Young stars
stand out to Chandra because they have strong
magnetic activity that heats their outer atmo-
sphere to tens of millions of degrees and causes
them to emit X-rays.

Scale and distance: Infrared image is about
452 light-years across; X-ray image is about
24 light-years across; object is about 5,190
light-years from Earth.

Wavelength/color: X-ray: red, green, blue;
Infrared: red, yellow, green, cyan, blue.

LIGHT FROM THE VOID

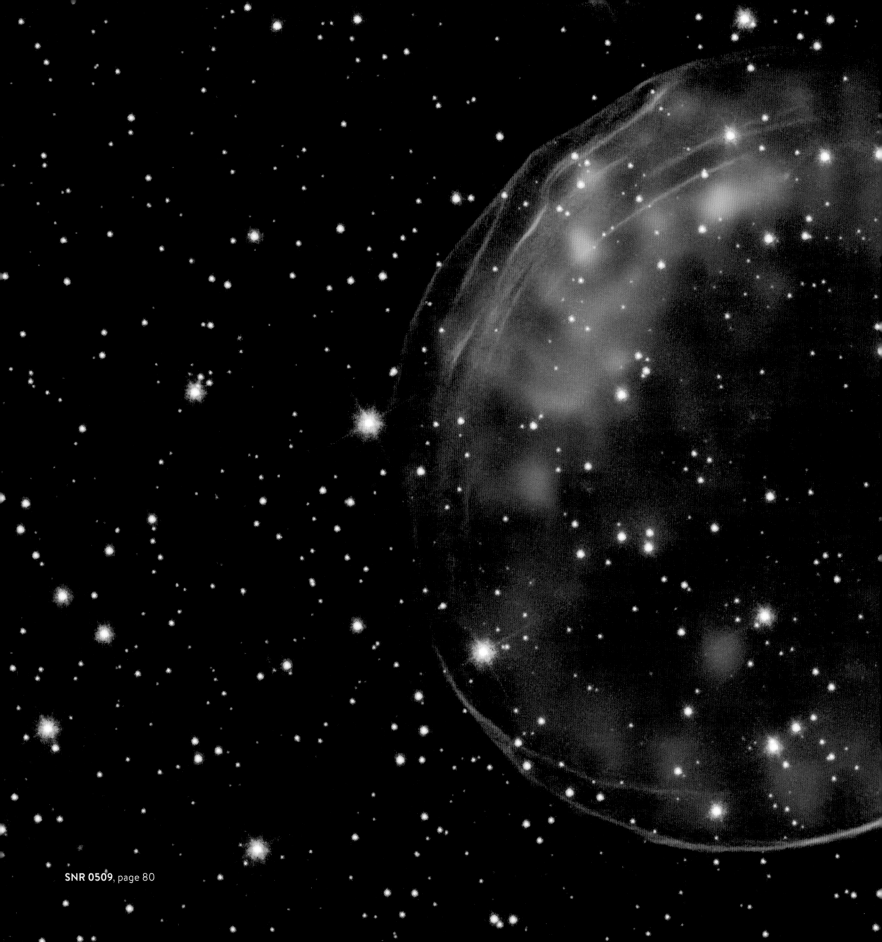

SNR 0509, page 80

2
BEGINNINGS
AT THE END

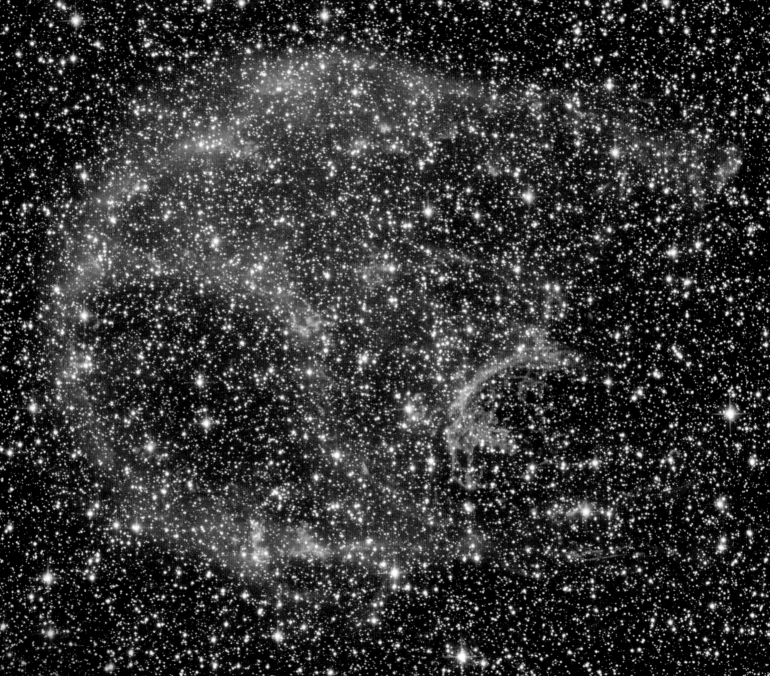

JUST AS IT HAS SEEN STARS BORN, Chandra has witnessed their dying. As a star's central engine begins to shut down amid a dearth of fuel, it starts to expel its outer atmosphere into the void. A very massive star dies in a far more spectacular fashion—as a supernova. Both the quiet and violent deaths of stars give rise to a new beginning: a rapidly expanding cloud of hot gas that shines brightly in X-rays.

Every fifty years or so, a massive star in our Galaxy blows itself up in a supernova explosion. Supernovas are some of the most violent events in the Universe, and the force of the explosion generates a blinding flash of radiation as well as shock waves that rumble across space.

This form of stellar death is not only about violence. Supernovas are also the primary means for seeding the Galaxy with elements such as carbon, nitrogen, oxygen, silicon, and iron that are necessary for life as we know it. Supernova explosions are responsible for disseminating most of the elements essential for life on Earth, which would otherwise be locked inside the furnaces of stars. We owe our very existence to these cosmic events: We are stardust indeed.

X-ray telescopes such as Chandra are important to the study of supernova remnants and the elements they produce because these events generate extremely high temperatures—millions of degrees—even thousands of years after the explosion. This means that many supernova remnants glow most strongly at X-ray wavelengths that are challenging to detect with other types of telescopes.

A supernova explosion usually leaves behind an extraordinarily dense object called a neutron star. In some cases, two neutron stars will remain bound to each other after their massive stellar predecessors explode. If the two neutron stars are close together, their orbits will shrink until they merge and generate a burst of gravitational waves—that is, ripples in space-time itself. In 2017, Chandra detected the afterglow of such an event, the first we have been able to document (see page 196).

Here we celebrate one of Chandra's greatest scientific legacies—a revolution in our understanding of how stars end their life in majesty. Several of the images that follow show the bodies of stars whose deaths have been witnessed by human beings, some centuries or even millennia ago. By pairing the information ancient astronomers gleaned with that from modern science, we can learn about these vital and remarkable objects that stretch across the Galaxy and beyond.

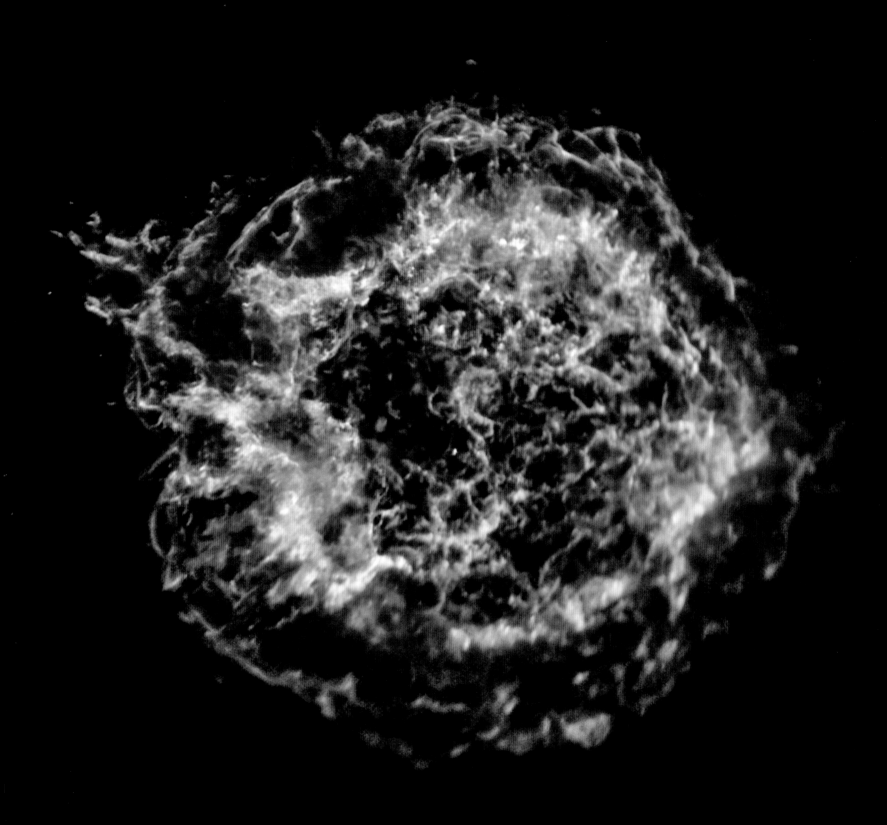

CASSIOPEIA A

Where do most of the elements essential for life on Earth come from? They come from inside the furnaces of stars and the explosions that mark the end of some stars' lives. Exploded stars and their remains show astronomers how stars produce and then disseminate many of the elements observed on Earth and in the cosmos at large. Cassiopeia A, one of the first objects Chandra observed after it was launched, is a spectacular supernova remnant that tells astronomers more about how these elements are dispersed into space.

Scale and distance: Image is about 29 light-years across; object is about 11,000 light-years from Earth.

Wavelength/color: X-ray: red, yellow, green, purple, blue.

VELA PULSAR

The Vela pulsar at the center of this image is a dense, dead spinning star that is sending out jets of high-energy particles into an environment of multimillion-degree gas clouds. These clouds are part of a huge sphere of hot expanding gas produced by the supernova explosion that created the Vela pulsar about 10,000 years ago. Astronomers think this explosion was so bright that would have appeared fifty times brighter than Venus from Earth's surface.

Scale and distance: Image is about 8.7 light-years across; object is about 1,000 light-years from Earth.

Wavelength/color: X-ray: red to orange.

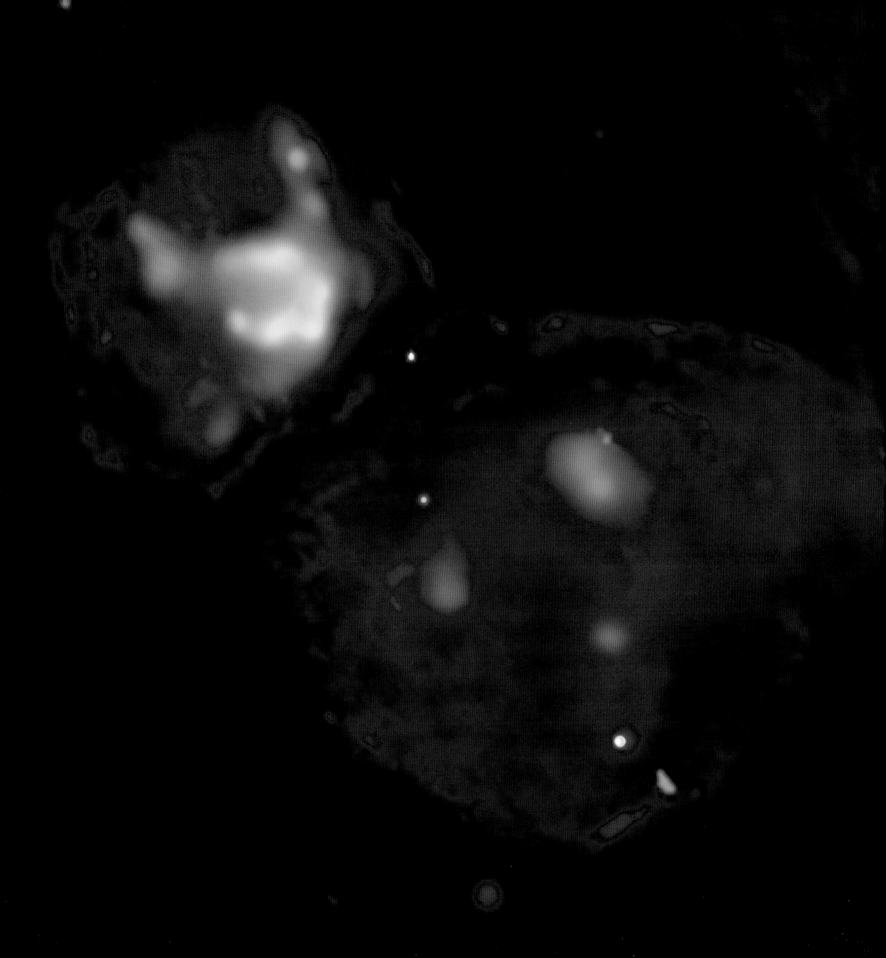

DEM L316

This cat-shaped image is produced by the remnants of two exploded stars in the Large Magellanic Cloud. Chandra data show that the shell of hot gas on the upper left contains considerably more iron than the one on the lower right. This implies that stars with very different ages exploded to produce these objects. The two shells, shown in optical light in this image, are quite distant from one another, and appear close together only given their superposition along the same line of sight.

Scale and distance: Image is 265 light-years across; object is about 160,000 light-years from Earth.

Wavelength/color: X-ray: red, green, blue; Optical: purple.

N132D

N132D is a supernova remnant in the Large Magellanic Cloud. The explosion of a massive star produced the horseshoe-shaped cloud of hot X-ray gas against a backdrop of thousands of stars in optical light. Shock waves produced by the explosion heated interstellar gas around the site to X-ray-emitting temperatures of millions of degrees. Optical data reveal cooler gas and a small, bright crescent-shaped cloud of emission from hydrogen gas.

Scale and distance: Image is about 150 light-years across; object is about 160,000 light-years from Earth.

Wavelength/color: X-ray: blue; Optical: pink and purple.

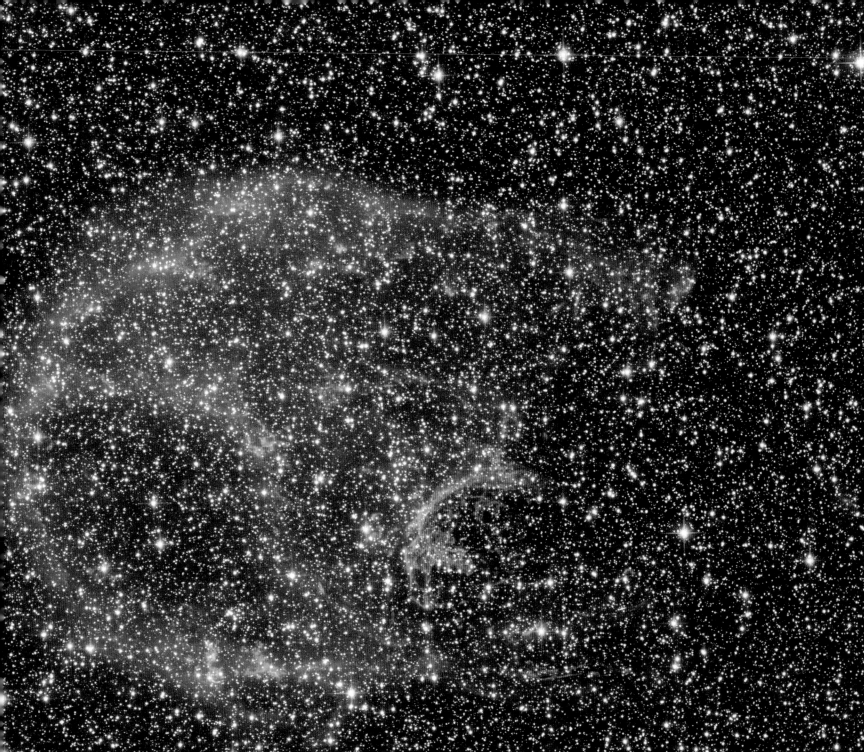

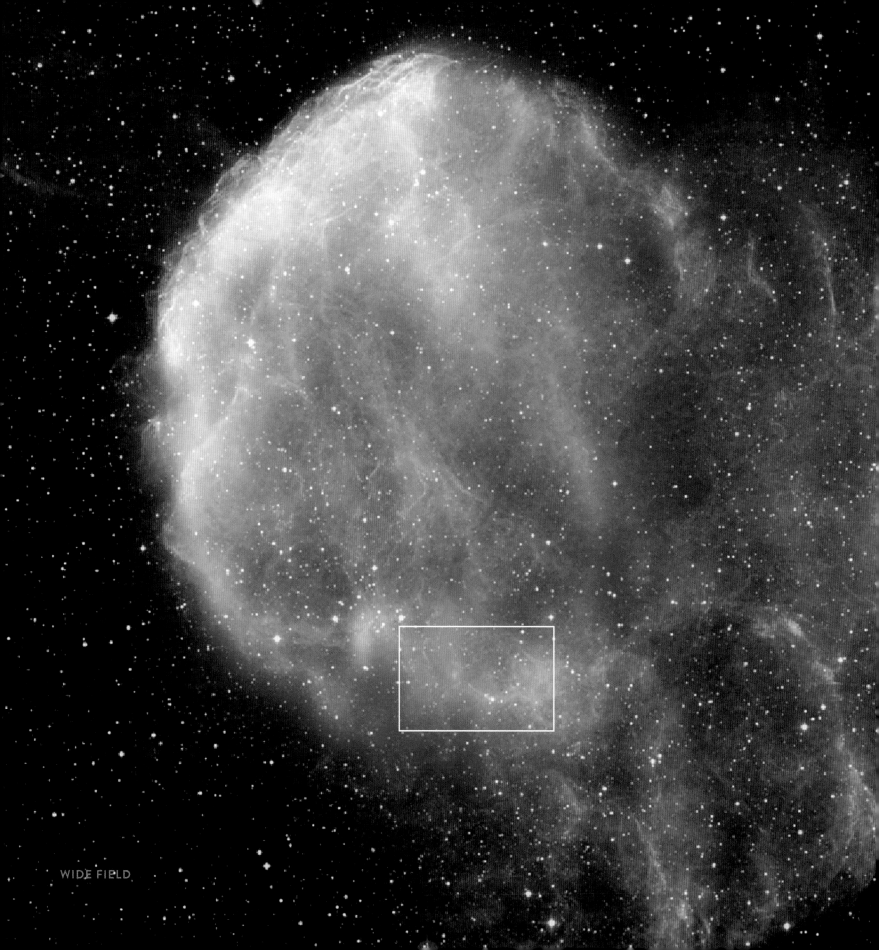

WIDE FIELD

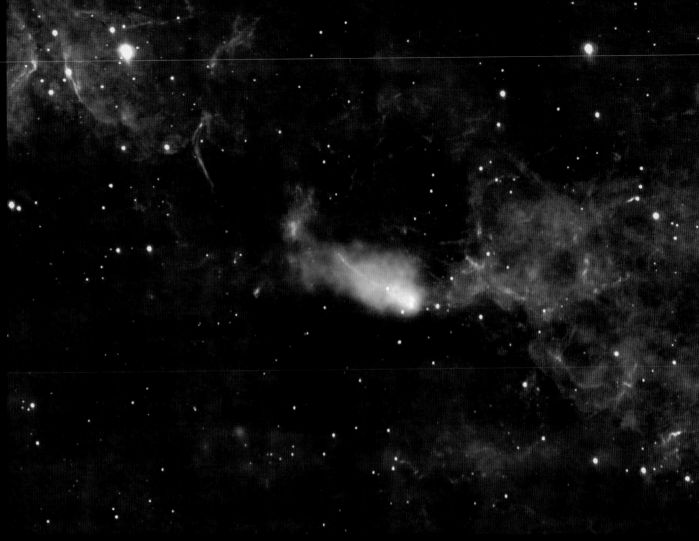

CLOSE UP

J0617 IN IC 443

The object known as J0617 is a neutron star located in the supernova remnant IC 433. Neutron stars are strange and fascinating, the dense cores of exploded stars made up of closely packed neutrons. This close-up view shows J0617 ejecting a comet-like wake of high-energy particles as it races through space. The full-field image shows X-rays from ROSAT and Chandra, as well as radio and optical observations of IC 443.

Scale and distance: Wide-field image is about 68 light-years across; inset image is 14 light-years across; object is about 5,000 light-years from Earth.

Wavelength/color: X-ray: blue; Radio: green; Optical: red.

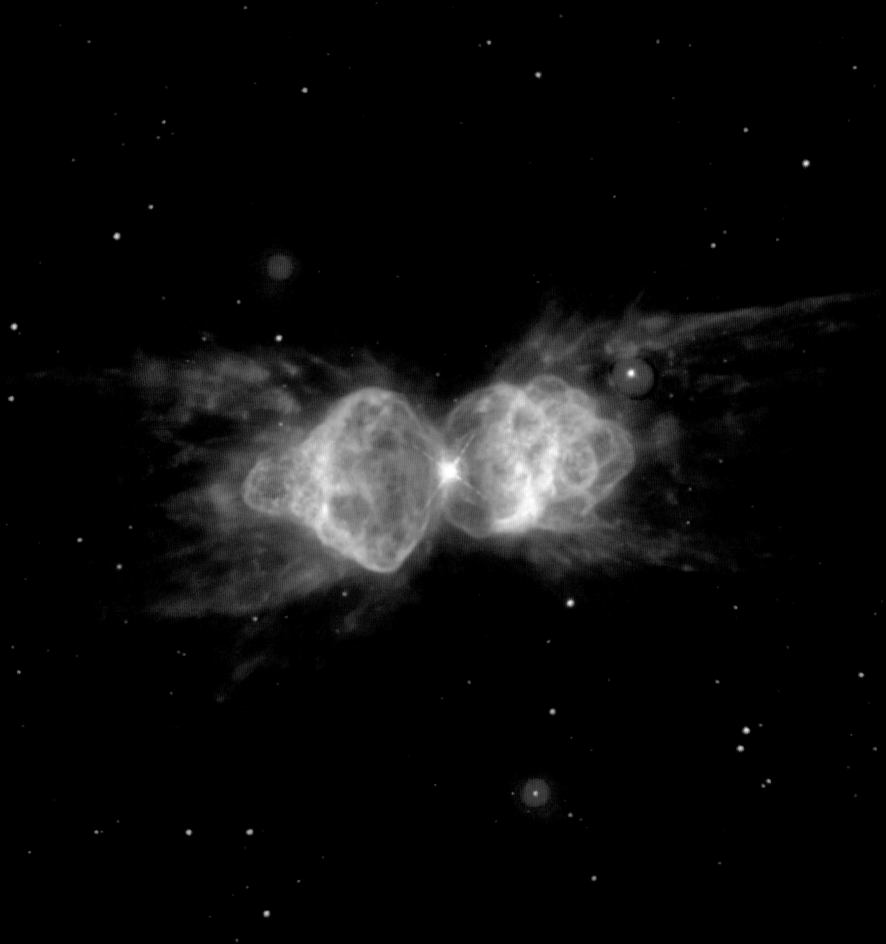

MZ 3 (ANT NEBULA)

The Ant Nebula, or Menziel 3, is a planetary nebula. Astronomers in previous centuries dubbed these objects planetary nebulas because some of them resemble a planet when viewed through a small telescope. In fact, they have nothing to do with planets, but rather represent the late stages of a Sun-like star's life, when its outer layers puff out. In this X-ray, infrared, and optical image of the Ant Nebula, dynamic elongated clouds envelop bubbles of multimillion-degree gas produced by high-velocity winds from dying stars.

Scale and distance: Image is about 1.6 light-years across; object is about 3,000 light-years from Earth.

Wavelength/color: X-ray: blue; Optical/Infrared: green and red.

BD+30-3639

Images of the planetary nebula BD+30-3639
show a hot bubble of multimillion-degree
gas, roughly 100 times the diameter of our
Solar System, surrounding a dying star. When
a star like our Sun uses up all of the hydrogen
in its core, it expands and sends the star's
outer layer of the star into space sometimes
in dramatic fashion. This multi-wavelength
image shows the nebula in X-ray, optical, and
infrared light about 1,000 years after the
bubble formed.

Scale and distance: Image is 0.45 light-years
across; object is about 5,000 light-years
from Earth.

Wavelength/color: X-ray: blue; Optical/
Infrared: green and red.

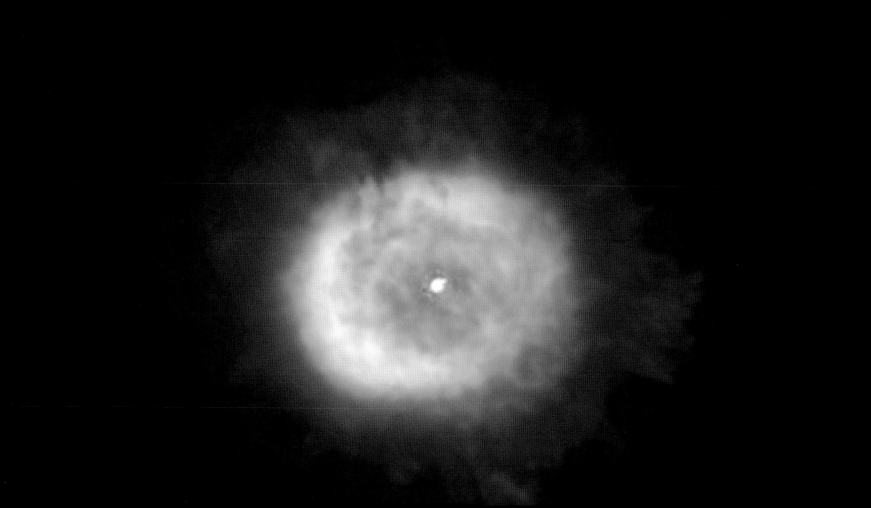

HEN 3-1475

Hen 3-1475 is a young planetary nebula in the making. The dying star in the center of this system has a thick torus of material surrounding it. Astronomers have found two jets shoot out of this star that precess, or change their orientation, slowly over time, much like a toy top wobbles around its axis. These fast-moving jets and this unusual motion may be giving this planetary nebula its unusual shape.

Scale and distance: Image is about 1.6 light-years across; object is about 18,000 light-years from Earth.

Wavelength/color: X-ray: blue; Optical/Infrared: green and red.

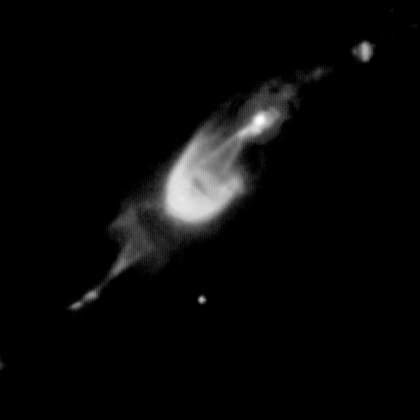

NGC 7027

NGC 7027 shows the remains of a Sun-like star that has ejected much of its mass to expose its hot core. The X-rays of this planetary nebula were probably produced when a relatively fast wind from the hot core collided with a slower one that was ejected earlier during the star's red giant phase. This collision heated the matter to several million degrees, so that it now glows in X-rays. Also shown in the image are infrared and optical emission from cooler material.

Scale and distance: Image is about 0.25 light-years across; object is about 3,000 light-years from Earth.

Wavelength/color: X-ray: blue; Optical/Infrared: green and red.

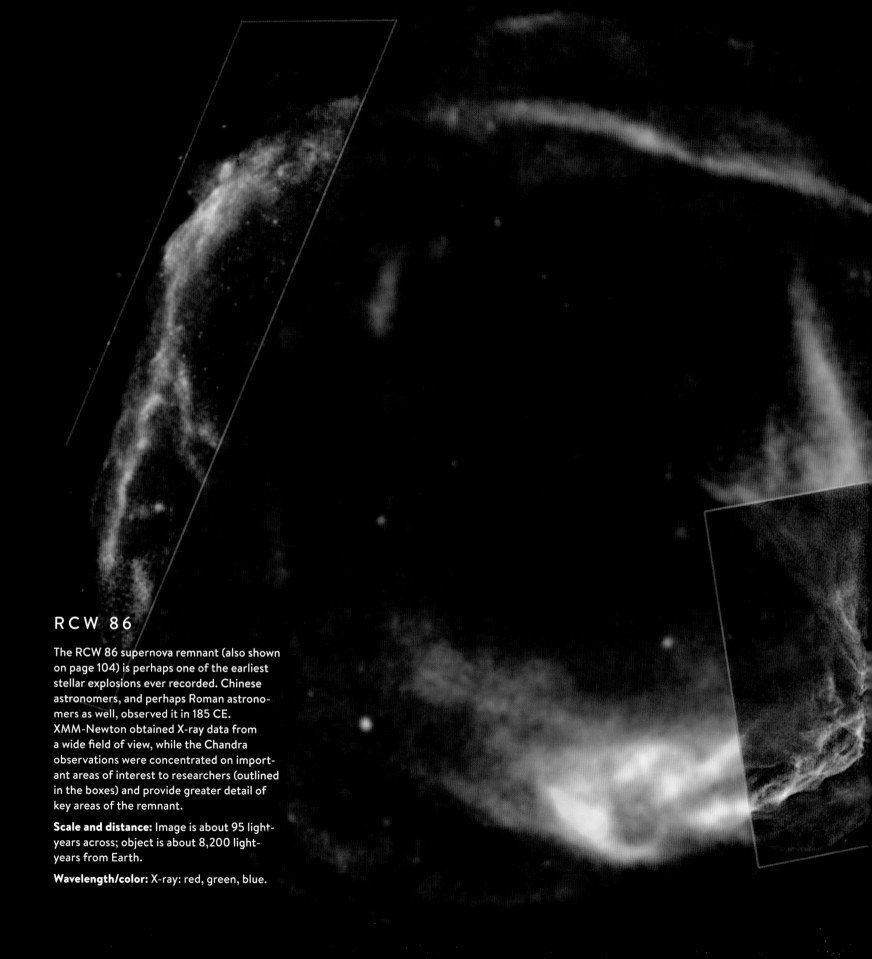

RCW 86

The RCW 86 supernova remnant (also shown on page 104) is perhaps one of the earliest stellar explosions ever recorded. Chinese astronomers, and perhaps Roman astronomers as well, observed it in 185 CE. XMM-Newton obtained X-ray data from a wide field of view, while the Chandra observations were concentrated on important areas of interest to researchers (outlined in the boxes) and provide greater detail of key areas of the remnant.

Scale and distance: Image is about 95 light-years across; object is about 8,200 light-years from Earth.

Wavelength/color: X-ray: red, green, blue.

G347.3-0.5

According to Chinese records from 393 CE, a bright star in the location of G347.3-0.5 was visible for months, rivaling the brilliance of Jupiter. X-rays of the exploded star are dominated by radiation from extremely high-energy electrons in a magnetized shell. The bright point-like source on the lower section of the image (which shows only the upper portion of the entire remnant) is similar to other known neutron stars. The high resolution Chandra data are shown in the outlined box, with the rest of the X-ray data are from XMM-Newton.

Scale and distance: Image is about 49 light-years across; object is about 3,000 light-years from Earth.

Wavelength/color: X-ray: purple.

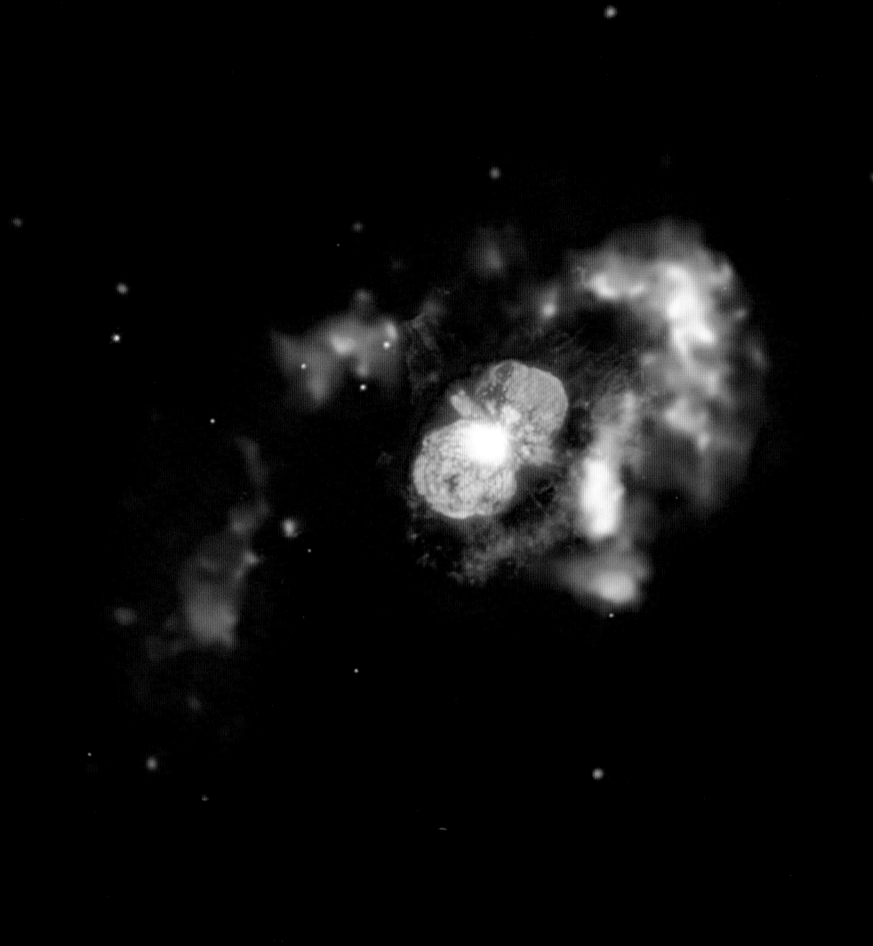

ETA CARINAE

Eta Carinae is a star between 100 and 150 times more massive than our Sun. Astronomers think this unusual system underwent a giant eruption during the 1840s. X-ray data from Chandra show where material from that explosion has collided with nearby gas and dust. Optical data reveal material ejected from the star has formed a bipolar structure. The star is thought to be consuming its nuclear fuel at an incredible rate and will explode as a supernova.

Scale and distance: Image is 4.8 light-years across; object is about 7,500 light-years from Earth.

Wavelength/color: X-ray: yellow to blue-violet; Optical: blue.

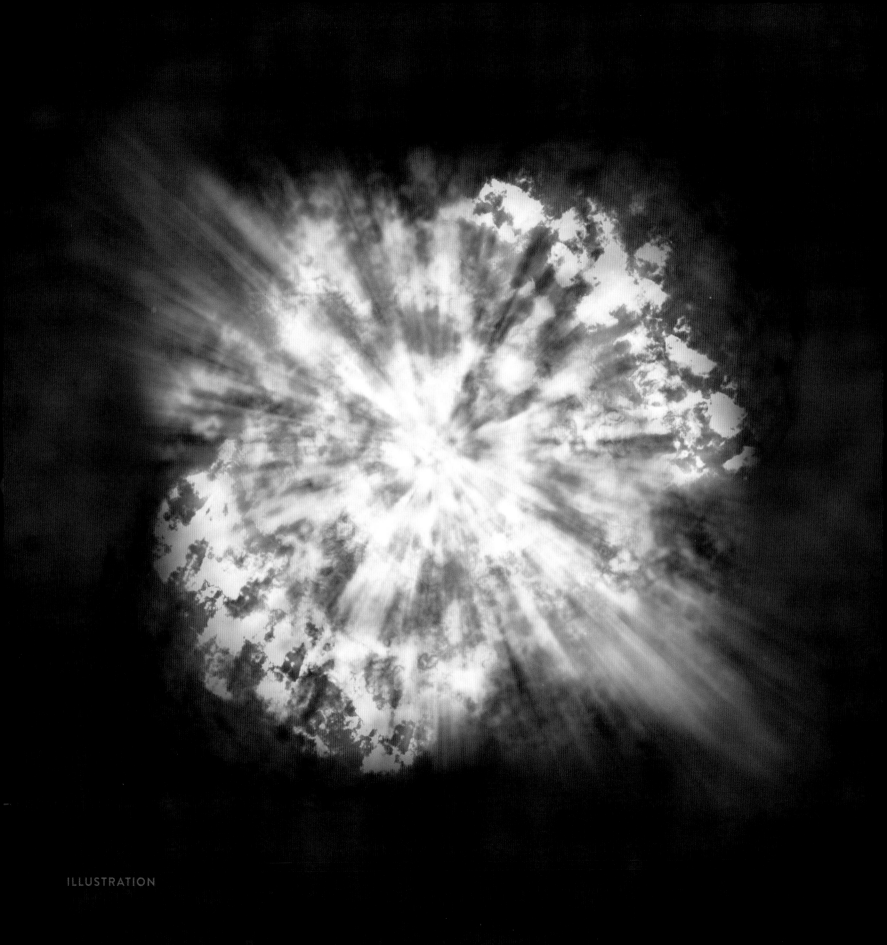

ILLUSTRATION

OPTICAL

SN 2006GY

SN 2006gy is among the brightest stellar explosions ever recorded and may be a long-sought new type of supernova. The discovery suggests that violent explosions of extremely massive stars were relatively common in the early Universe, and thus 2006gy may offer a glimpse into how the very first stars died. The illustration at left depicts the explosion, with optical observations at upper right and Chandra's X-ray view of the system lower right. SN 2006GY is the upper-right feature in both images. The lower left is light from the center of the galaxy.

Scale and distance: Each panel is about 3,000 light-years across; object is about 238 million light-years from Earth.

Wavelength/color: X-ray: purple; Optical: red, green, blue.

X-RAY

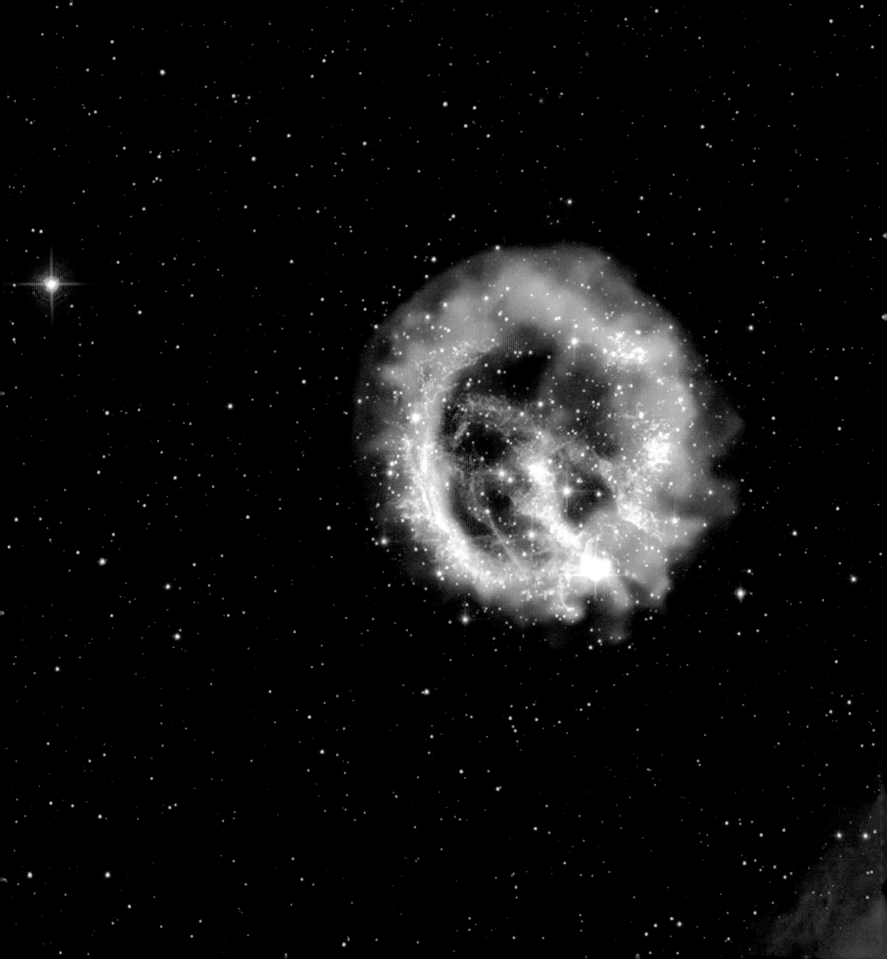

E0102-72.3

E0102-72.3 is a supernova remnant in the Small Magellanic Cloud. This composite of Chandra and Hubble data shows details of the aftermath of a massive star that exploded and would have been visible from Earth over 1,000 years ago. Chandra data depict an outer blast wave produced by the supernova and an inner ring of cooler material.

Scale and distance: Image is about 165 light-years across; object is about 200,000 light-years from Earth.

Wavelength/color: X-ray: blue, cyan, orange; Optical: blue, green, red.

77

PSR B1509-58

PSR B1509-58 contains a 1,700-year-old pulsar only 12 miles in diameter that is in the center of this Chandra image. The pulsar is spewing energy out into the space around it, forming a complex and intriguing structure that spans 150 light-years. The pulsar is spinning around nearly seven times a second and has a magnetic field at its surface that is estimated to be 15 trillion times stronger than the Earth's magnetic field.

Scale and distance: Image is about 97 light-years across; object is about 17,000 light-years from Earth.

Wavelength/color: X-ray: red, green, blue.

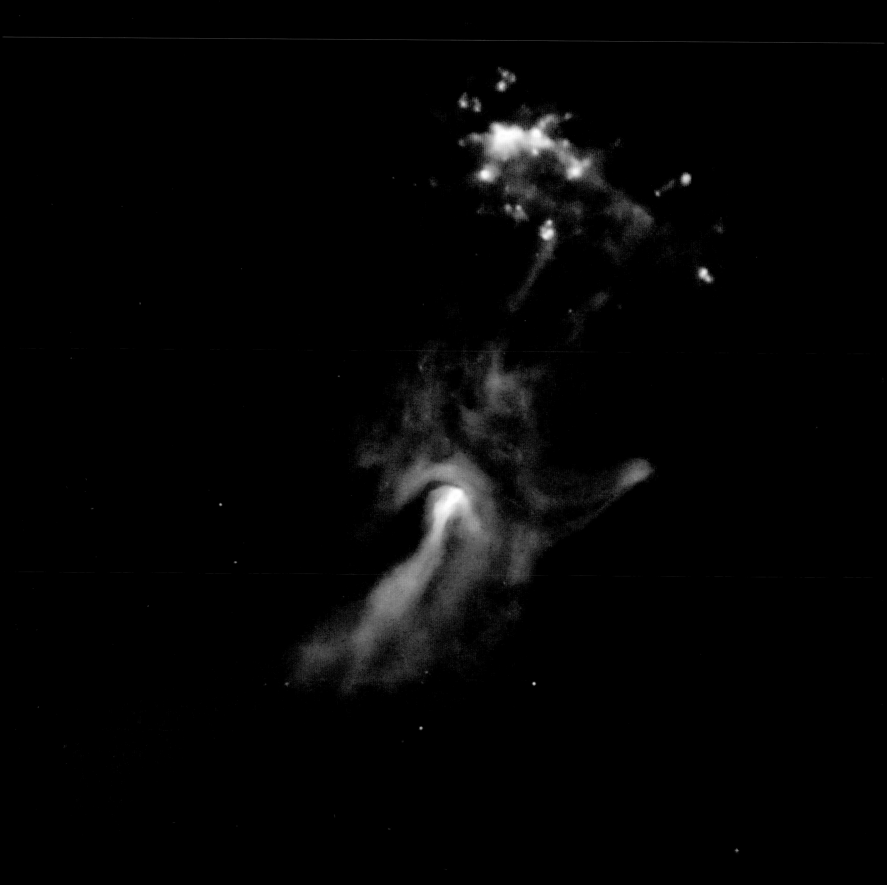

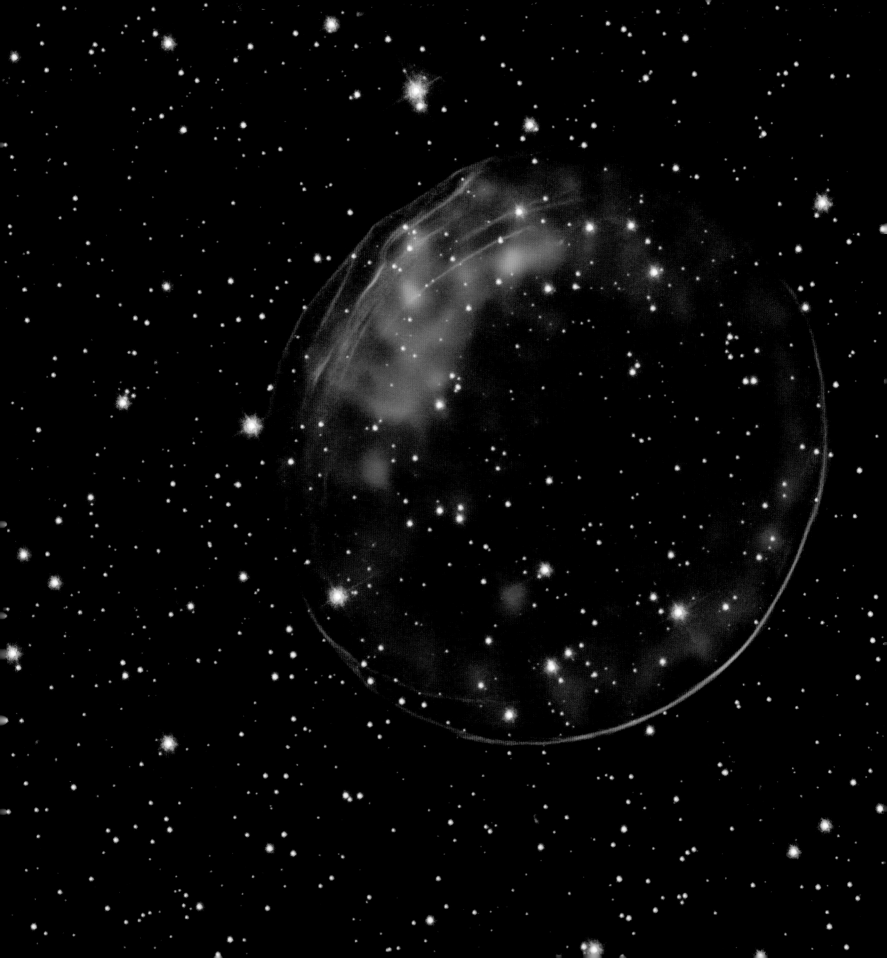

SNR 0509-67.5

The supernova that resulted in the creation of SNR 0509-67.5 occurred nearly 400 years ago for Earth viewers. The Chandra X-ray data show material in the center of the remnant that has been heated to millions of degrees. Combined with optical data, the image also shows the star field and gas that has been shocked by the expanding blast wave. The bubble-shaped shroud of gas (in red) is 23 light-years across and is expanding at more than 11 million miles per hour (5,000 kilometers per second).

Scale and distance: Image is about 58 light-years across; object is about 160,000 light-years from Earth.

Wavelength/color: X-ray: green, blue; Optical: orange, red, violet.

NGC 6543

The Cat's Eye Nebula (NGC 6543) planetary nebula represents a phase that our Sun will experience several billion years from now. At this stage, the Sun will expand to become a red giant and then shed most of its outer layers, leaving behind a hot core that contracts to form a dense white dwarf star. The X-ray emission that Chandra detected in the Cat's Eye (shown with Hubble optical data) is caused by shock waves as wind from the dying star collides with the ejected atmosphere.

Scale and distance: Image is about 1.7 light-years across; object is about 3,000 light-years from Earth.

Wavelength/color: X-ray: purple; Optical: orange, blue.

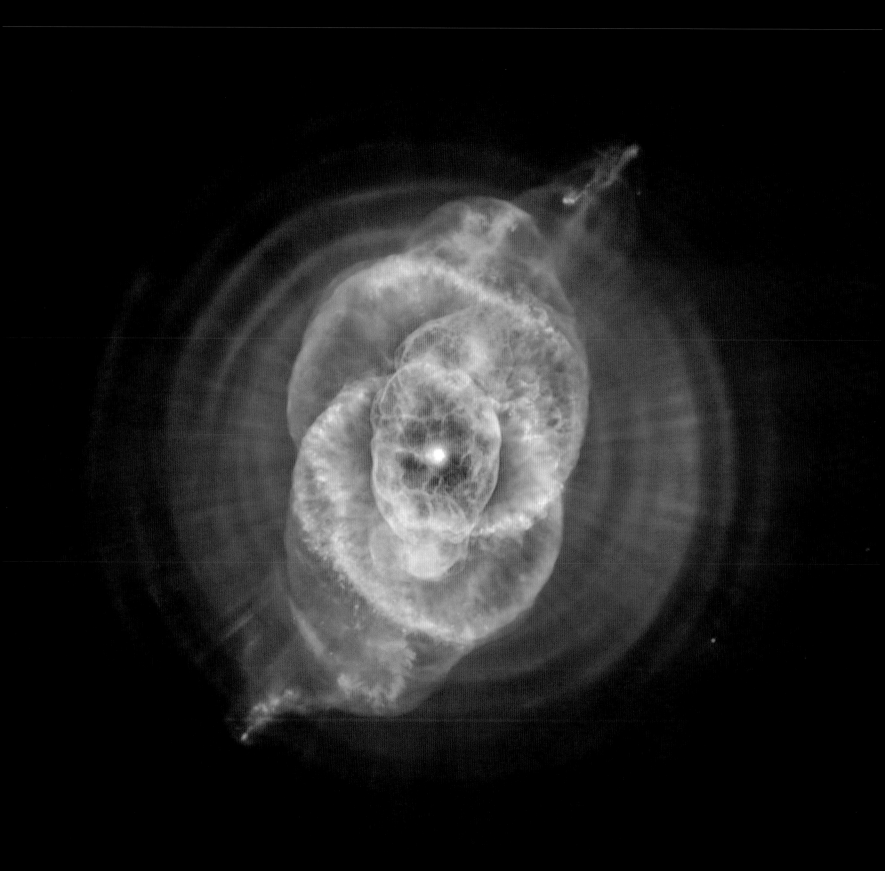

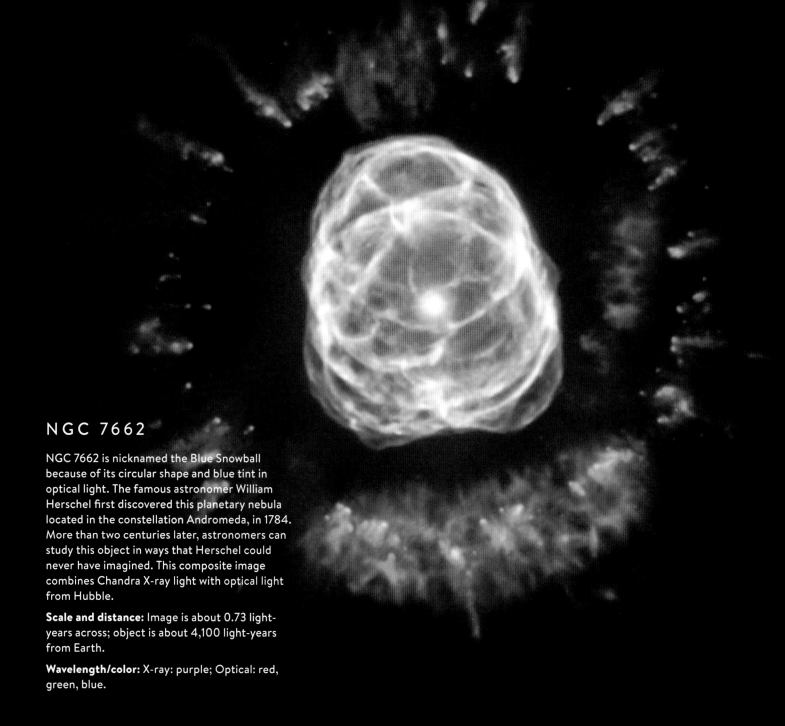

NGC 7662

NGC 7662 is nicknamed the Blue Snowball because of its circular shape and blue tint in optical light. The famous astronomer William Herschel first discovered this planetary nebula located in the constellation Andromeda, in 1784. More than two centuries later, astronomers can study this object in ways that Herschel could never have imagined. This composite image combines Chandra X-ray light with optical light from Hubble.

Scale and distance: Image is about 0.73 light-years across; object is about 4,100 light-years from Earth.

Wavelength/color: X-ray: purple; Optical: red, green, blue.

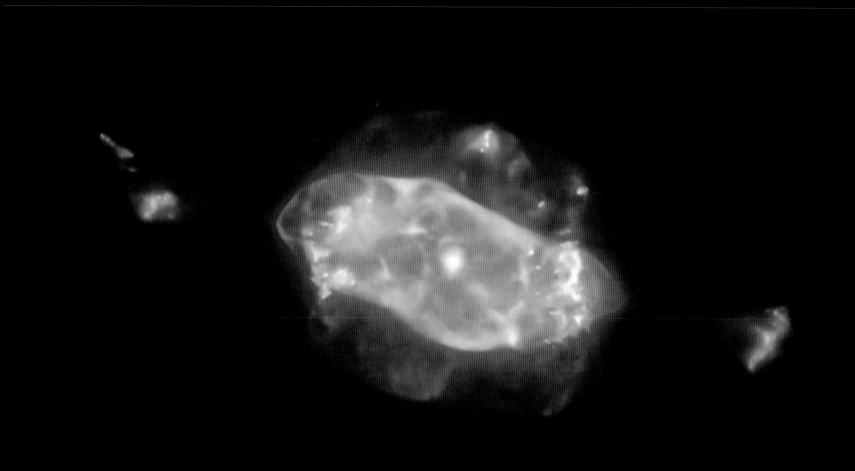

NGC 7009

NGC 7009, known as the Saturn Nebula, is a planetary nebula in the constellation Aquarius. Its nickname comes from its shape, which resembles our Solar System's ringed planet seen edge-on. Like all planetary nebulas, NGC 7009 was a star like our Sun before it ran out of hydrogen to fuse and began to slough off its outer layers. That material was then blown out by strong winds from the star, creating the nebula seen here in X-ray and optical light, with the white dwarf star in its center.

Scale and distance: Image is about 1.8 light-years across; object is about 4,700 light-years from Earth.

Wavelength/color: X-ray: purple; Optical: red, green, blue.

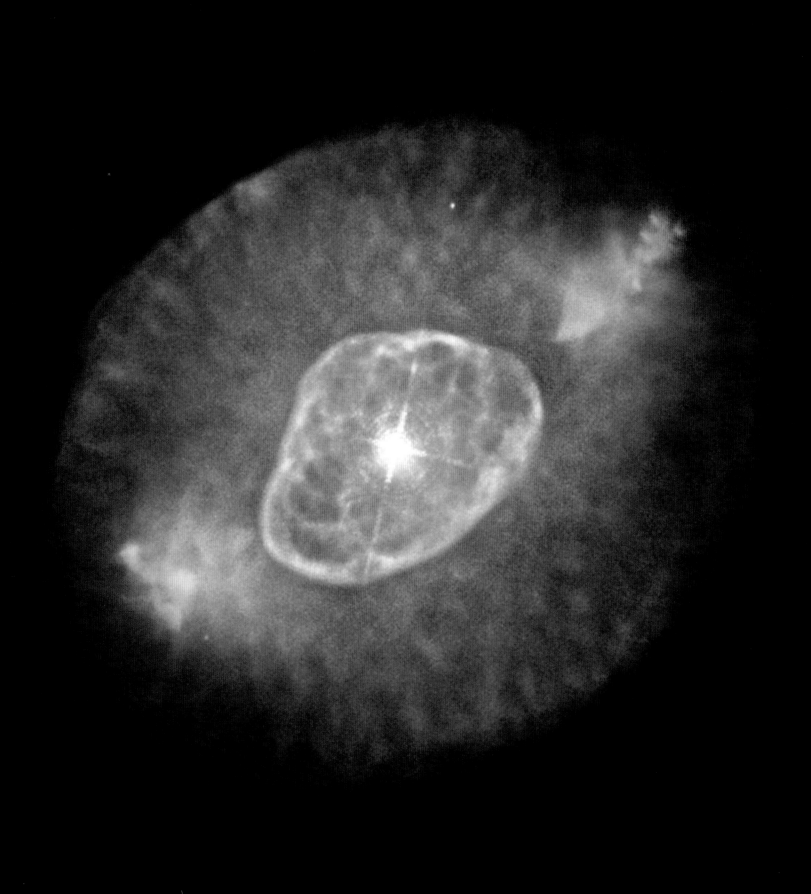

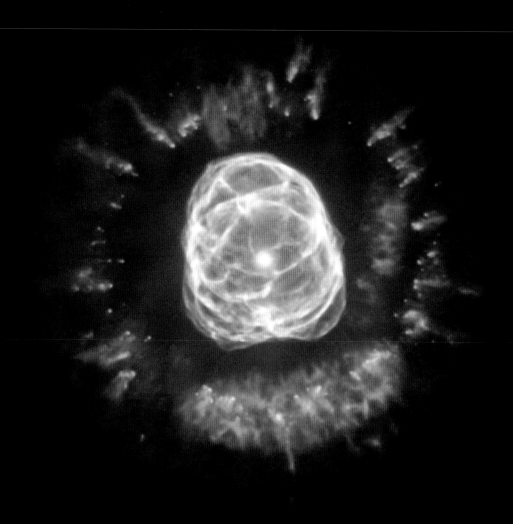

NGC 6826

NGC 6826 is a planetary nebula that somewhat resembles an eye in optical and X-ray light. The surrounding gas likely once made up almost half of the star's mass for most of its life. The hot remnant star (in the center of the pink oval) drives a fast wind into older material, creating a heated bubble that pushes the older gas ahead of it to form a bright rim. This doomed star is one of the brightest stars in any nearby planetary nebulas.

Scale and distance: Image is about 0.77 light-years across; object is about 4,200 light-years from Earth.

Wavelength/color: X-ray: purple; Optical: red, green, blue.

NGC 2392

When a star like our Sun uses up all of the hydrogen in its core, it becomes a planetary nebula. This is seen in NGC 2392. During this stage, the star begins to cool and expand, increasing its radius by tens to hundreds of times its original size. Eventually the outer layers of the star are swept away, leaving behind a hot core. The radiation from the hot star and the interaction of winds create the complex and filamentary shell of a planetary nebula, as seen in X-ray and optical light here.

Scale and distance: Image is about 1.2 light-years across; object is about 4,200 light-years from Earth.

Wavelength/color: X-ray: pink; Optical: orange, green, blue.

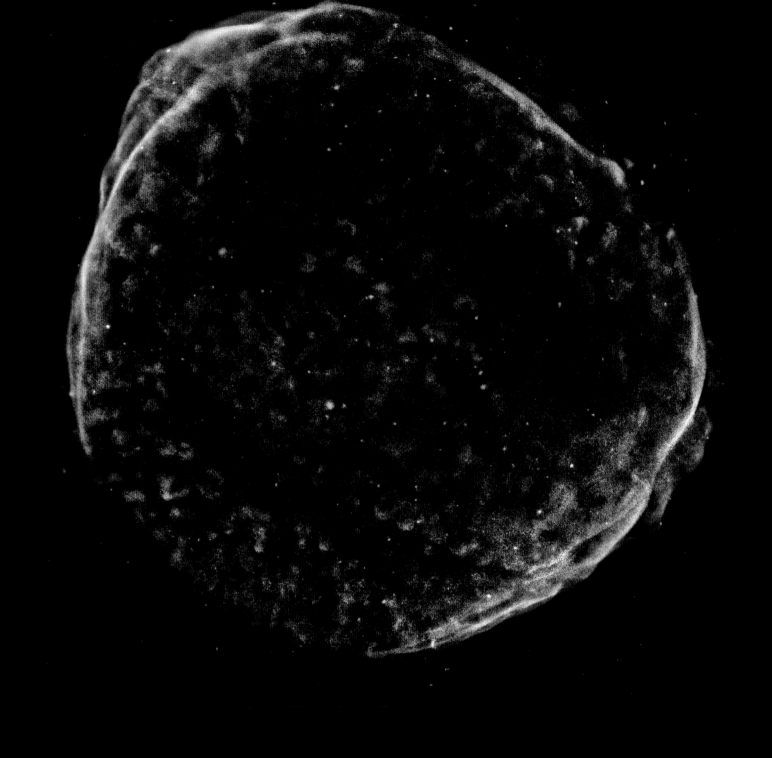

SN 1006

In 1006 CE, a new star suddenly appeared in Earth's sky. Over the course of a few days it became brighter than the planet Venus. The supernova of 1006, or SN 1006, may have been the brightest ever recorded in human history. SN 1006 heralded not the appearance of a new star but the cataclysmic death of an old one. It was likely a white dwarf star that had been pulling matter off an orbiting companion star until it exploded. Today, the debris field glows brightly in X-rays that can be captured by Chandra.

Scale and distance: Image is about 70 light-years across; object is about 7,000 light-years from Earth.

Wavelength/color: X-ray: red, green, blue.

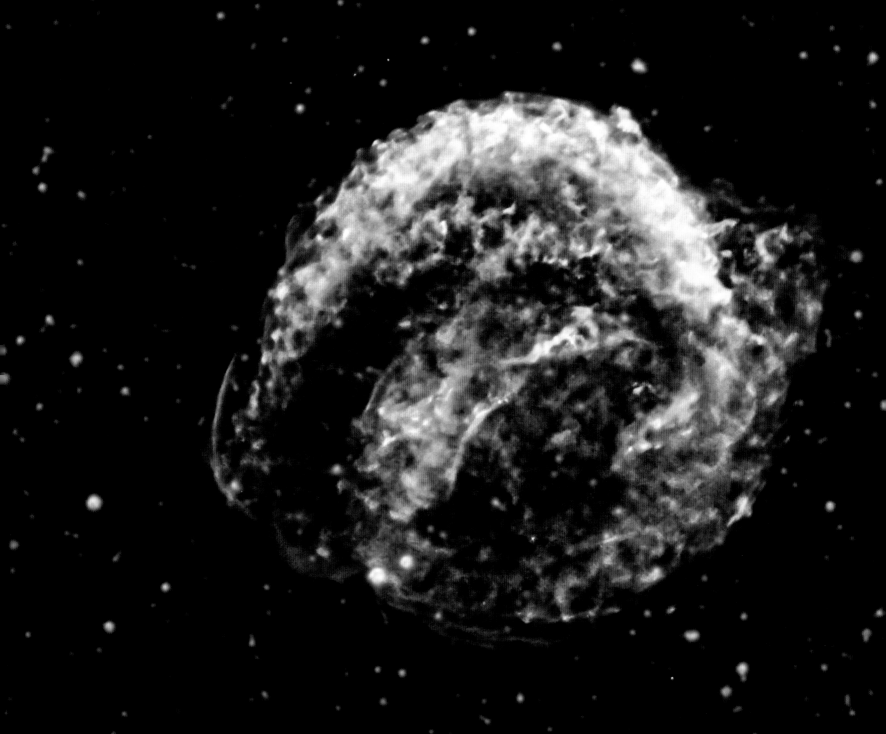

KEPLER'S SUPERNOVA REMNANT

This is the remnant of Kepler's supernova, the famous explosion that was discovered by Johannes Kepler in 1604. There are different types of supernovas. The one responsible for Kepler's involved the thermonuclear explosion of a white dwarf star. These supernovas are important cosmic distance markers for tracking the accelerated expansion of the Universe. This image shows Chandra data set against the optical field of stars.

Scale and distance: Image is about 30 light-years across; object is perhaps 20,000 light-years from Earth.

Wavelength/color: X-ray: red, orange, green, blue, magenta; Optical: white.

W 4 9 B

The W49B supernova remnant may contain the most recent black hole formed in the Milky Way galaxy. Most supernova explosions that destroy massive stars are generally symmetrical. In the W49B supernova, however, it appears that the material near its poles (left and right sides) was ejected at much higher speeds than that at its equator. This image combines Chandra data with infrared and radio data.

Scale and distance: Image is about 60 light-years across; object is about 26,000 light-years from Earth.

Wavelength/color: X-ray: green, blue; Radio: magenta; Infrared: yellow.

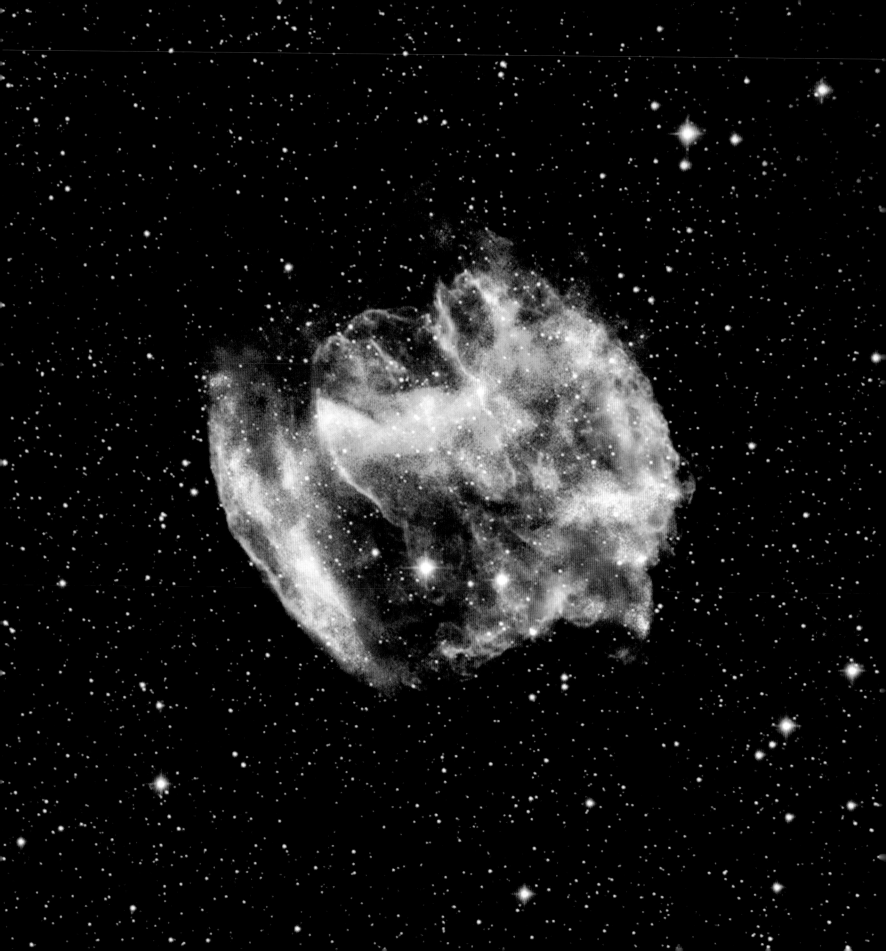

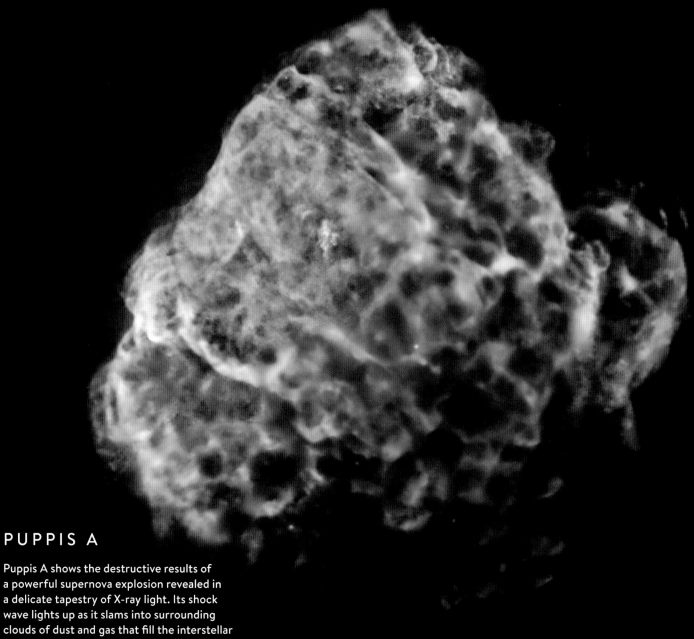

PUPPIS A

Puppis A shows the destructive results of a powerful supernova explosion revealed in a delicate tapestry of X-ray light. Its shock wave lights up as it slams into surrounding clouds of dust and gas that fill the interstellar space in this region. The image shows the remains of a supernova that would have been witnessed on Earth about 3,700 years ago.

Scale and distance: Image is about 180 light-years across; object is about 7,000 light-years from Earth.

Wavelength/color: X-ray: red, green, blue.

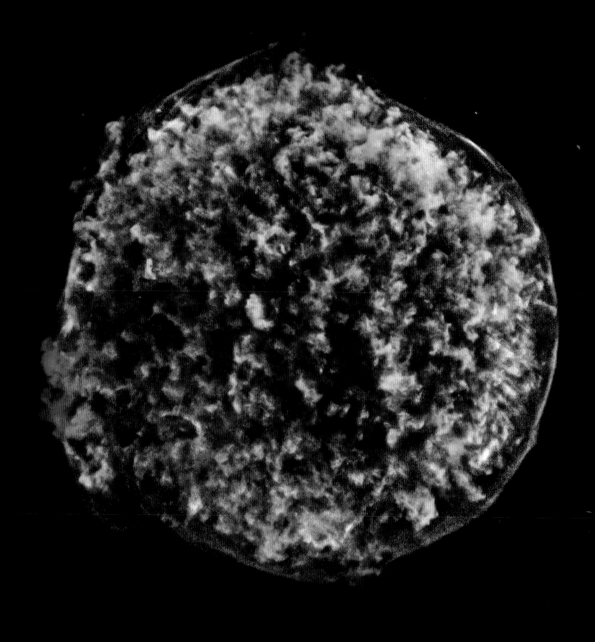

TYCHO'S SUPERNOVA REMNANT

When the star that created this supernova remnant exploded in 1572, it was so bright that it remains visible today. And though he wasn't the first or only person to observe this stellar spectacle, the Danish astronomer Tycho Brahe wrote a book about his extensive observations of the event, gaining the honor of its being named after him. Today, astronomers using Chandra can study the intricate remains of this shattered star in X-ray light.

Scale and distance: Image is about 36 light-years across; object is about 13,000 light-years from Earth.

Wavelength/color: X-ray: red, green, blue.

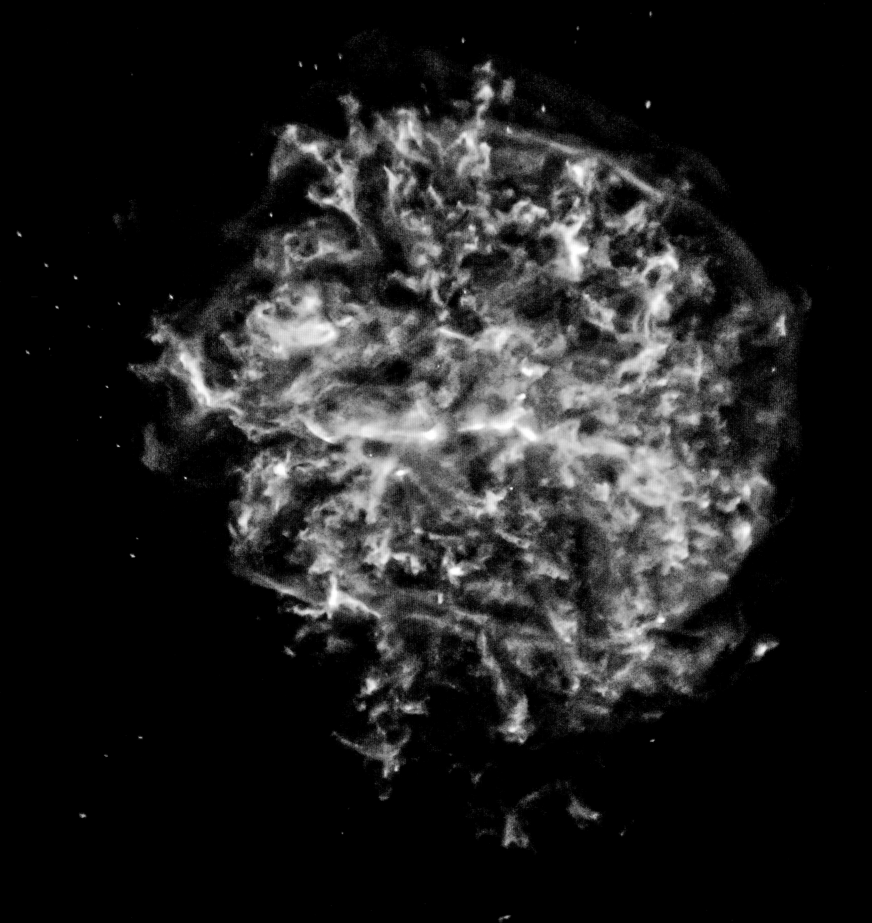

G292.0+1.8

G292.0+1.8 is one of three supernova remnants in the Milky Way known to contain large amounts of oxygen. Oxygen-rich supernovas are of great interest because they are a primary source of the heavy elements necessary to form planets and, in the end, most life forms. Chandra's image shows a spectacular expanding debris field containing oxygen, magnesium, silicon, and sulfur, all forged in the star before it exploded.

Scale and distance: Image is about 66 light-years across; object is about 20,000 light-years from Earth.

Wavelength/color: X-ray: red, orange, green, blue.

CRAB NEBULA

The Crab Nebula is the remains of a star whose explosion was visible in 1054 CE. The combination of rapid rotation and a strong magnetic field in the Crab Nebula generates an intense electromagnetic field that creates jets moving away from the north and south poles of the pulsar, and an intense wind flowing out in the equatorial direction. This image shows the Chandra X-rays alongside optical and infrared light.

Scale and distance: Image is about 10 light-years across; object is about 6,500 light-years from Earth.

Wavelength/color: X-ray: blue; Optical: purple; Infrared: pink.

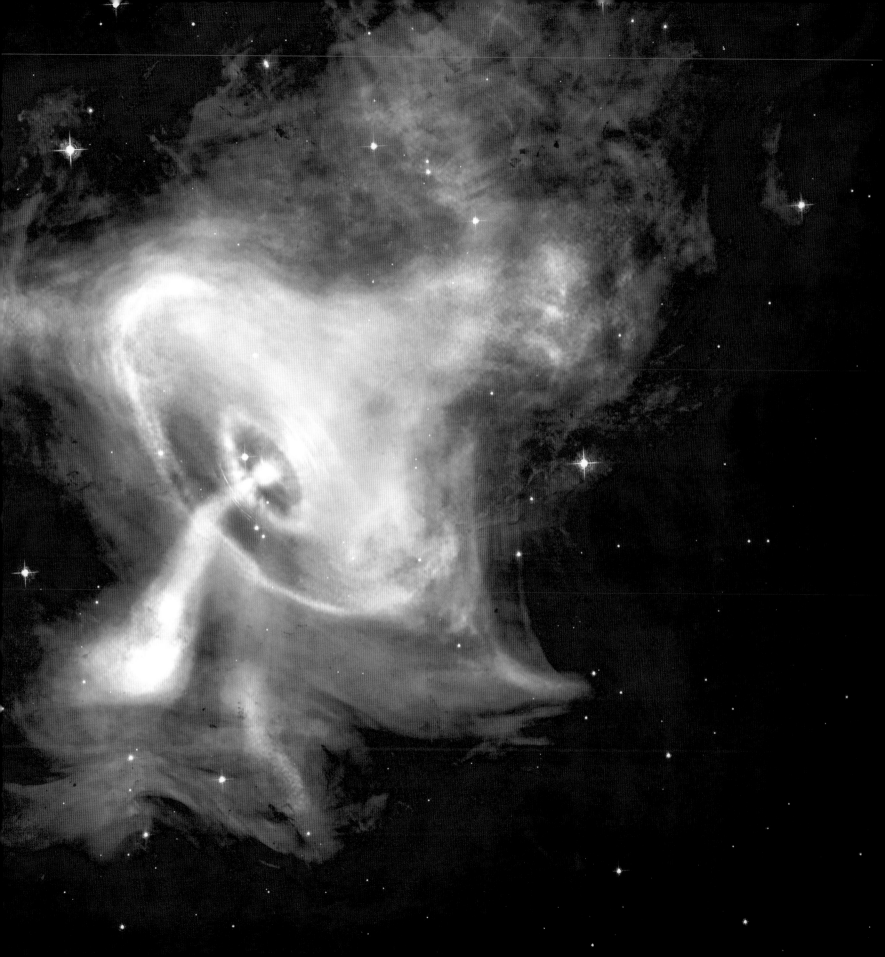

3C58

3C58 is the remnant of a supernova observed in 1181 CE by Chinese and Japanese astronomers. This image shows the center of 3C58 and its rapidly spinning neutron star (called a pulsar) surrounded by a thick ring of X-ray emission. The pulsar has produced jets of X-rays blasting away from it, extending trillions of miles.

Scale and distance: Image is about 35 light-years across; object is about 10,000 light-years from Earth.

Wavelength/color: X-ray: red, green, blue.

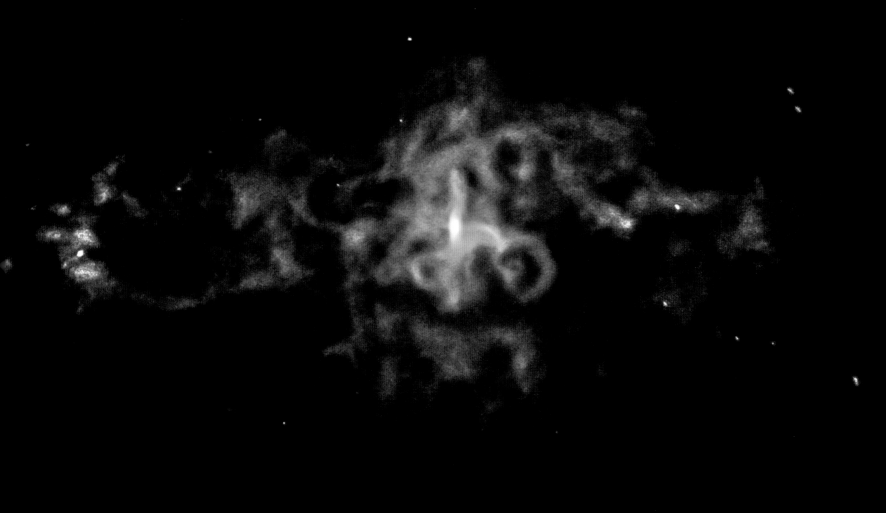

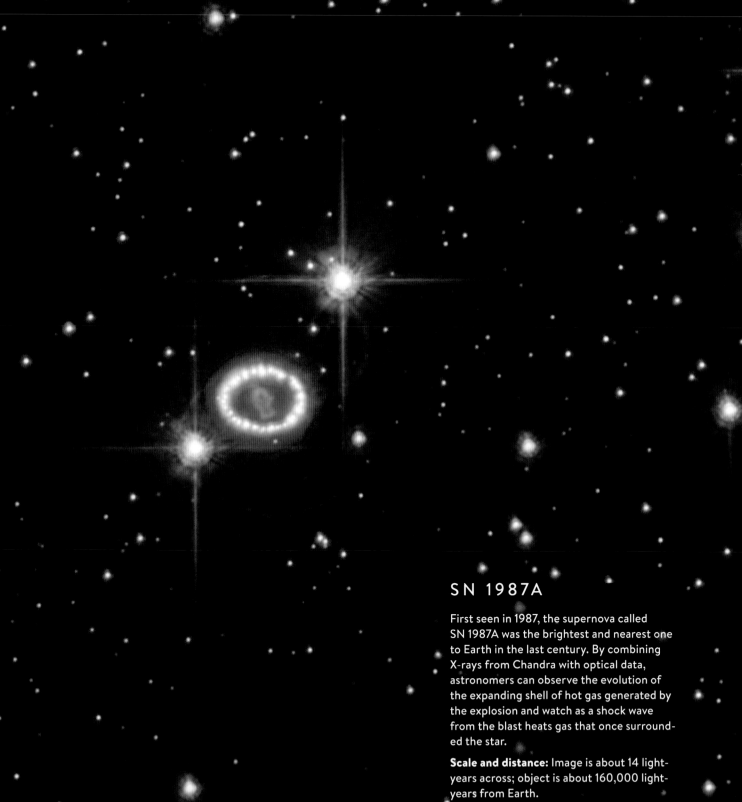

SN 1987A

First seen in 1987, the supernova called
SN 1987A was the brightest and nearest one
to Earth in the last century. By combining
X-rays from Chandra with optical data,
astronomers can observe the evolution of
the expanding shell of hot gas generated by
the explosion and watch as a shock wave
from the blast heats gas that once surround-
ed the star.

Scale and distance: Image is about 14 light-
years across; object is about 160,000 light-
years from Earth.

Wavelength/color: X-ray: blue; Optical: red,
green, blue.

CIRCINUS X-1

Circinus X-1 contains a neutron star—the collapsed core left behind after a star has exploded—in orbit with a massive star. Four partial rings appear as circles around Circinus X-1 in X-ray light (the unusual shape swing to the field of view of Chandra's detectors). These rings are light echoes, similar to the sound echoes that we may experience on Earth. The echoes around Circinus X-1 are produced when a burst of X-rays from the star system reflects off of clouds of dust between Circinus X-1 and Earth.

Scale and distance: Image is about 300 light-years across; object is about 30,700 light-years from Earth.

Wavelength/color: X-ray: red, green, blue; Optical: white/gold.

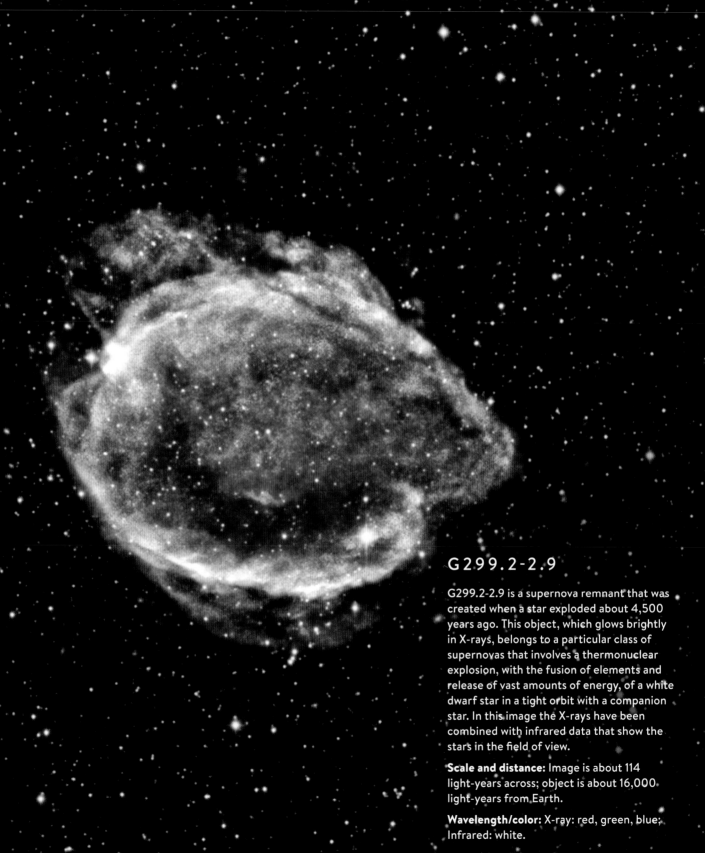

G299.2-2.9

G299.2-2.9 is a supernova remnant that was created when a star exploded about 4,500 years ago. This object, which glows brightly in X-rays, belongs to a particular class of supernovas that involves a thermonuclear explosion, with the fusion of elements and release of vast amounts of energy, of a white dwarf star in a tight orbit with a companion star. In this image the X-rays have been combined with infrared data that show the stars in the field of view.

Scale and distance: Image is about 114 light-years across; object is about 16,000 light-years from Earth.

Wavelength/color: X-ray: red, green, blue; Infrared: white.

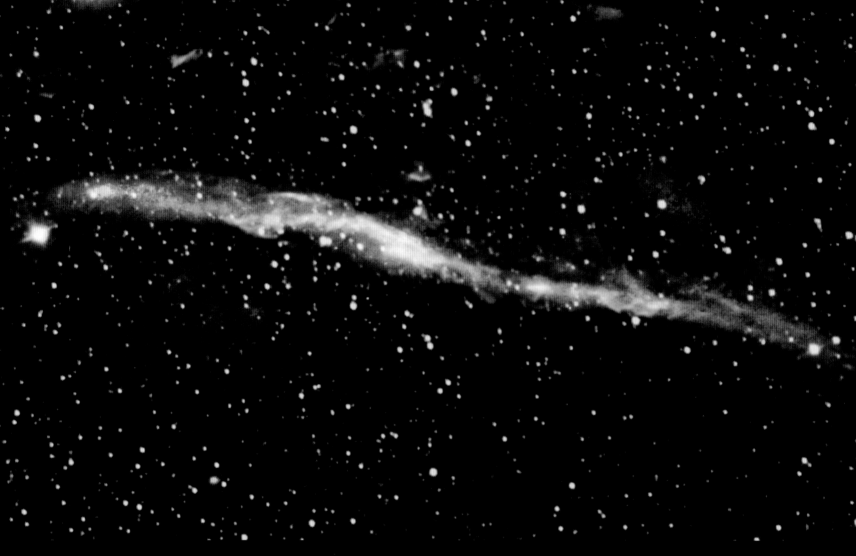

RCW 86

During the Apollo flights, astronauts reported seeing odd flashes of light, visible even with their eyes closed. Scientists determined that the cause was cosmic rays, that is, extremely energetic particles from outside the Solar System. By studying supernova remnant RCW 86, (also shown on page 70), astronomers determined that some cosmic rays are generated in the remnants of exploded stars. This image shows only the northern ridge of RCW 86. In fact, it's much larger and appears circular when imaged in full.

Scale and distance: Image is about 46.5 light-years across; object is about 8,200 light-years from Earth.

Wavelength/color: X-ray: blue, pink; Optical: yellow.

R AQUARII

R Aquarii is a white dwarf orbiting a pulsating red giant star. Occasionally, the white dwarf pulls enough material from the red giant onto its surface to generate a thermonuclear explosion. Since shortly after Chandra launched, astronomers have been using the telescope to monitor the behavior of R Aquarii, giving them a better understanding of the behavior of this volatile stellar pair.

Scale and distance: Image is about 0.86 light-years across; object is about 710 light-years from Earth.

Wavelength/color: X-ray: cyan; Optical: red.

CRAB NEBULA

This image shows the Crab Nebula again, but only the X-ray light detected by Chandra. At the center of the Crab Nebula is an extremely dense, rapidly rotating neutron star left behind by the explosion. This neutron star has the mass equivalent to the sun crammed into a rapidly spinning ball of neutrons twelve miles across.

Scale and distance: Image is about 8.7 light-years across; object is about 6,500 light-years from Earth.

Wavelength/color: X-ray: red, green, blue.

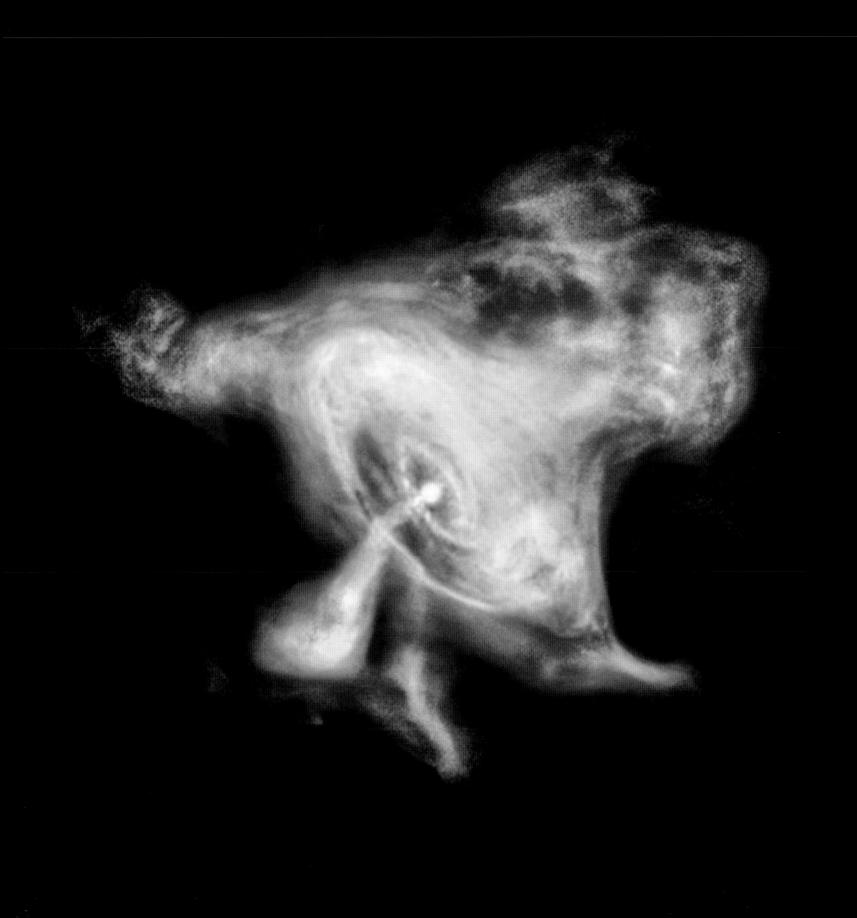

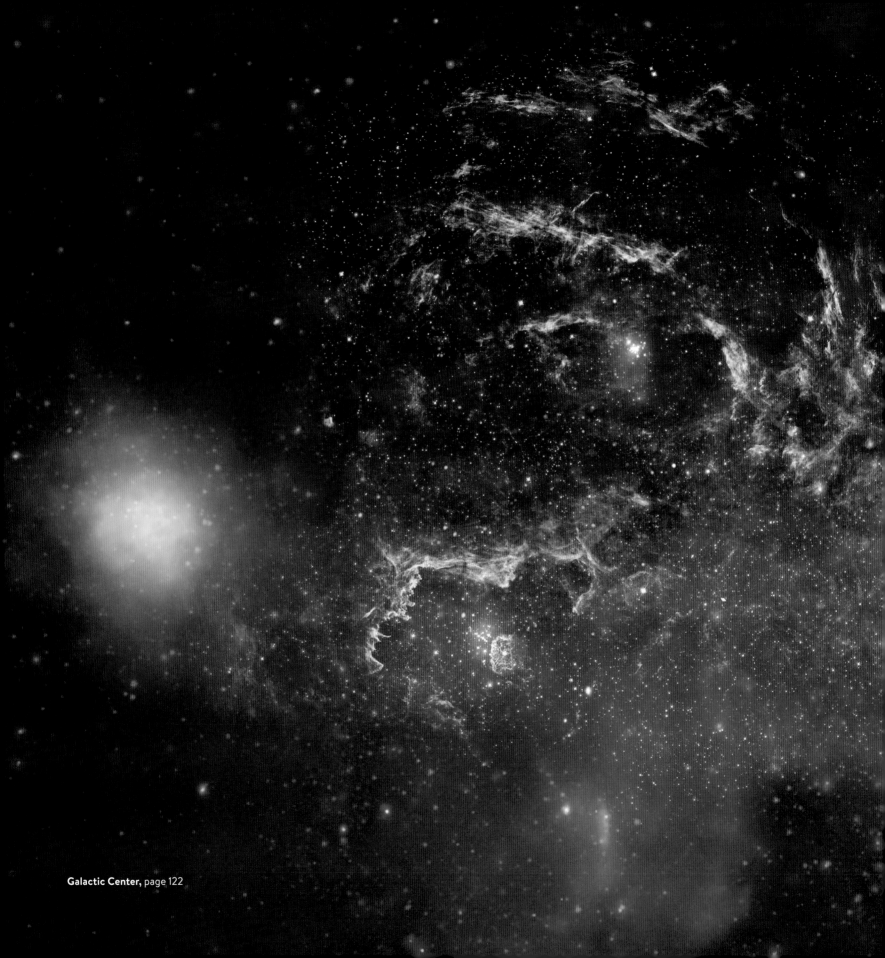

Galactic Center, page 122

3

KINGDOMS
OF THE VOID

Galaxy Center, page 137

GALAXIES ARE SYSTEMS of stars, gas, dust, and dark matter held together by gravity. There are billions of galaxies throughout the Universe, and they come in different shapes and sizes. There are irregular small dwarf galaxies, majestic spiral galaxies, and elliptical galaxies ranging in size from dwarfs to supergiants ten times larger than our Milky Way galaxy.

Within these galaxies are black holes, neutron stars, and bubbles of hot gas that reveal themselves in X-ray light. Astronomers use the Chandra X-ray Observatory to study how galaxies behave and what happens inside of them.

The X-ray images captured by Chandra are essential to our understanding of these island kingdoms in space. For example, Chandra's view of elliptical galaxies reveals that they are filled with multimillion-degree gas, heated presumably by supernova explosions. Most of the gas in spiral galaxies is in the form of cool, dusty clouds. In both elliptical and spiral galaxies, X-ray images give us portraits of the end phases of stellar evolution—regions where supernovas have heated gas to millions of degrees, and objects where gravity has tightened its grip to form neutron stars and black holes.

The most extreme examples of gravity's force are found deep in the centers of most galaxies, where supermassive black holes lurk. These gravitational monsters can contain masses ranging from a few million to a few billion Suns. In many galaxies, the supermassive black hole mainly makes its presence known through its gravitational force on the motions of stars, and by X-rays produced when gas is heated as it falls toward the black hole. But when large supplies of dust and gas surround supermassive black holes, the acceleration and heating of this gas as it is pulled into the black hole can produce stupendous amounts of energy at X-ray and other wavelengths and transform the appearance of the entire galaxy. Such galaxies are called active galaxies or quasars.

One of the most important galaxies that Chandra has studied is our own, the Milky Way. Chandra has provided an unparalleled view of the center of our Galaxy, some 26,000 light-years away, where a supermassive black hole called Sagittarius A* resides (see page 113). Chandra provides us with views of galactic doppelgangers to the Milky Way, as well as visions of galaxies completely different from our own.

ESO 137-001

Spiral galaxy ESO 137-001 is zooming toward
the upper left of this Chandra and Hubble
composite image, in between other galaxies
in the Norma cluster. Intergalactic gas in
this area is sparse, but at 180 million degrees
Fahrenheit it glows in X-rays detected by
Chandra. The galaxy is moving at nearly
4.5 million miles per hour, so rapidly that
much of its own gas is torn away.

Scale and distance: Image is about 100,000
light-years across; object is about 220 million
light-years from Earth.

Wavelength/color: X-ray: blue; Optical: cyan,
orange, white.

SAGITTARIUS A*

Sagittarius A* is the supermassive black hole at the center of the Milky Way. Chandra has monitored Sagittarius A* periodically over the course of its mission and has caught it flaring numerous times. How quickly the flares rise and fall indicates that they are occurring near the event horizon, or point of no return, around the black hole. Chandra has also discovered more than 2,000 other X-ray sources, which this image shows, and huge lobes of 20-million-degree gas. The lobes indicate that enormous explosions occurred near the black hole several times over the last 10,000 years.

Scale and distance: Image is about 91 light-years across; object is about 26,000 light-years from Earth.

Wavelength/color: X-ray: red, green, blue.

M82

M82 is a beautiful example of a starburst galaxy. Optical light shows the disk of a modest-sized galaxy along with matter blasting out of it. Infrared light shows the cool gas and dust that are also being ejected. Chandra's X-ray image reveals superheated gas from the violent outflow from star formation in the central regions of the galaxy. Astronomers think this burst of star formation was triggered by a close encounter with a large nearby galaxy about 100 million years ago.

Scale and distance: Image is about 44,500 light-years across; object is about 12 million light-years from Earth.

Wavelength/color: X-ray: blue; Optical: green, orange; Infrared: red.

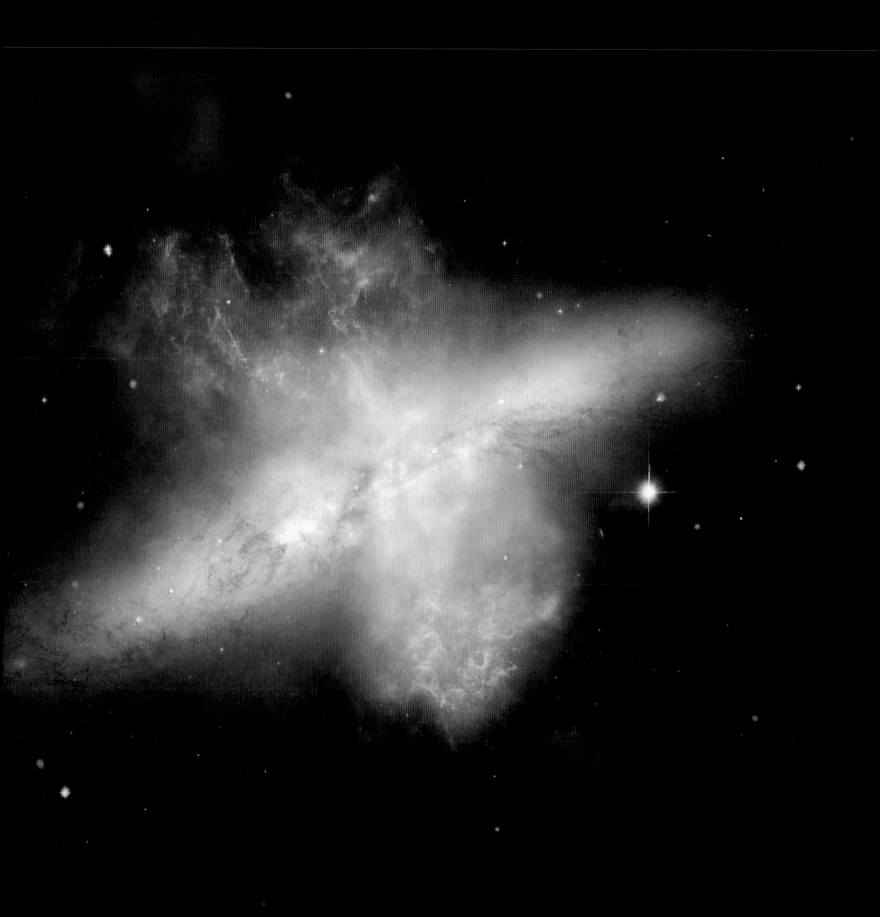

NGC 4631

NGC 4631 reveals a giant halo of hot gas surrounding the spiral galaxy. The structure across the middle of the image and the extended faint filaments represent data from Hubble that depict giant bursting bubbles created by merging clusters of massive stars. Chandra data provide the first unambiguous evidence for a halo of hot gas surrounding a galaxy that is very similar to our Milky Way. Such observations can provide an important tool for understanding our own galactic environment.

Scale and distance: Image is about 18,000 light-years across; object is about 25 million light-years from Earth.

Wavelength/color: X-ray: blue, purple; Ultraviolet: red, orange.

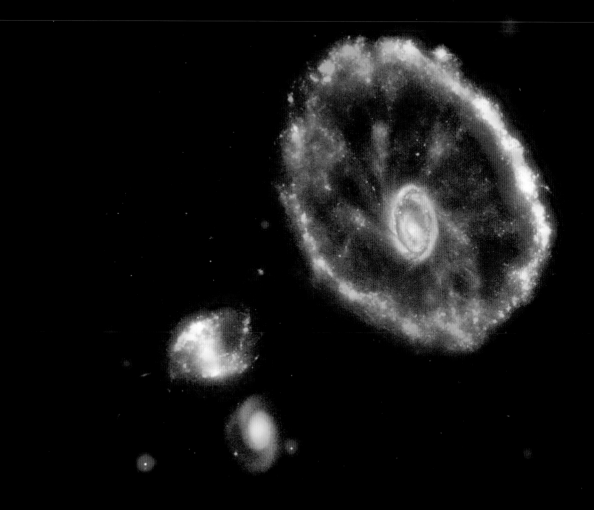

CARTWHEEL GALAXY

The Cartwheel is one of five galaxies in a group. The unusual shape of the Cartwheel Galaxy is likely the result of a previous collision with one of the smaller galaxies (on the lower left) several hundred million years ago. This collision produced compression waves of gas within the galaxy, triggering bursts of star formation. Scientists attribute the brightness of the X-rays in the Cartwheel's rim to matter falling into black holes left behind by the chaos. The Chandra information is shown composited with ultra-violet, infrared, and optical data.

Scale and distance: Image is about 310,000 light-years across; object is about 400 million light-years from Earth.

Wavelength/color: X-ray: purple; Ultraviolet: blue; Optical: green; Infrared: red.

X-RAY

3C321

3C321 has been nicknamed the Death Star galaxy because it is blasting, at nearly the speed of light, a jet from its black hole that is smashing into another galaxy. Chandra identified the supermassive black hole lurking in the galaxy's center. Such jets produce high amounts of radiation, especially high-energy X-rays and gamma rays, which can be lethal in large quantities. Radio waves from the jet are shown, as well as optical and ultraviolet data of the galaxy.

Scale and distance: Image is about 180,000 light-years across; object is about 1.4 billion light-years from Earth.

Wavelength/color: X-ray: purple; Radio: blue; Ultraviolet: red; Optical: yellow.

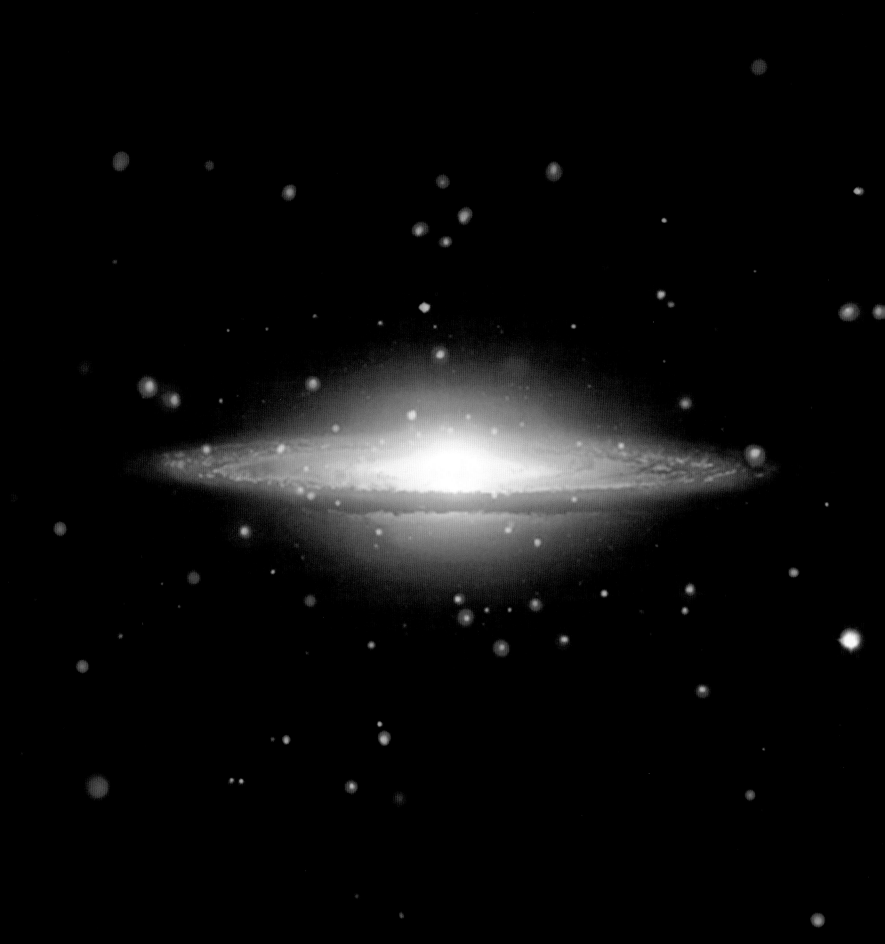

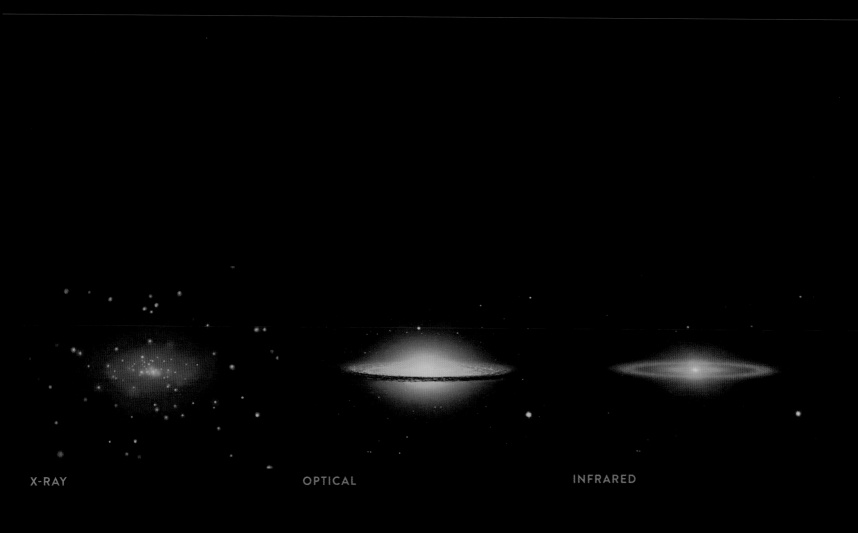

X-RAY

OPTICAL

INFRARED

SOMBRERO GALAXY

This image shows the Sombrero galaxy, also known as Messier 104, with data from the Chandra, Hubble, and Spitzer observatories. The main figure combines images from the three telescopes, while the inset images show the individual observatory contributions. Chandra's X-ray image shows hot gas in the galaxy and point sources that are a mixture of objects within the Sombrero as well as quasars in the background.

Scale and distance: Image is about 70,000 light-years across; object is about 28 million light-years from Earth.

Wavelength/color: X-ray: blue; Optical: green; Infrared: red.

GALACTIC CENTER

The central region of our Milky Way is a bustling galactic downtown with a supermassive black hole at its hub. This view combines Hubble, Spitzer, and Chandra data to reveal what is happening in this beautifully complex region. X-rays from Chandra show gas heated to millions of degrees by stellar explosions and outflows from the Galaxy's supermassive black hole, Sagittarius A*.

Scale and distance: Image is about 240 light-years across; object is about 26,000 light-years from Earth.

Wavelength/color: X-ray: blue, purple; Optical: yellow; Infrared: red.

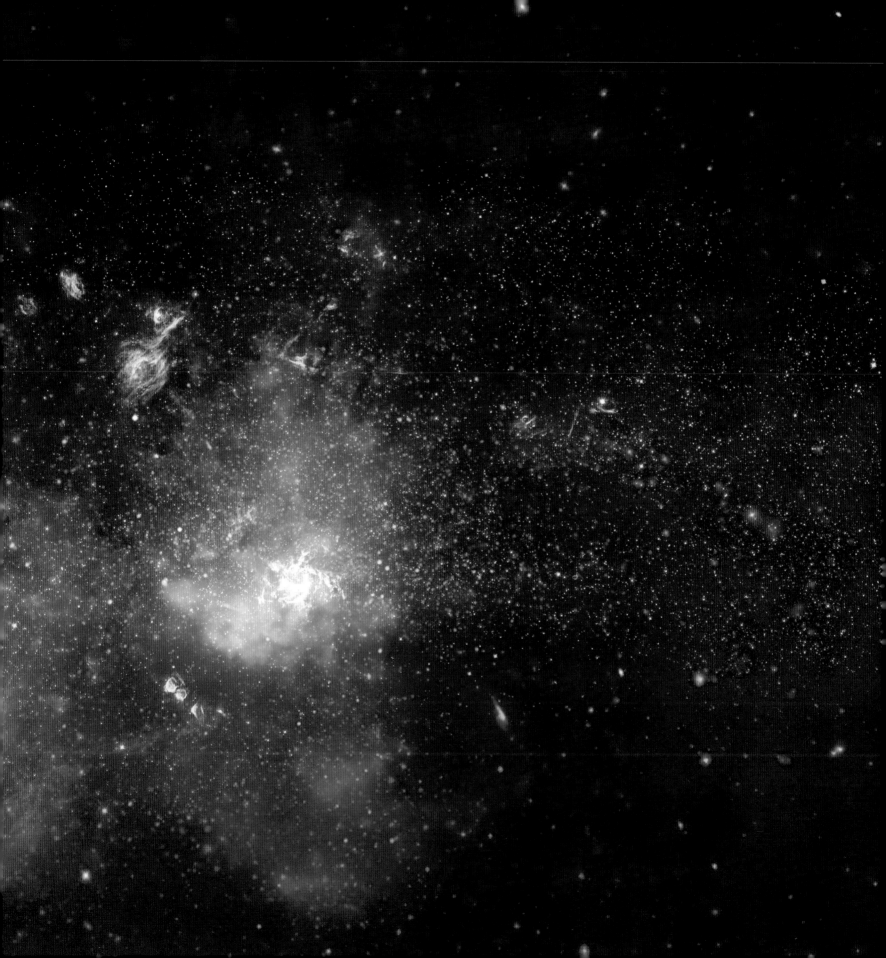

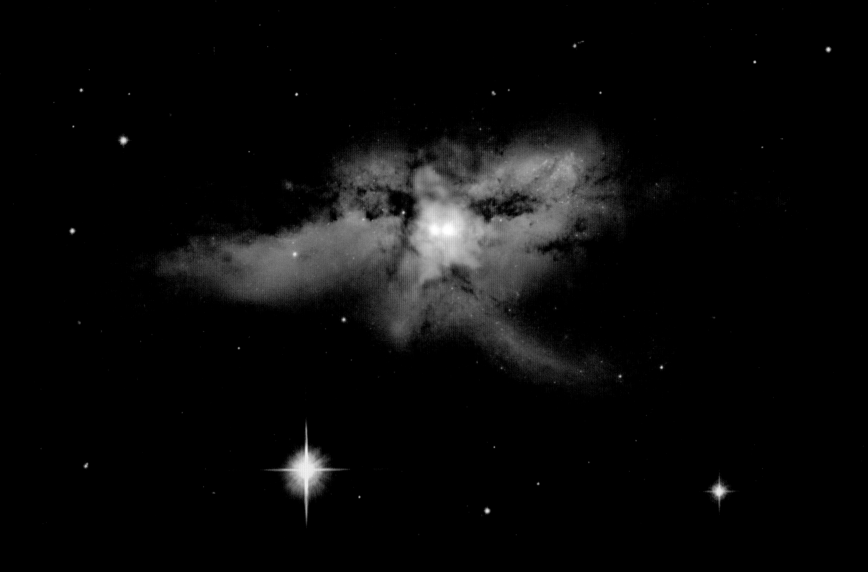

NGC 6240

NGC 6240 is a galaxy merger in which two supermassive black holes are a mere 3,000 light-years apart, as shown in this image of Chandra and Hubble data. These black holes, depicted as two bright objects in the center of the galaxy, have been spiraling toward one another for the past 30 million years. Tens or perhaps even hundreds of millions of years from now, the two black holes will likely drift into each other and merge into a more massive black hole.

Scale and distance: Image is about 300,000 light-years across; object is about 330 million light-years from Earth.

Wavelength/color: X-ray: red, green, blue; Optical: white.

STEPHAN'S QUINTET

Stephan's Quintet is a group of five galaxies that provides a rare snapshot as spiral galaxies merge to form elliptical ones. One galaxy is thought to be passing through the others at almost two million miles per hour. This generates a shock wave (cyan color) that heats the gas and creates the ridge of X-ray emission detected by Chandra. The optical data shown is from Hubble.

Scale and distance: Image is about 510,000 light-years across; object is about 280 million light-years from Earth.

Wavelength/color: X-ray: cyan; Optical: red, yellow, blue, white.

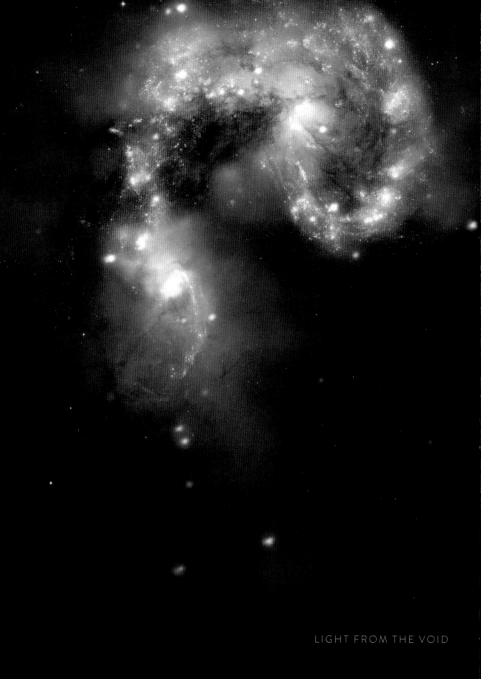

X-ray image of the Antennae reveals huge clouds of hot interstellar gas that have been injected with rich deposits of elements from supernova explosions. This enriched gas, which includes elements such as oxygen, iron, magnesium, and silicon, will be incorporated into new generations of stars and planets. The X-ray data have been combined with Hubble and Spitzer data to complete this galactic portrait.

Scale and distance: Image is about 61,000 light-years across; object is about 60 million light-years from Earth.

Wavelength/color: Optical: yellow; X-ray: blue; Infrared: red.

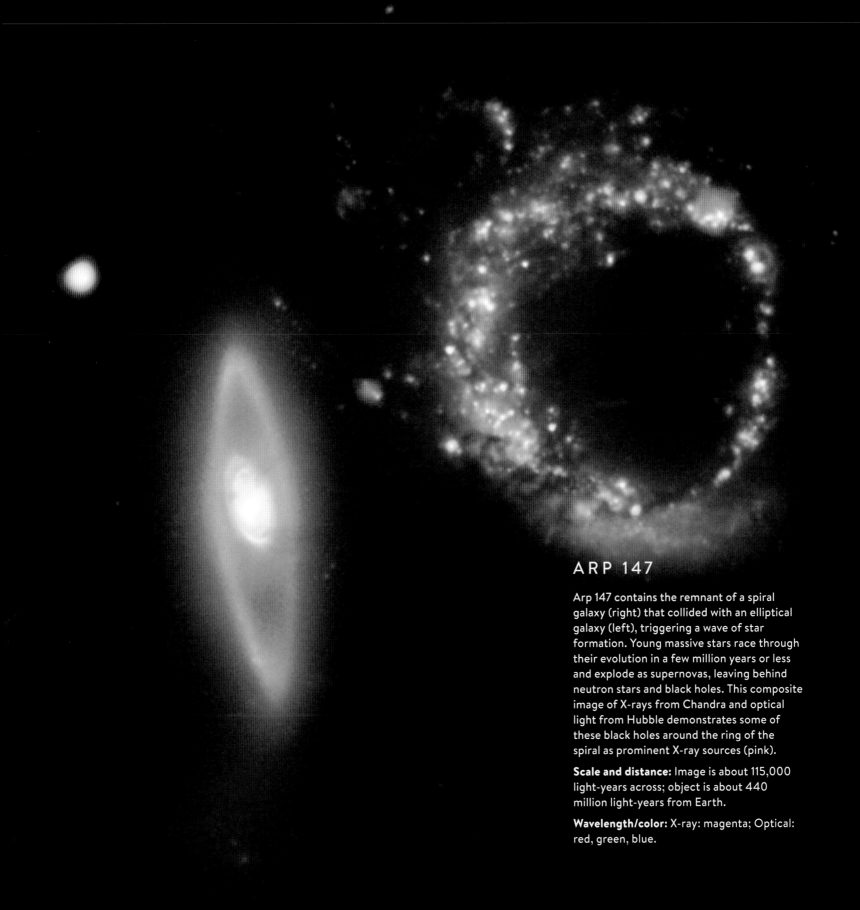

ARP 147

Arp 147 contains the remnant of a spiral galaxy (right) that collided with an elliptical galaxy (left), triggering a wave of star formation. Young massive stars race through their evolution in a few million years or less and explode as supernovas, leaving behind neutron stars and black holes. This composite image of X-rays from Chandra and optical light from Hubble demonstrates some of these black holes around the ring of the spiral as prominent X-ray sources (pink).

Scale and distance: Image is about 115,000 light-years across; object is about 440 million light-years from Earth.

Wavelength/color: X-ray: magenta; Optical: red, green, blue.

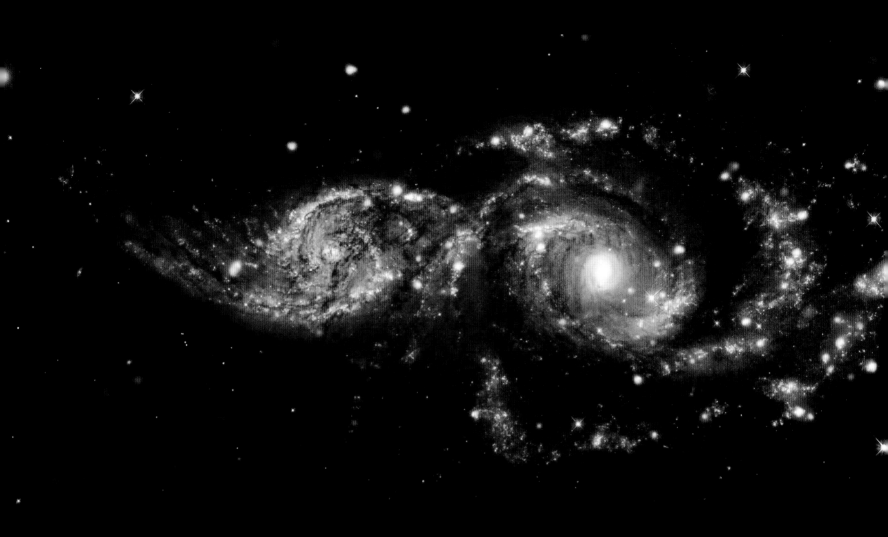

NGC 2207 AND IC 2163

NGC 2207 and IC 2163, currently in the process of colliding with each other, have produced one of the most bountiful collections of super bright X-ray lights (pink) called ultraluminous X-ray sources (ULXs). The true nature of ULXs is still debated, but they are probably an unusual type of X-ray binary consisting of a star in a tight orbit around either a neutron star or a black hole.

Scale and distance: Image is about 180,000 light-years across; object is about 130 million light-years from Earth.

Wavelength/color: X-ray: pink; Optical: red, green, blue; Infrared: red.

M106

M106 is a spiral galaxy like our Milky Way. It is different from our Galaxy, however, in certain ways. First, it has two extra spiral arms that glow in X-ray, optical, and radio light that are not aligned with the plane of the galaxy, but rather intersect it. Additionally, the supermassive black hole at the center of M106 is about ten times larger than the one in the Milky Way. It is also consuming material at a faster rate, potentially increasing its impact on the evolution of its host galaxy.

Scale and distance: Image is about 44,000 light-years across; object is about 23 million light-years from Earth.

Wavelength/color: X-ray: blue; Radio: purple; Optical: gold, blue; Infrared: red.

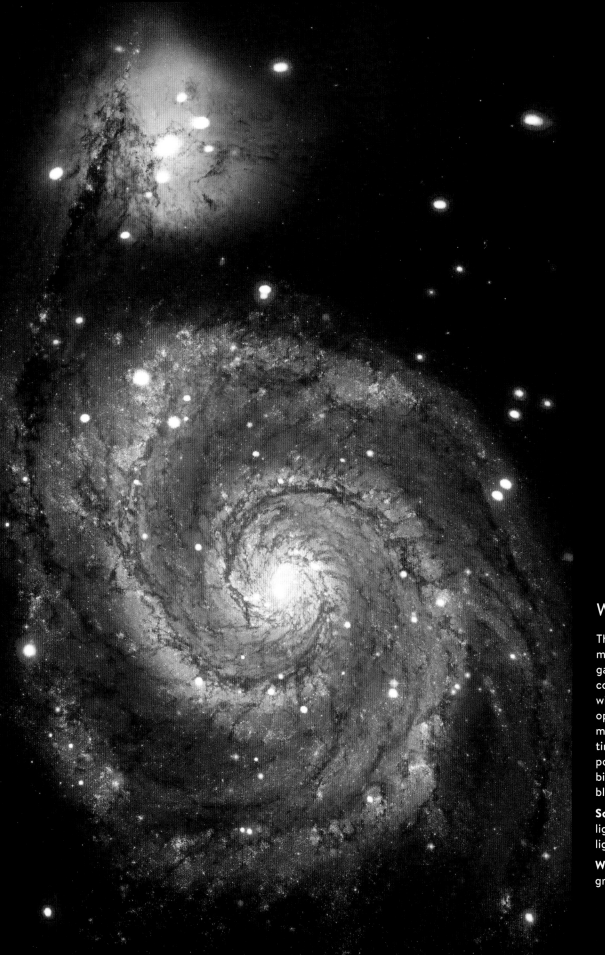

WHIRLPOOL GALAXY

The Whirlpool Galaxy, a spiral galaxy, is in the midst of merging with a smaller companion galaxy (upper left). Scientists think this ongoing collision is triggering waves of star formation within the Whirlpool. This image contains optical data from Hubble as well as nearly a million seconds' worth of Chandra observing time. The Chandra data reveal hundreds of point-like sources, most of which are X-ray binary systems containing a neutron star or black hole in orbit with a star like the Sun.

Scale and distance: Image is about 52,000 light-years across; object is about 30 million light-years from Earth.

Wavelength/color: X-ray: purple; Optical: red, green, blue.

CENTAURUS A

Centaurus A is the nearest galaxy to Earth that contains a supermassive black hole actively powering a jet. This Chandra image shows opposing jets of high-energy particles extending to the outer reaches of the galaxy and numerous smaller black holes in orbit with stars that are also visible. Astronomers think that such jets are important vehicles for transporting energy from the black hole to the much larger dimensions of a galaxy, and that they affect the rate at which stars form there.

Scale and distance: Image is about 58,000 light-years across; object is about 11 million light-years from Earth.

Wavelength/color: X-ray: red, green, blue.

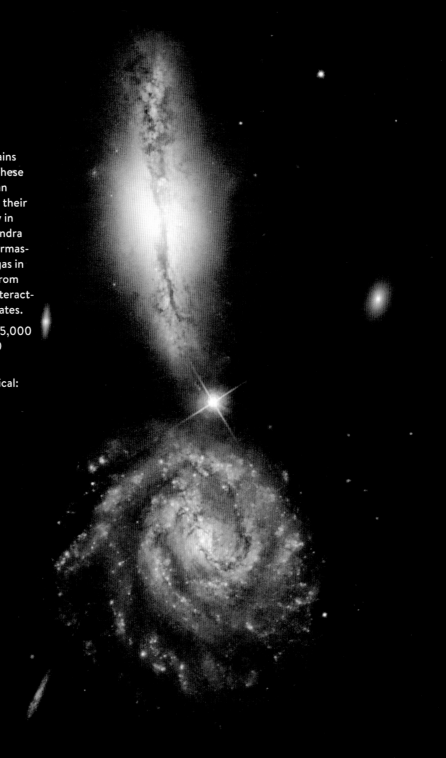

VV 340

VV 340, also known as Arp 302, contains
a pair of galaxies destined to merge. These
two galaxies are in the early stage of an
interaction that will eventually lead to their
becoming one single combined galaxy in
millions of years. X-ray data from Chandra
reveal the presence of a growing supermas-
sive black hole obscured by dust and gas in
the northern, or upper, galaxy. Data from
other telescopes show that the two interact-
ing galaxies are evolving at different rates.

Scale and distance: Image is about 285,000
light-years across; object is about 450
million light-years from Earth.

Wavelength/color: X-ray: purple; Optical:
red, green, blue.

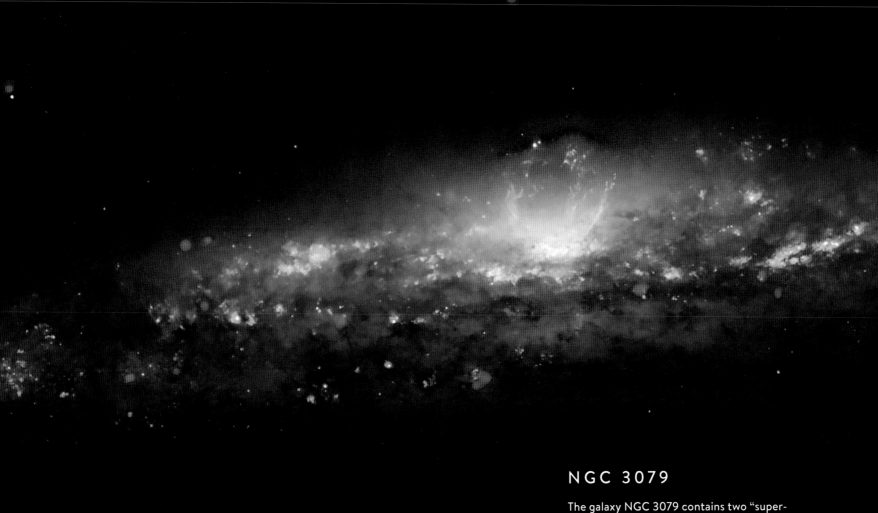

NGC 3079

The galaxy NGC 3079 contains two "super-bubbles" that stretch out on opposite sides of the center of the galaxy. Astronomers think these superbubbles were created by outbursts from a supermassive black hole or the winds from young stars. Chandra data reveals that the NGC 3079 galaxy contains an accelerator that can create particles over a hundred times more energetic than the Large Hadron Collider.

Scale and distance: Image is about 62,000 light-years across; object is about 67 million light-years away.

Wavelength/color: X-ray: purple; Optical: orange and blue

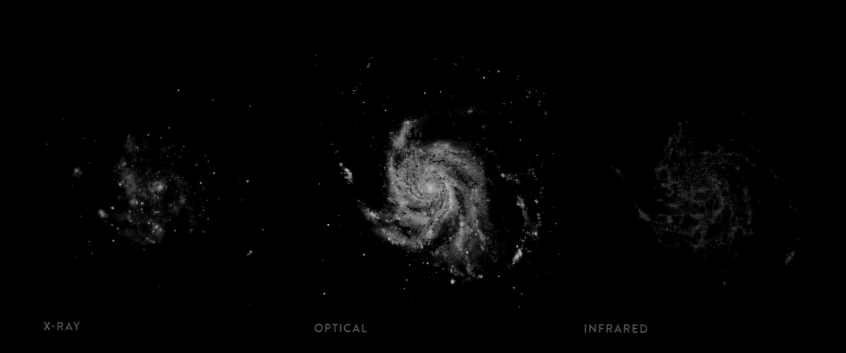

X-RAY OPTICAL INFRARED

M101

M101 also known as the Pinwheel, is a face-on spiral galaxy. Sources of X-rays detected by Chandra include million-degree gas, the debris from exploded stars, and material zooming around black holes and neutron stars. Infrared light highlights the heat emitted by dust lanes in the galaxy where stars can form. Visible light data come mostly from stars that trace the same spiral structure as the dust lanes.

Scale and distance: Image is about 114,000 light-years across; object is about 21 million light-years from Earth.

Wavelength/color: X-ray: purple; Ultraviolet: blue; Optical: yellow; Infrared: red.

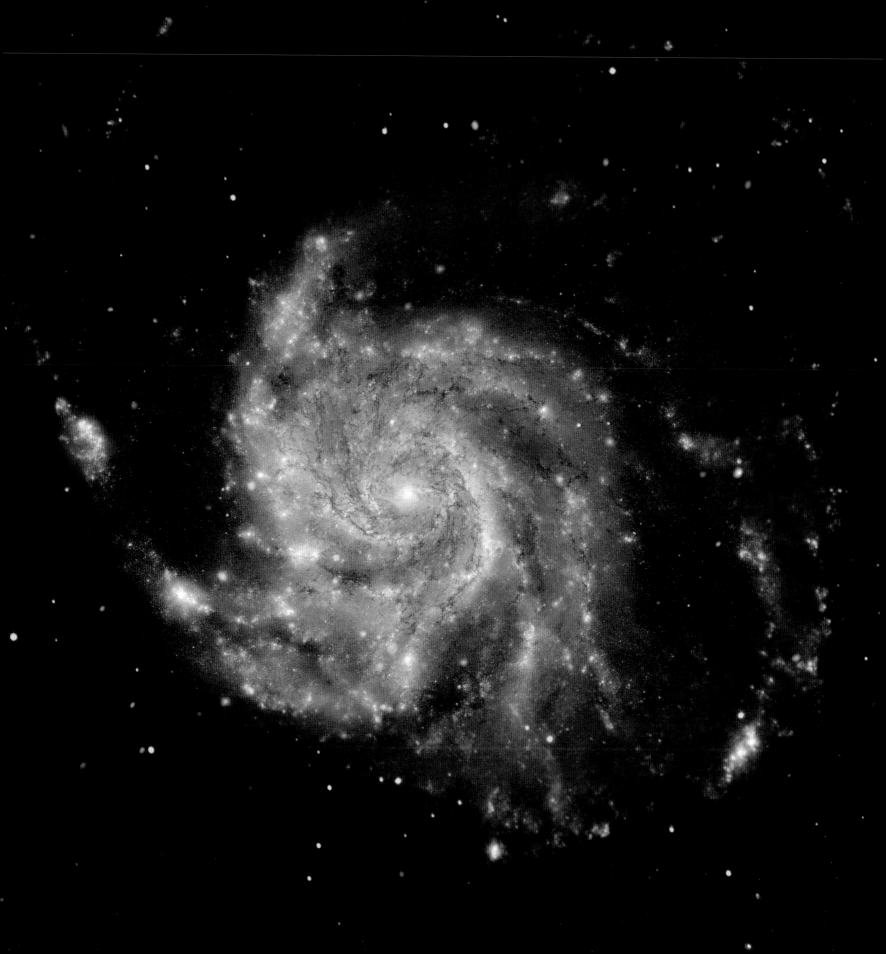

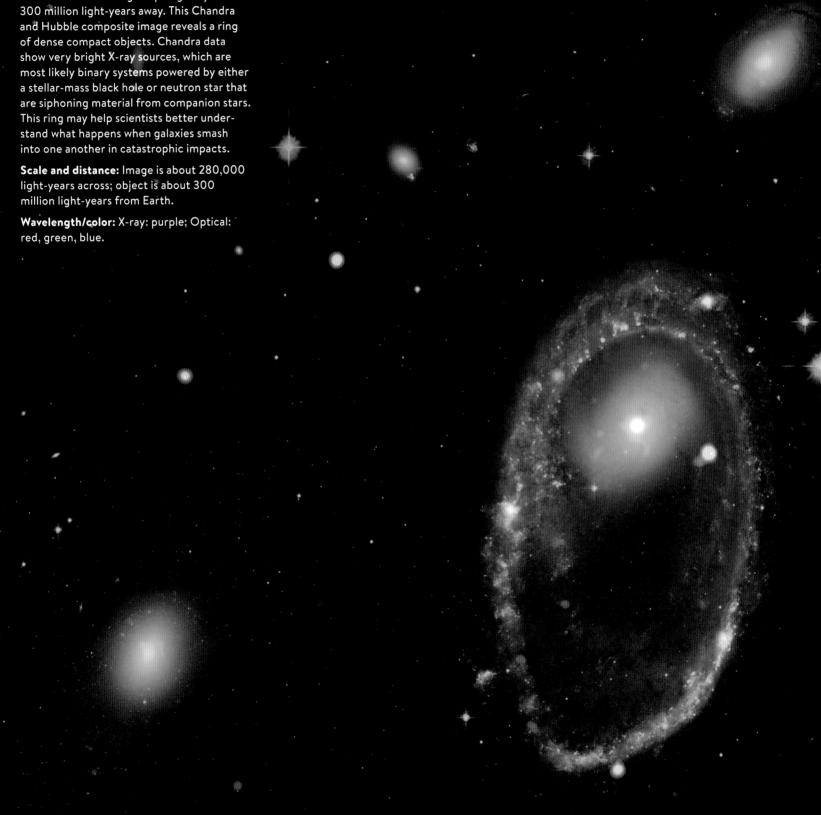

AM 0644-741

AM 0644-741 is a ring-shaped galaxy about 300 million light-years away. This Chandra and Hubble composite image reveals a ring of dense compact objects. Chandra data show very bright X-ray sources, which are most likely binary systems powered by either a stellar-mass black hole or neutron star that are siphoning material from companion stars. This ring may help scientists better understand what happens when galaxies smash into one another in catastrophic impacts.

Scale and distance: Image is about 280,000 light-years across; object is about 300 million light-years from Earth.

Wavelength/color: X-ray: purple; Optical: red, green, blue.

GALAXY CENTER

This Chandra image captures the environment around our Galaxy's supermassive black hole that inhabits its center. The diffuse X-ray light is from gas that has been heated by stellar explosions, outflows powered by the central supermassive black hole and winds from massive stars. The thousands of point sources are produced by normal stars feeding material onto compact, stellar remnants: black holes, neutron stars, and white dwarfs.

Scale and distance: Image is about 4 light-years across; object is 26,000 light-years away.

Wavelength/color: X-ray; red, green, blue.

El Gordo, page 154

4
SHAPE OF THE
EXPANSE

Toothbrush Cluster, page 165

GALAXY CLUSTERS

GALAXY CLUSTERS ARE THE LARGEST OBJECTS in the Universe held together by gravity. More than just cosmic behemoths, galaxy clusters are used to investigate some of the biggest mysteries of science today.

What makes up galaxy clusters? They contain three main ingredients. First are hundreds or thousands of galaxies containing stars, planets, dust, and gas. Second are vast clouds of hot gas that permeate the space between the galaxies. Third is dark matter, an unidentified form of matter that thus far can be detected only by its gravitational effects.

The hot gas that fills the space between galaxies contains more mass than all the galaxies in the cluster. Even the most powerful optical telescopes cannot see this superheated gas—only an X-ray telescope like Chandra can. Moreover, Chandra's exceptional X-ray vision allows astronomers to study details in these reservoirs of hot gas that reveal secrets about such phenomena as powerful outbursts driven by giant black holes.

Scientists think that galaxy clusters form as clumps of dark matter, and that their associated galaxies are pulled together by gravity to form groups of dozens of galaxies, which in turn merge to form clusters of galaxies. The gas in galaxy clusters is heated as the cluster forms. This heating can be a violent process as gas clouds enveloping groups of galaxies collide and merge to become a cluster over billions of years.

Astronomers using Chandra have uncovered dramatic evidence of these mega-mergers. Galaxy clusters themselves collide, some of the most powerful events in the Universe since the Big Bang itself. Chandra has captured images of these colossal collisions and helped unlock their secrets.

Chandra observations of the clouds of hot gas in clusters of galaxies also provide clues to the origin, evolution, and destiny of our Universe. Astronomers have used Chandra to show that the acceleration in the expansion of the Universe has stifled the growth of galaxy clusters over billions of years, providing further evidence for a mysterious force called dark energy. These studies have also given a unique test of Einstein's theory of general relativity.

Here we tour some of the most dramatic images of galaxy clusters ever taken. One of the most famous is the Bullet Cluster system, where astronomers have captured dark matter being ripped apart of hot gas during a violent collision of two clusters. Images of the Perseus galaxy cluster reveal the deepest note in the Universe, about fifty-seven octaves below middle C, that is being sounded by a supermassive black hole at its center. These are just a hint of the wonders these cosmic giants would keep hidden from us without the X-ray eyes of Chandra.

3C 295

3C 295 is at the heart of a giant cluster of galaxies. Chandra data shows a central galaxy embedded in a vast cloud of hot gas. This cloud, containing more than a hundred galaxies, has a temperature of 50 million degrees. The X-rays from the central galaxy are concentrated in three bright knots, probably produced by matter falling into a supermassive black hole.

Scale and distance: Image is about 960,000 light-years across; object is about 4.7 billion light-years from Earth.

Wavelength/color: X-ray: red, blue.

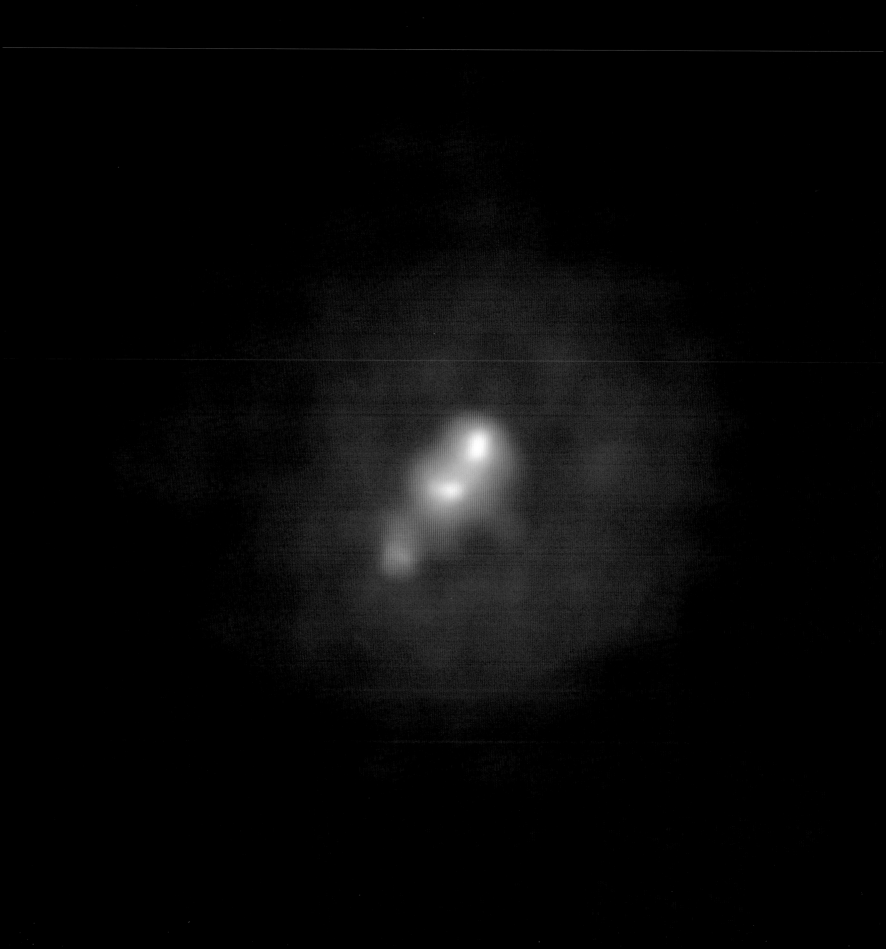

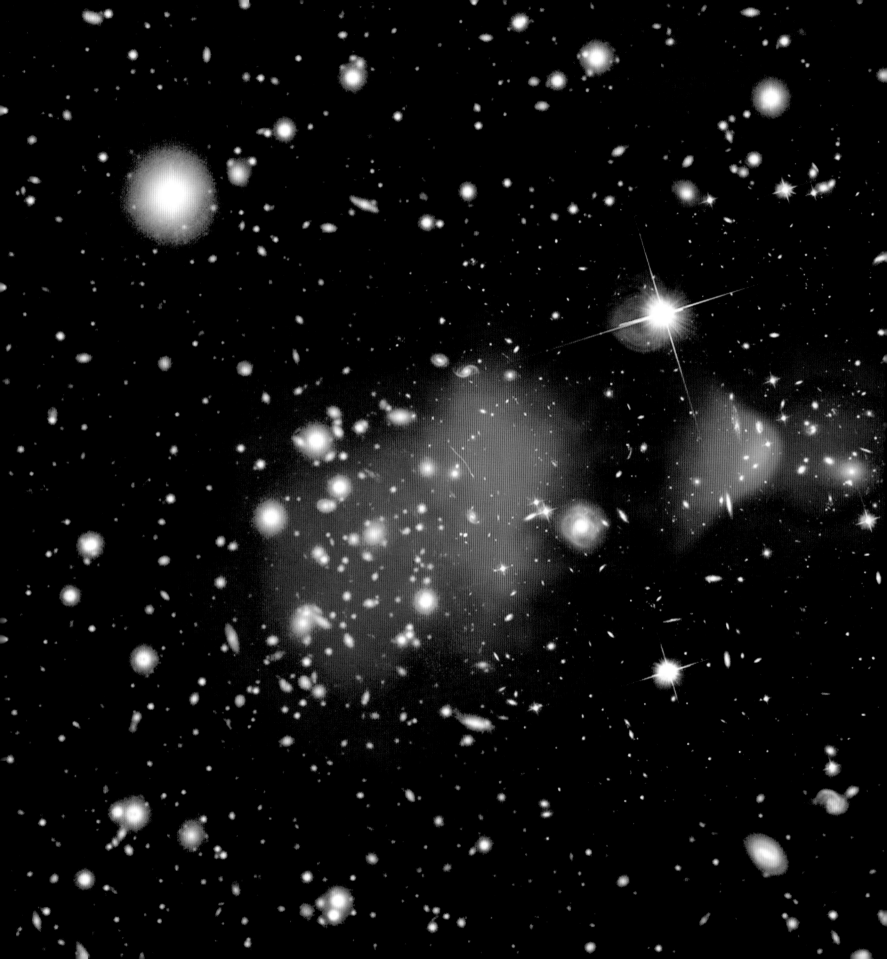

1E 0657-56

1E 0657-56, known as the Bullet Cluster, was formed by the collision between two enormous galaxy clusters, one of the most energetic events in the Universe since the Big Bang. It was so violent that this collision wrenched the hot gas detected by Chandra away from the dark matter in the clusters. This image provides direct evidence for the existence of dark matter, mysterious matter that is invisible to light and detected only through its gravity. Astronomers can use a phenomenon called gravitational lensing, predicted by Einstein's theory of general relativity, where the path of light from a distant source is bent by intervening mass, to infer the presence of dark matter.

Scale and distance: Image is about 8 million light-years across; object is about 3.8 billion light-years from Earth.

Wavelength/color: X-ray: pink; Optical: white/orange; Gravitational lensing map: blue.

ABELL 1689

Although it looks placid, Abell 1689 is an immense cluster of galaxies that may be the site of ongoing merging activity. While the multimillion-degree gas appears smooth in the Chandra image, temperature information suggests that the structure is complicated. The long arcs in the optical image, the largest system of such arcs ever found, are caused by gravitational lensing of the background galaxies by matter in the galaxy cluster.

Scale and distance: Image is about 2 million light-years across; object is about 2.2 billion light-years from Earth.

Wavelength/color: X-ray: purple; Optical: yellow.

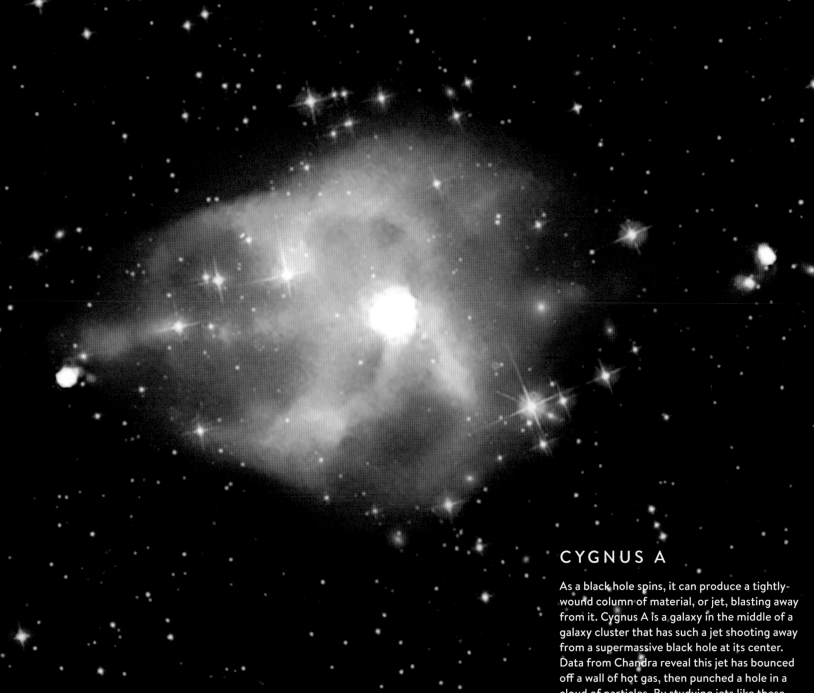

CYGNUS A

As a black hole spins, it can produce a tightly-wound column of material, or jet, blasting away from it. Cygnus A is a galaxy in the middle of a galaxy cluster that has such a jet shooting away from a supermassive black hole at its center. Data from Chandra reveal this jet has bounced off a wall of hot gas, then punched a hole in a cloud of particles. By studying jets like these, astronomers can learn more about how black holes influence their surroundings.

Scale and distance: Image is about 540,000 light-years across; object is about 760 million light-years from Earth.

Wavelength/color: X-ray: purple; Optical: red, green, and blue.

M 87

This image shows the eruption of a galactic supervolcano in the massive galaxy M87, as witnessed by Chandra in X-rays and by the Very Large Array, a radio telescope complex in New Mexico, in radio waves. At a distance of about 50 million light-years, M87 is relatively close to Earth and lies at the center of the Virgo cluster, which contains thousands of galaxies. A giant black hole at the core of M87 is producing massive jets of energetic particles similar to a volcanic eruption.

Scale and distance: Image is about 200,000 light-years across; object is about 50 million light-years from Earth.

Wavelength/color: X-ray: blue; Radio: red, orange.

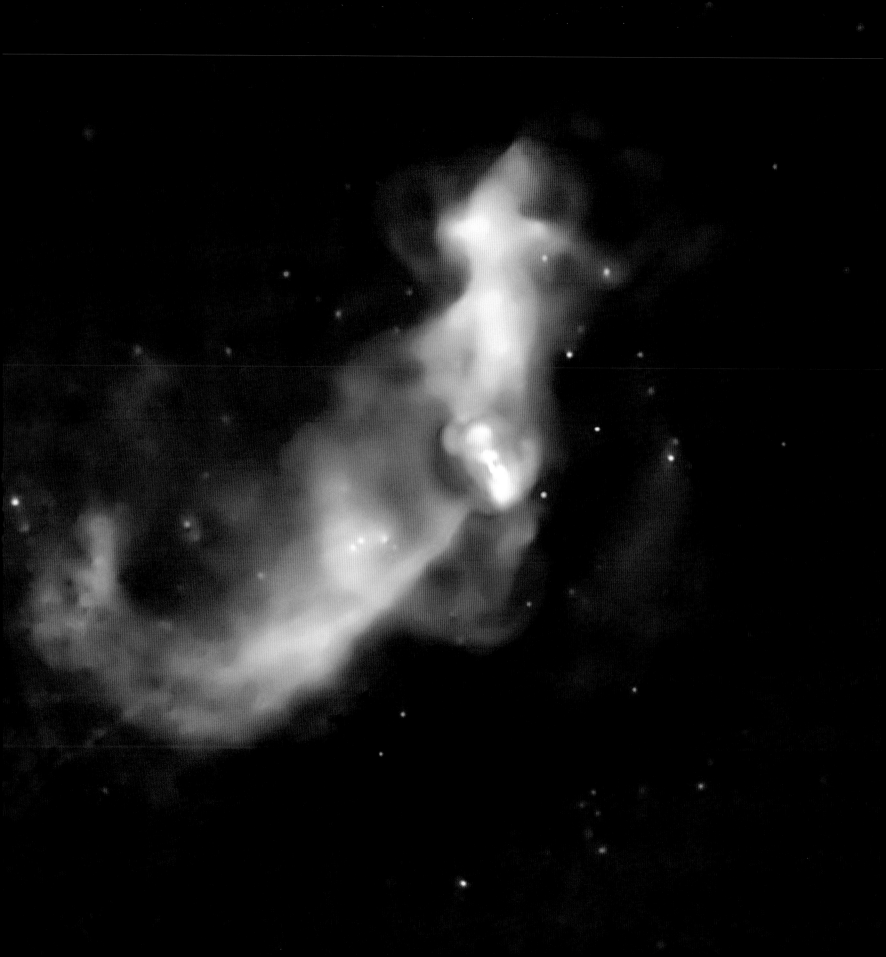

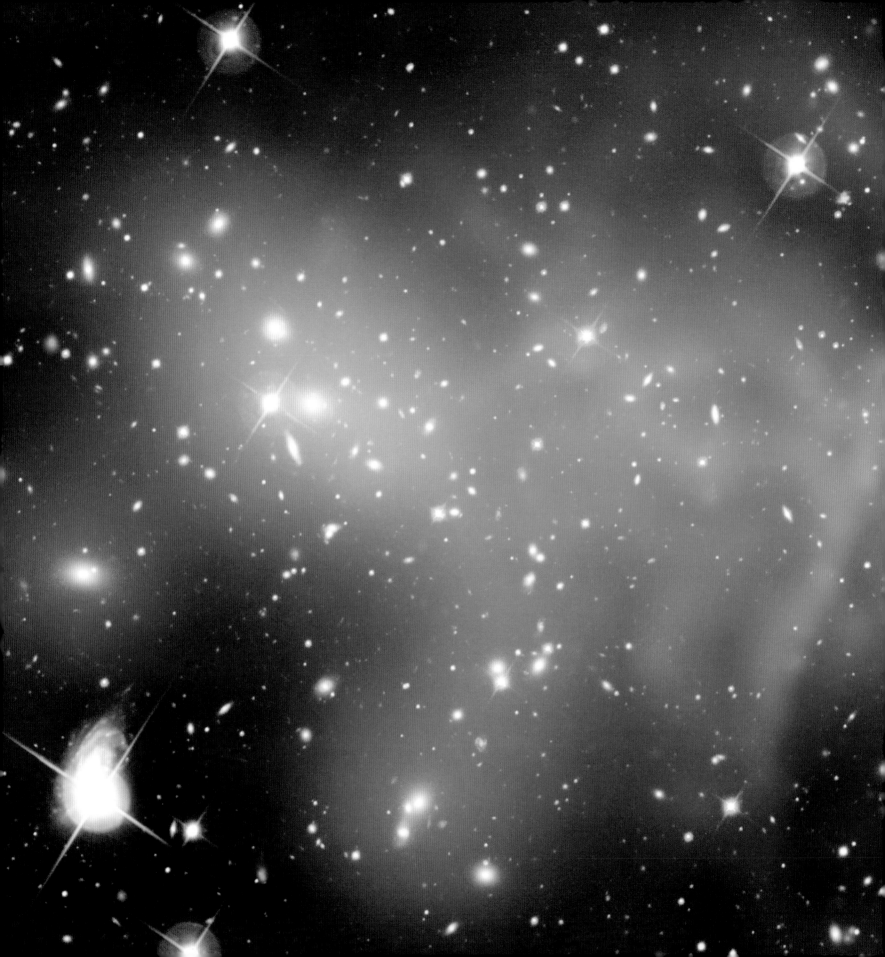

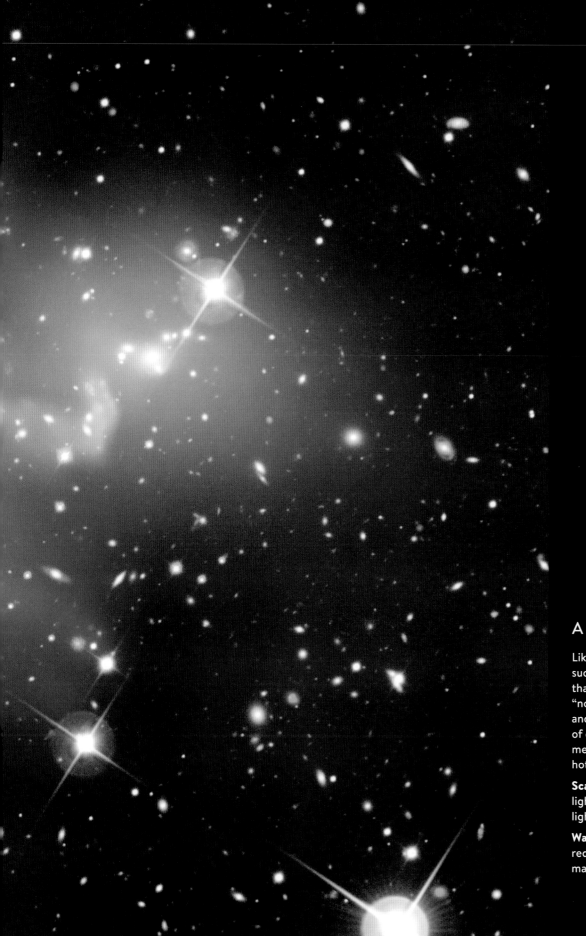

ABELL 520

Like the Bullet Cluster, Abell 520 is the site of such a violent collision between galaxy clusters that dark matter has been wrenched apart from "normal" matter. This composite image of X-ray and optical information shows the distribution of dark matter, galaxies, and hot gas in this merging galaxy cluster. Chandra reveals the hot gas spanning the site of the collision.

Scale and distance: Image is about 5.4 million light-years across; object is about 2.4 billion light-years from Earth.

Wavelength/color: X-ray: green; Optical: red, green, blue, orange; Gravitational lensing map: blue.

151

HERCULES A

Hercules A is a galaxy with a supermassive black hole pulling in lots of matter relatively quickly. Chandra data reveals a giant cloud of super-heated gas that has been pumped with energy by the infall of matter into the central black hole. Hercules A's black hole is about 1,000 times more massive than the one in our Milky Way. This composite image contains optical data as well as radio data that show jets of particles streaming away from the black hole for about one million light-years.

Scale and distance: Image is about 1.7 million light-years across; object is about 1.9 billion light-years from Earth.

Wavelength/color: X-ray: pink; Radio: blue; Optical: orange, blue.

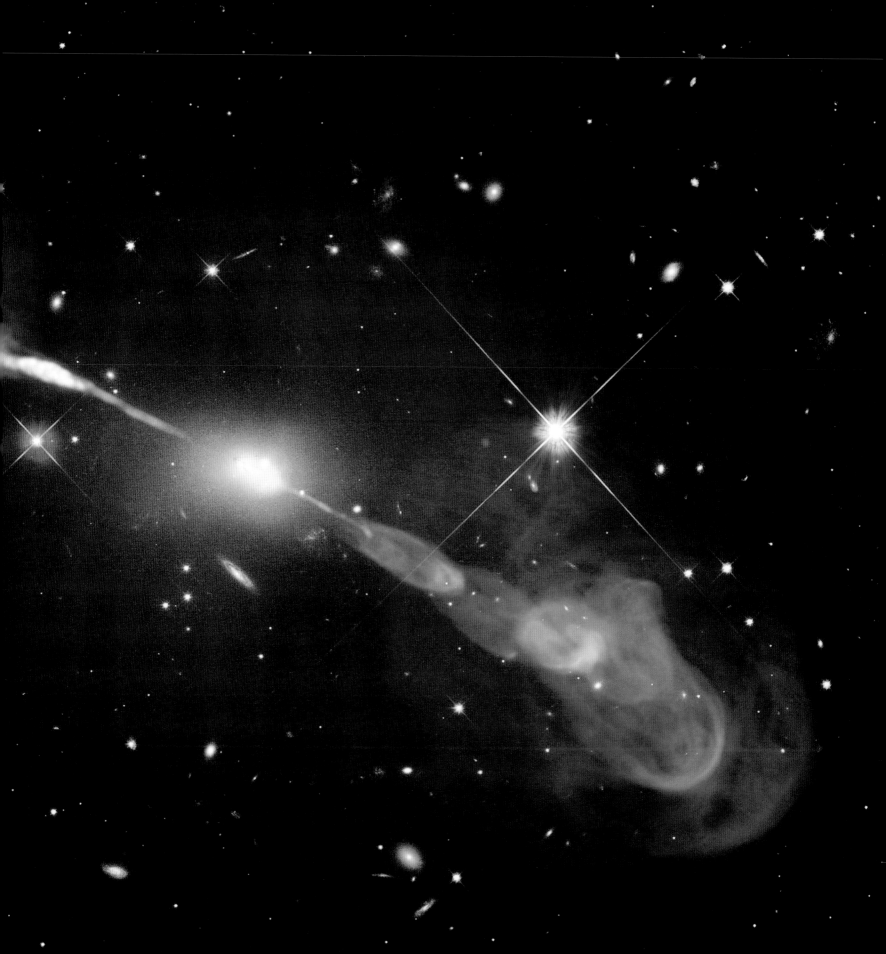

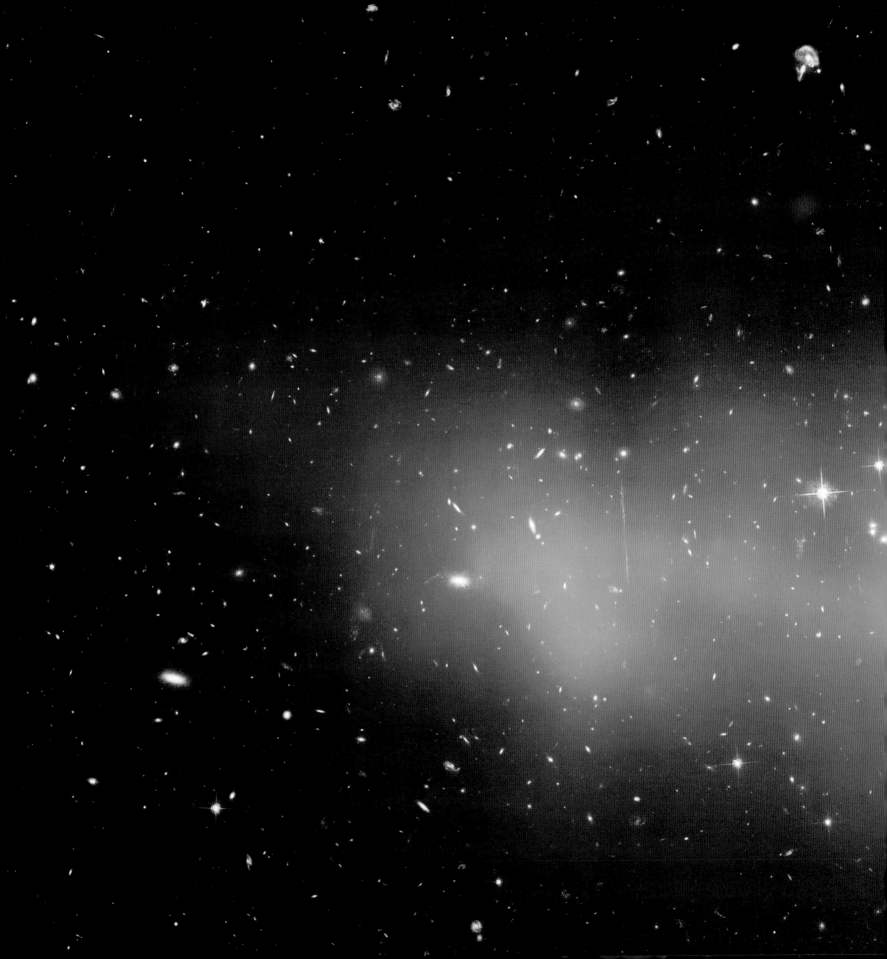

EL GORDO

This cluster of galaxies was nicknamed El Gordo, meaning "the fat one" in Spanish, because of its gigantic mass. This composite image of El Gordo contains X-rays from Chandra, a map of where the dark matter is found determined by gravitational lensing, and the individual galaxies in the cluster and stars in the field of view as observed by Hubble. El Gordo is the most massive and hottest galaxy cluster known, and it gives off more X-rays than any known galaxy cluster at its distance or beyond as well.

Scale and distance: Image is about 7.7 million light-years across; object is about 7.2 billion light-years from Earth.

Wavelength/color: X-ray: red; Optical: red, green, blue; Gravitational lensing map: blue.

155

SDSS J103842.59+484917.7

This group of galaxies has been nicknamed the Cheshire Cat because of its resemblance to a smiling feline. Some of the catlike features are actually distant galaxies whose light has been stretched and bent by the large amounts of mass in foreground galaxies, the gravitation lensing effect. X-rays from Chandra, combined with Hubble data in this image, show that the two eye galaxies and the smaller galaxies associated with them are slamming into one another.

Scale and distance: Image is about 1.45 million light-years across; object is about 4.6 billion light-years from Earth.

Wavelength/color: X-ray: pink; Optical: red, green, blue.

MS 0735.6+7421

The galaxy cluster MS 0735.6+7421 is home to one of the most powerful eruptions from a black hole ever observed. Chandra data reveal holes, or cavities, in the cluster's hot gas created by an outburst from a supermassive black hole at the cluster's center. Radio waves show enormous jets ejected from the black hole, while galaxies in the cluster and stars in the field of view are seen in an optical image. The power required to displace the gas exceeded the power output of the Sun by nearly 10 trillion times in the past 100 million years.

Scale and distance: Image is about 2 million light-years across; object is about 2.6 billion light-years from Earth.

Wavelength/color: X-ray: blue; Optical: yellow; Radio: red.

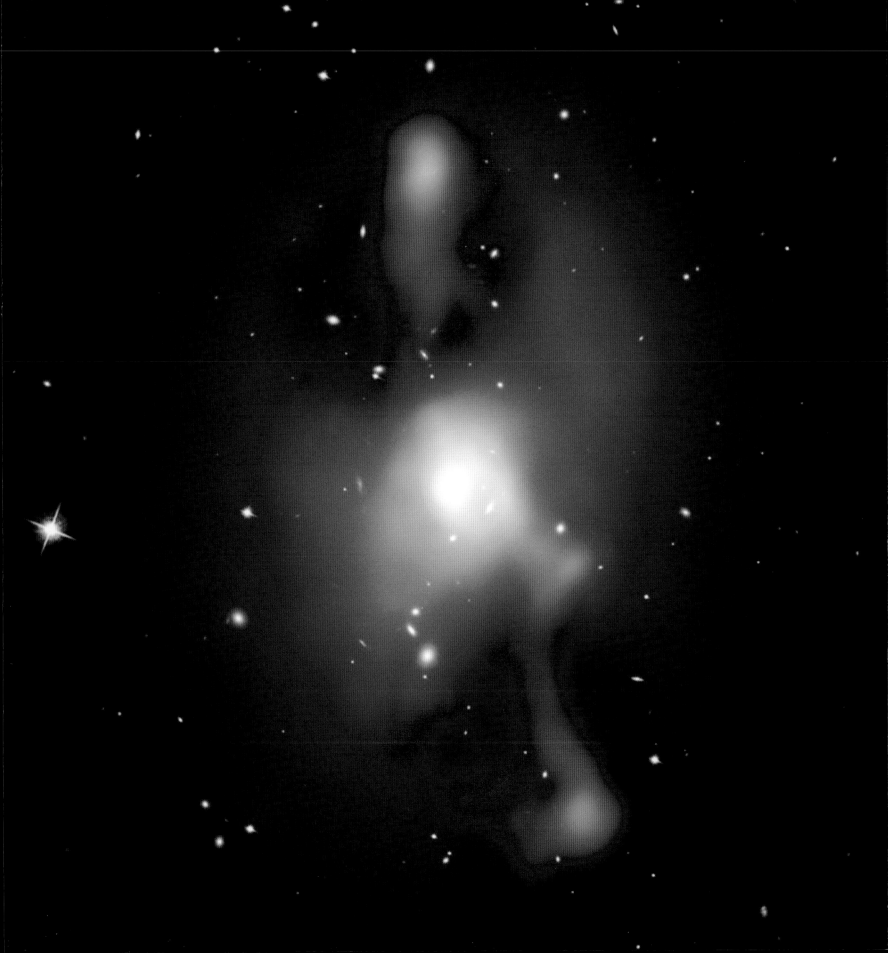

MACS J0416.1-2404

Chandra shows gas in the merging clusters with temperatures of millions of degrees in this system known as MACS J0416.1-2404. Galaxies in the clusters and more distant galaxies lying behind the clusters appear in an optical light image. Some of these background galaxies are highly distorted because of gravitational lensing, the bending of light by massive objects. This effect can also magnify the light from these objects, enabling astronomers to study background galaxies that would otherwise be too faint to detect.

Scale and distance: Image is about 3.6 million light-years across; object is about 4.29 billion light-years from Earth.

Wavelength/color: X-ray: blue; Radio: pink; Optical: red, green, blue.

MACS J0717.5+3745

MACS J0717.5+3745 is a cosmic train wreck, the
only known collision of four separate galaxy
clusters in the known Universe. X-rays from
Chandra reveal the massive amounts of hot gas
that pervade the galaxy cluster. Jets of plasma
launched by a supermassive black hole in one of
the galaxies can be seen in radio waves from the
Very Large Array, and the galaxies can be seen
in optical light from Hubble.

Scale and distance: Image is about 6.8 million
light-years across; object is about 5.4 billion
light-years from Earth.

Wavelength/color: X-ray: blue; Optical: red,
green, blue; Radio: pink.

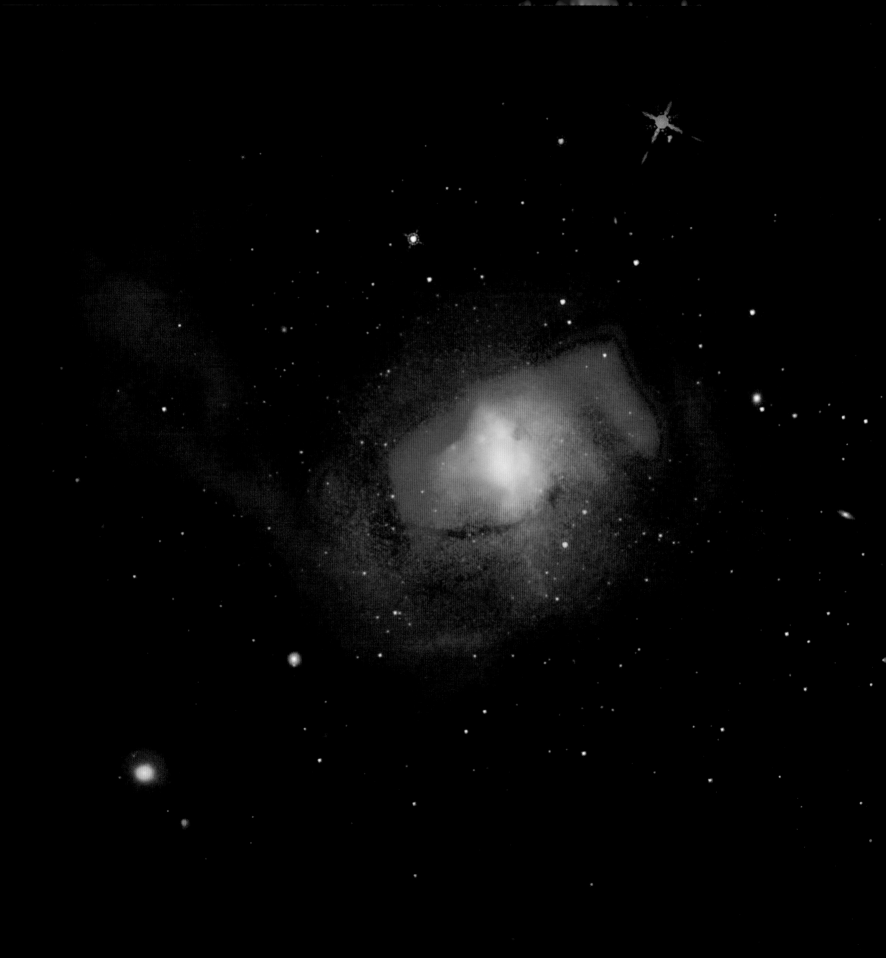

NGC 4696

Astronomers have found that the black hole in NGC 4696 has been pumping material and energy into its environment about every 5 to 10 million years. The black hole is at the center of this large elliptical galaxy within the core of the Centaurus galaxy cluster. X-rays from Chandra and other telescopes show evidence for repeated eruptions from the black hole. These bursts created cavities, filled with radio emissions, within the hot gas that glows in X-rays in the cluster.

Scale and distance: Image is about 93,000 light-years across; object is about 145 million light-years from Earth.

Wavelength/color: X-ray: red; Radio: blue; Optical: green.

ABELL 3411
AND ABELL 3412

Two of the most powerful phenomena in the Universe, a supermassive black hole and the collision of giant galaxy clusters, combined to create a stupendous cosmic particle accelerator. An eruption from a supermassive black hole has been swept up into the collision between the galaxy clusters Abell 3411 and Abell 3412. The result is an extraordinary acceleration of particles that explains mysterious swirling structures seen in radio data. X-rays from Chandra were combined with several other telescopes to make this discovery.

Scale and distance: Image is about 9.8 million light-years across; object is about 2 billion light-years from Earth.

Wavelength/color: X-ray: blue; Radio: pink; Optical: red, green, blue.

RX J0603.3+4214 (TOOTHBRUSH CLUSTER)

This galaxy cluster has invoked the nickname of the Toothbrush Cluster because of its resemblance to that everyday object. In fact, the stem of the brush is caused by radio waves, while the diffuse emission where the toothpaste would go is produced by X-rays observed by Chandra. An optical image from the Subaru telescope shows galaxies and stars, and a map from gravitational lensing shows the concentration of the mass, which is about 80 percent dark matter.

Scale and distance: Image is about 14.6 million light-years across; object is about 2.7 billion light-years from Earth.

Wavelength/color: X-ray: purple; Radio: green; Optical: red, green, blue; Gravitational lensing map: blue.

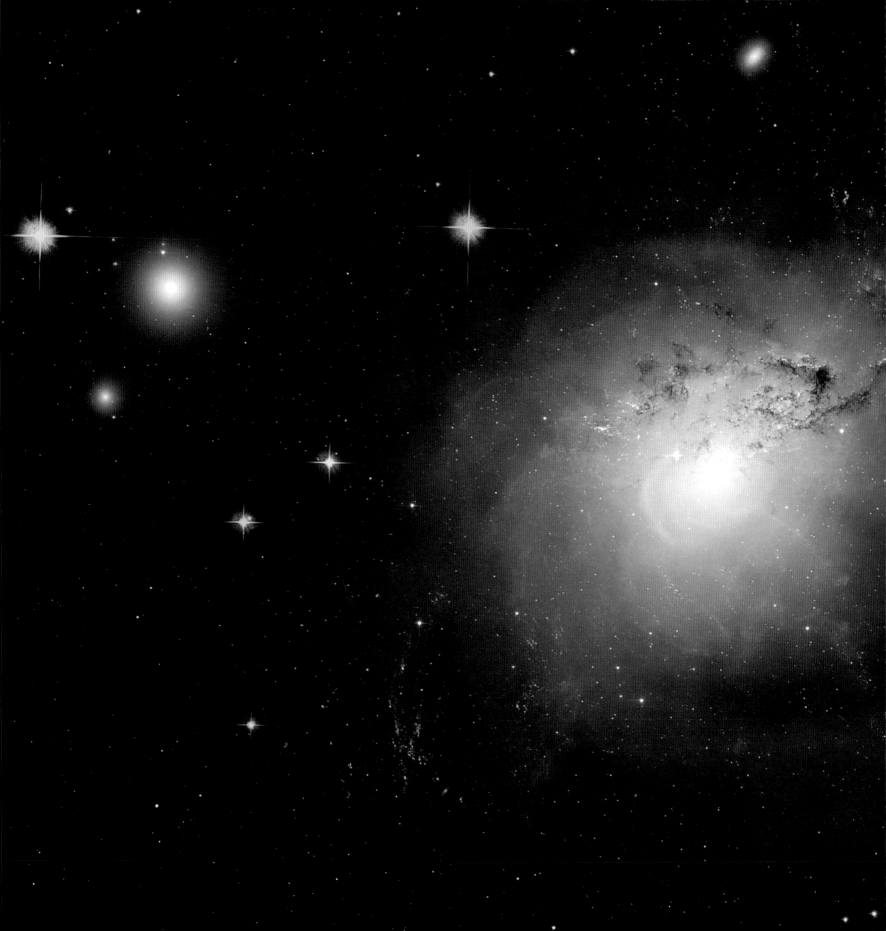

PERSEUS A

Among Chandra's most important scientific legacies is the discovery of buoyantly rising bubbles in the hot gas that permeates clusters of galaxies. The first such discovery was in NGC 1275, the giant galaxy in the heart of the Perseus cluster. Radio data show jets launched by the central supermassive black hole that are responsible for inflating the bubbles. Scientists also used Chandra to discover ripples in the hot gas of Perseus, which translates to a sound that is the deepest note in the Universe.

Scale and distance: Image is 280,000 light-years across; object is about 250 million light-years from Earth.

Wavelength/color: X-ray: violet; Radio: pink; Optical: red, green, blue.

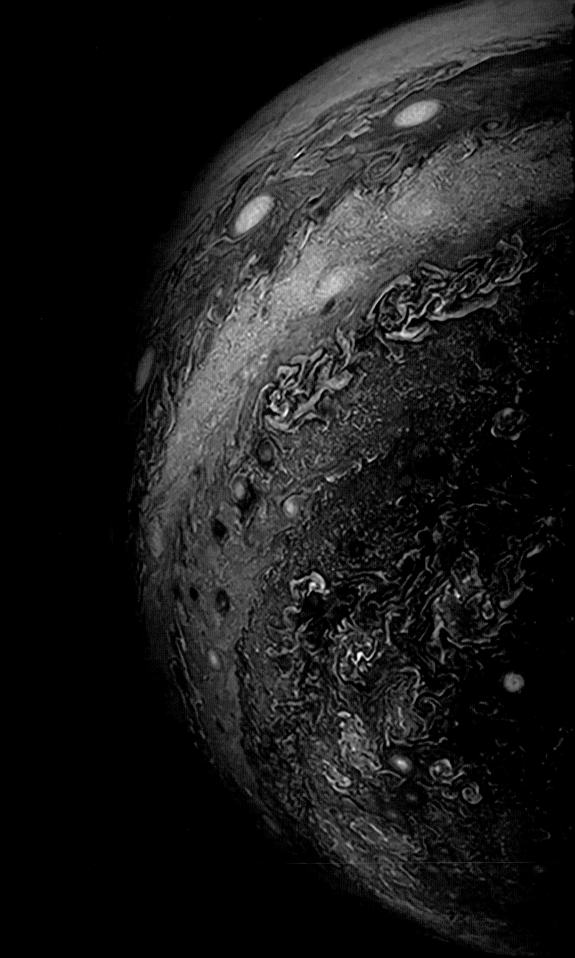

Jupiter, South Pole, page 188

5

GOING
BEYOND

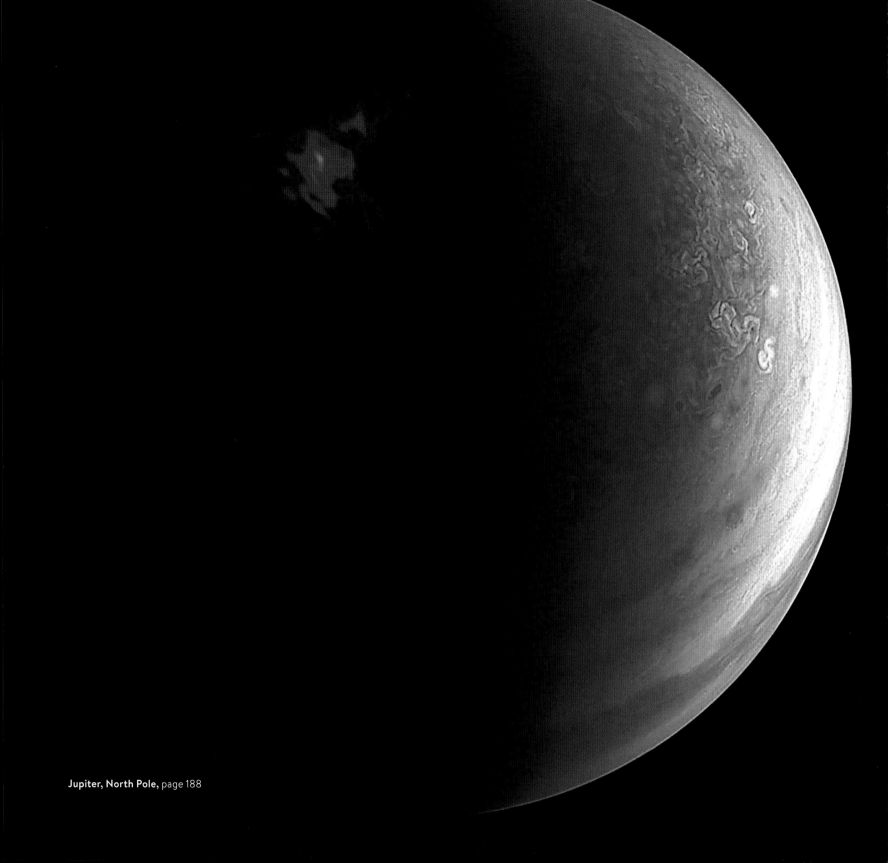

Jupiter, North Pole, page 188

ALL FOUR OF NASA'S "Great Observatories"—the Hubble Space Telescope, Compton Gamma Ray Observatory, Chandra X-ray Observatory, and Spitzer Space Telescope—have proven to be immensely flexible observation platforms. That is, instead of being able to observe only a certain type of cosmic object or phenomenon, they have been used to study nearly the full gamut of what the Universe has to offer. With a broad range of capabilities, each designed to look at a certain range of light, they have enabled an enormous and ever-widening range of scientific uses.

Today, astrophysicists around the globe, including hundreds of new scientists each year, use Chandra to observe the wonders of our Universe, sometimes in previously unanticipated ways. The science they have discovered has resulted in the publication of thousands of refereed papers, which span a breadth of science too broad to be placed into merely a few categories.

The exploration enabled by Chandra is truly expansive. This section touches on some of these expected—and unexpected—

areas that the powerful X-ray telescope has investigated. Some of the topics that Chandra studies were not even discovered when the telescope was being developed and planned. For example, "exoplanets," that is, planets outside our Solar System, were not found until the mid-1990s, two decades after the Chandra project was conceived. Similarly, scientists did not know of the existence of dark energy, the mysterious force that dominates the accelerated expansion of the Universe, until about the time Chandra was launched.

Chandra is such an amazing specimen of science and engineering that it is able to contribute to the understanding of these new and evolving areas of astrophysics. This is a testament to those who conceived and built the telescope and its instruments.

This final section provides a sample of the range of objects that Chandra has investigated. We expect Chandra to bring forward many more discoveries in the future. Its journey continues. Where it takes us depends only on the imagination of scientists who use it and the wonders that the Universe has to offer.

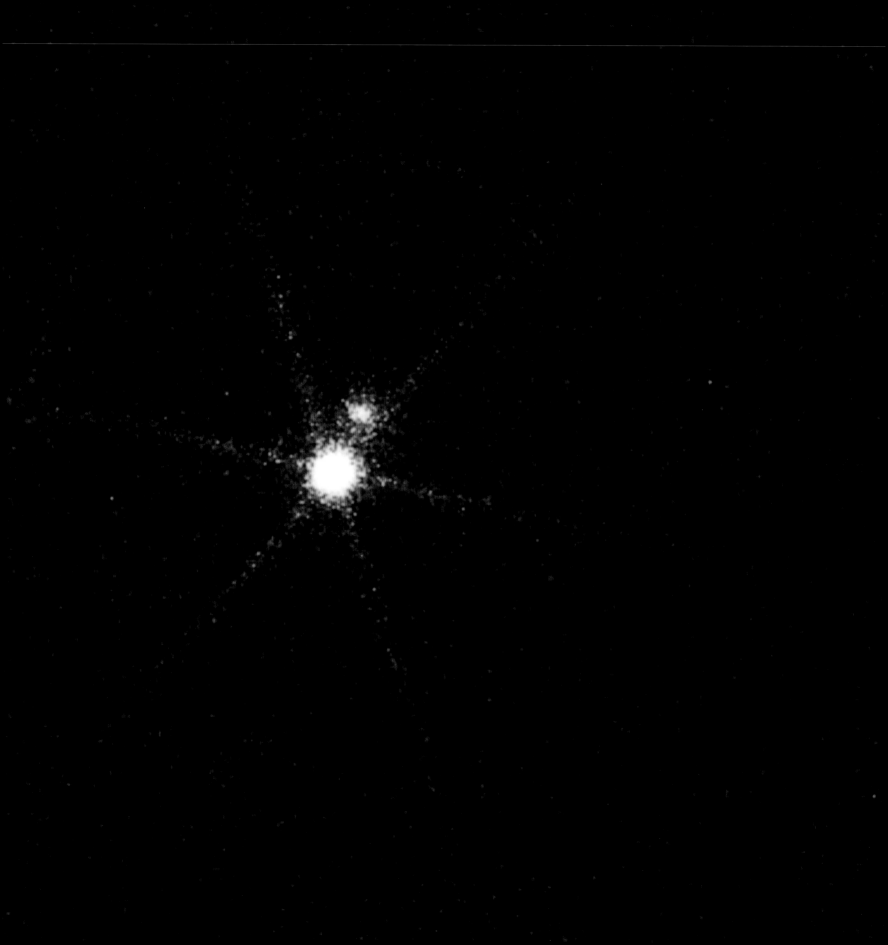

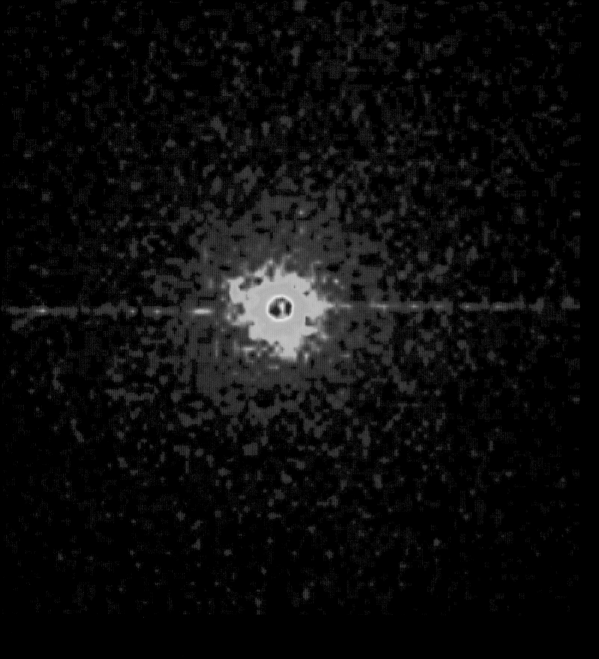

CYGNUS X-3

The X-ray emission from Cygnus X-3 owes to matter streaming from a normal star onto a nearby neutron star or black hole. The Chandra image of Cygnus X-3, with intensity varying from black to red, shows the normal star as the X-ray source in the middle surrounded by a halo, created by light scattering off dust grains along the line of sight between Chandra. (The sharp horizontal line is an instrument effect due to the brightness of the source.) Scientists have used the radiation from the halo as a way to measure cosmic distances.

Scale and distance: Image is about 29 light-years across; object is about 30,000 light-years from Earth.

Wavelength/color: X-ray: black to red.

XTE J1118+480

This Chandra spectrum of a black hole is similar to the colorful spectrum of sunlight produced by a prism. These data reveal that a flaring black hole source, known as XTE J1118+480, has a disk of material swirling around it that stops much farther out than some theories predict. Scientists think that the disk may be truncated when material erupts into a hot bubble of gas before taking its final plunge into the black hole.

Scale and distance: Image is 5.8 light-years across; object is about 5,000 light-years from Earth.

Wavelength/color: X-ray: black to red.

THE MOON

While the Earth's Moon itself is too cold to give off X-rays, it can turn into an X-ray source when sunlight bombards its surface. The incoming light from the Sun allows Chandra to detect oxygen, magnesium, aluminum, and silicon in the lunar soil. This helps improve our understanding of how the Moon formed. X-rays also appear to come from the dark portion of the Moon, which are actually charged atoms from the Sun colliding with atoms in Earth's extended outer atmosphere.

Scale and distance: The Moon is 2,159 miles across; object was about 230,000 miles from Earth at the time of observation.

Wavelength/color: X-ray: blue.

OPTICAL

X-RAY

JANUARY 24, 2004

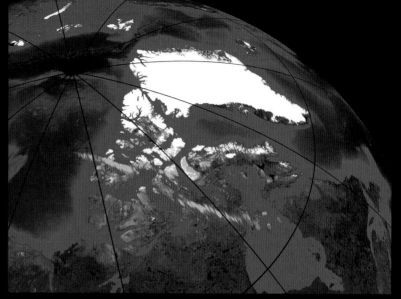

JANUARY 30, 2004

nabled by Chandra have determined the black hole's spin, mass, and distance with unprecedented accuracy.

Scale and distance: Image is about 424 light-years across; object is about 6,070 light-years from Earth. X-ray image is 8 light-years across.

Wavelength/color: X-ray: blue to white.

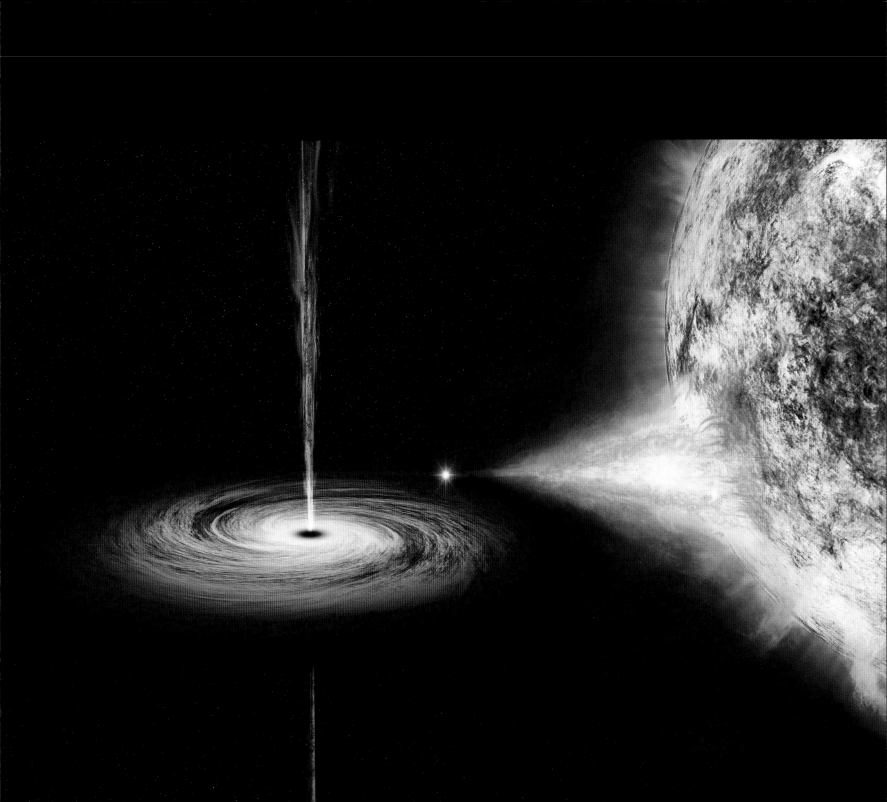

COROT-2A

Although it looks calm, this Chandra observation of star CoRoT-2a reveals that the star is blasting the atmosphere of a giant planet in close orbit around it (see illustration). While the planet cannot be seen directly, data from Chandra provide clues as to the origin, nature, and fate of this and other planets outside our Solar System throughout our Galaxy. Astronomers think that high-energy radiation is evaporating about 5 million tons of matter from the planet every second.

Scale and distance: Image is about 1.2 light-years across; object is about 880 light-years from Earth.

Wavelength/color: X-ray: purple to white.

X-RAY & OPTICAL/INFRARED

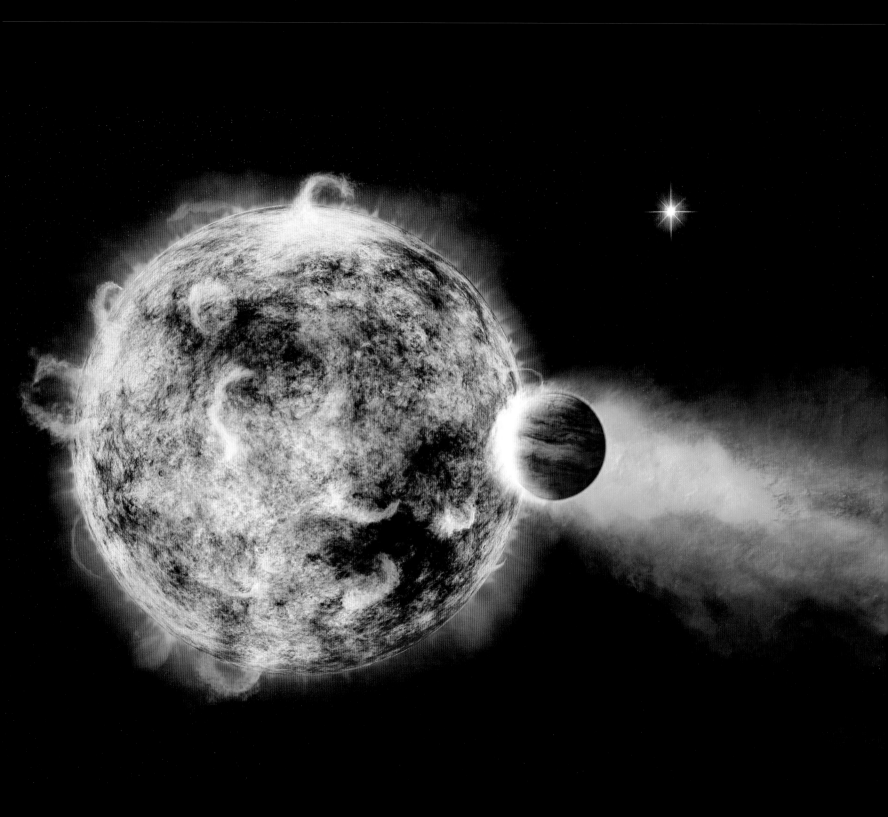

HD 189733b

With HD 189733b, astronomers using X-rays detected a planet outside our Solar System passing in front of its parent star for the first time. The X-ray data suggest that planet HD 189733b has a larger atmosphere than previously thought, and the parent star may be evaporating the atmosphere of HD 189733b more quickly than expected (see illustration). HD 189733b is a Jupiter-sized planet that orbits its star at about the distance of Mercury from the Sun. These sources appear in the X-ray image: the top most is HD 189733b, while the right and bottom objects are the companion star and a background object, respectively.

Scale and distance: Image is about 0.02 light-years across; object is about 60 light-years from Earth.

Wavelength/color: X-ray: purple to white.

X-RAY

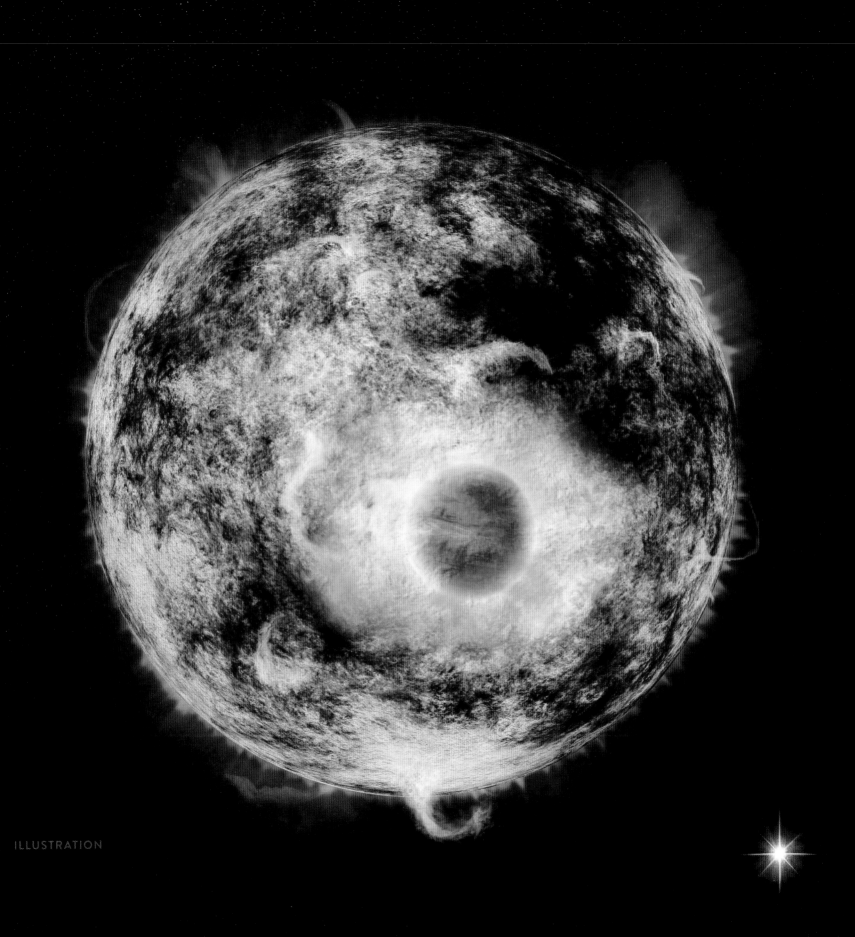

ILLUSTRATION

RADIO

VLA J2130+12

VLA J2130+12 sits in the far left of the field of this image of M15, an ancient globular cluster. VLA J2130+12 is an unusual source in the Milky Way, containing a very quiet black hole a few times the mass of our Sun. Chandra's observations of this system imply that there could be many more black holes in the Milky Way galaxy than previously accounted for.

Scale and distance: Main image is about 5.4 light-years across; box is about 0.2 light-years across; object is about 7,200 light-years from Earth.

Wavelength/color: X-ray: purple; Radio: green; Optical: red, green, blue.

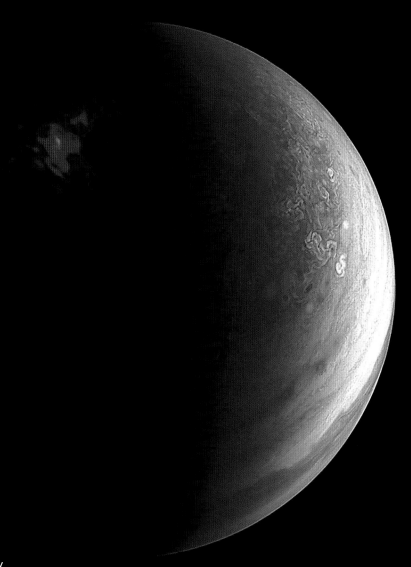

JUPITER

Jupiter is the fifth planet from the Sun in our Solar System. X-ray data from Chandra reveal that the auroras at Jupiter's poles behave independently. This makes Jupiter unlike Earth, where the north and south pole auroras generally mirror each other. Scientists are combining Chandra observations with data from NASA's Juno spacecraft, currently in orbit around the planet, to learn more about the beautiful gas giant.

Scale and distance: Jupiter's diameter is 86,880 miles; object is about 459 million miles from Earth (on date of Chandra observations).

Wavelength/color: X-ray: purple.

NORTH POLE

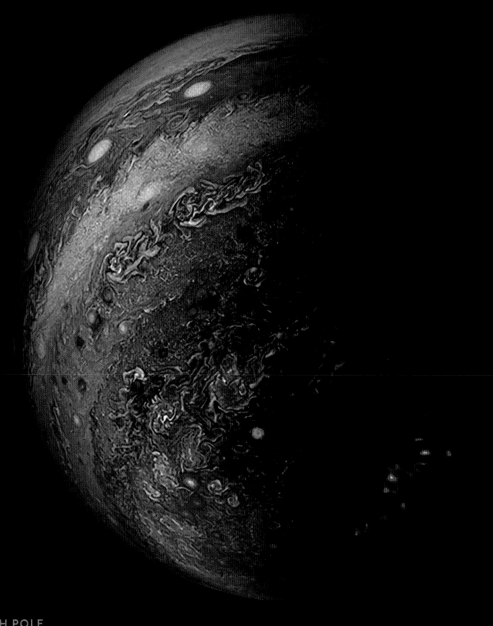

SOUTH POLE

GJ 176

X-rays may provide valuable information about whether a star system will be hospitable to life on other planets. Stellar X-rays mirror magnetic activity, which can produce energetic radiation and eruptions that could impact surrounding planets. Researchers used Chandra and XMM-Newton to study twenty-four stars like our Sun that were at least one billion years old, including GJ 176, seen in a Chandra image in the inset within the artist's illustration.

Scale and distance: Image is about 0.079 light-years wide; object is about 30.2 light-years from Earth.

Wavelength/color: X-ray: blue.

X-RAY

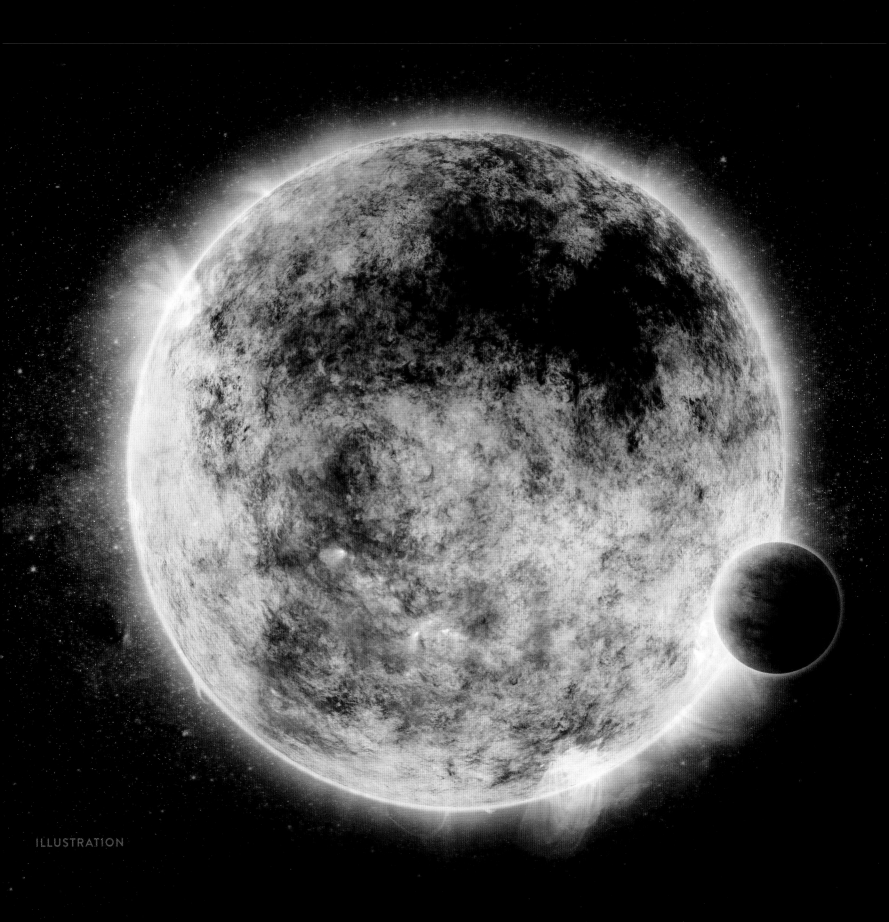

ILLUSTRATION

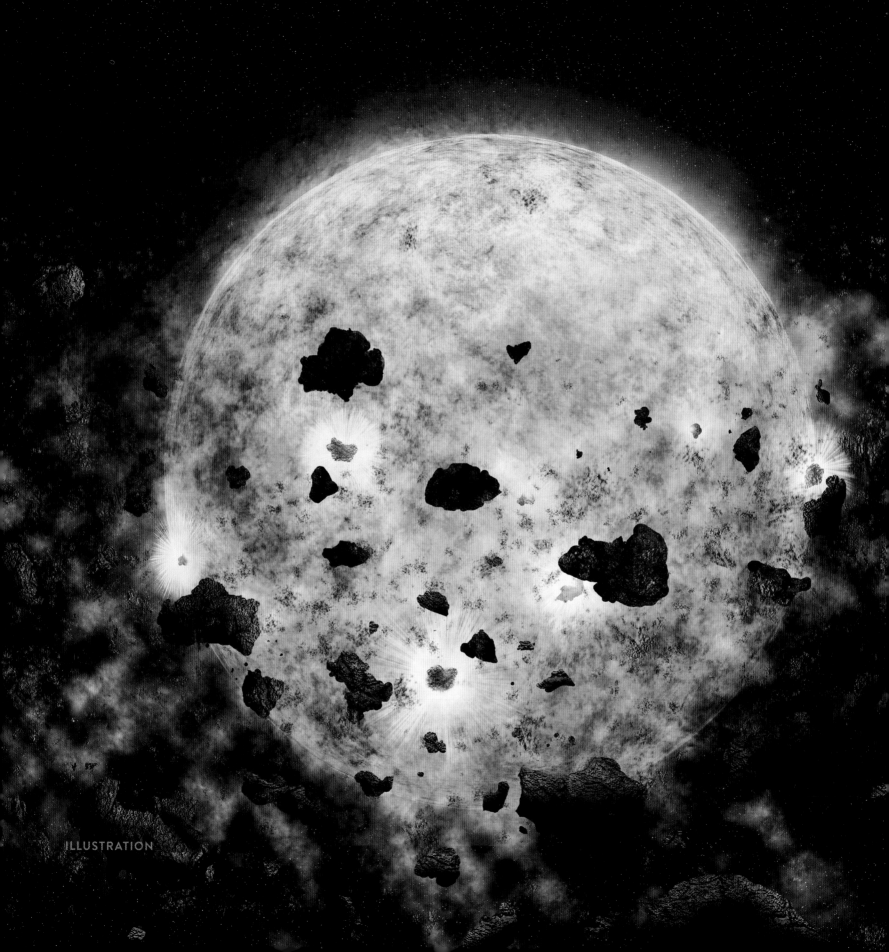

ILLUSTRATION

RW AUR A

Chandra data indicate that a young star has likely destroyed and consumed an infant planet, depicted in the artist's illustration. If confirmed, this would be the first time that astronomers have witnessed such an event. The star, known as RW Aur A, is a few million years old. Studying this with Chandra data, seen as a spectrum, may help astronomers gain insight into the processes affecting the early stages of planet development.

Scale and distance: No image, spectra are displayed; object is about 450 light-years from Earth.

Wavelength/color: No color scale: spectra.

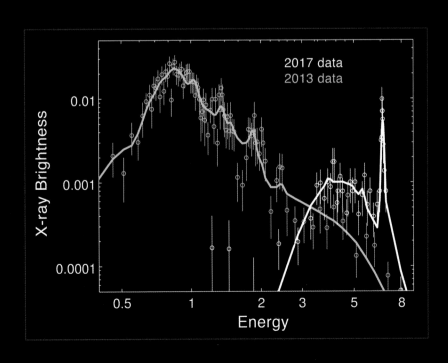

ILLUSTRATION

GW170817

Astronomers used Chandra data to study GW170817 in the days, weeks, and months after the detection of gravitational waves from the source by the Laser Interferometer Gravitational Wave Observatory (LIGO) on August 17, 2017. The change in the X-rays between late summer and the end of 2017 are shown in the inset boxes. X-rays from Chandra are critical for understanding what happens when two neutron stars collide. In the case of GW170817, some scientists think this event may have spawned the lowest-mass black hole presently known.

Scale and distance: Image is about 205,000 light-years across; object is 130 million light-years from Earth.

Wavelength/color: X-ray: purple.

AUGUST/SEPTEMBER 2017

DECEMBER 2017

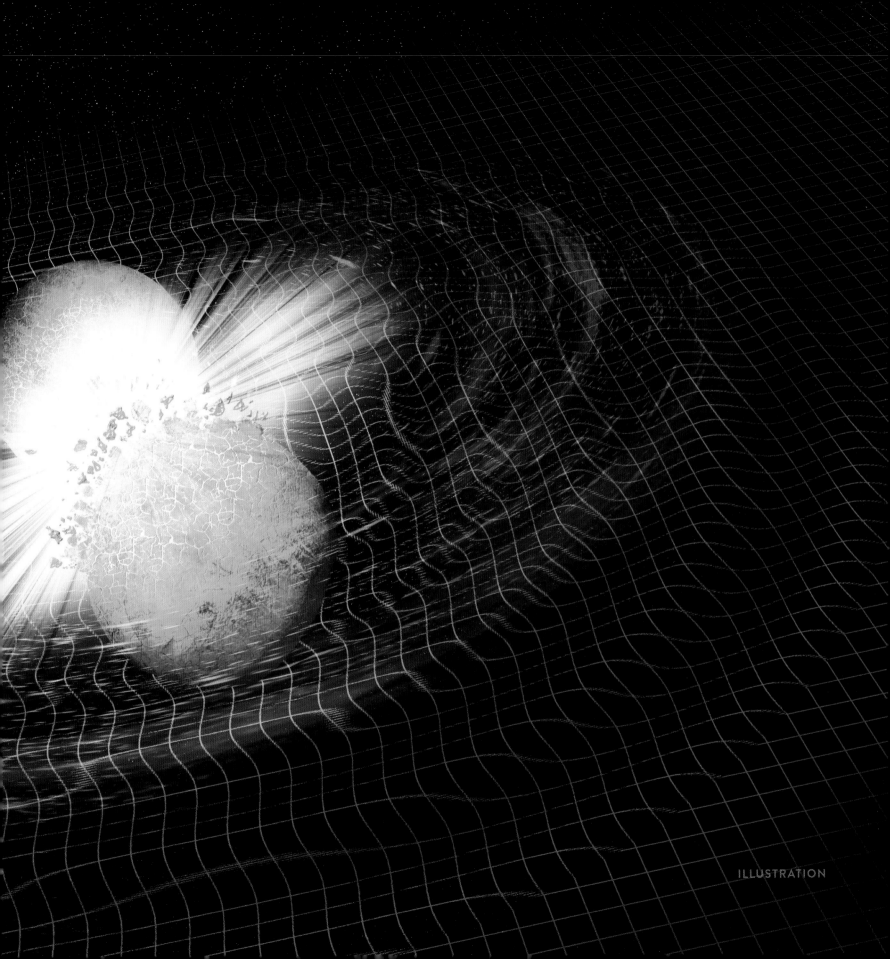

ILLUSTRATION

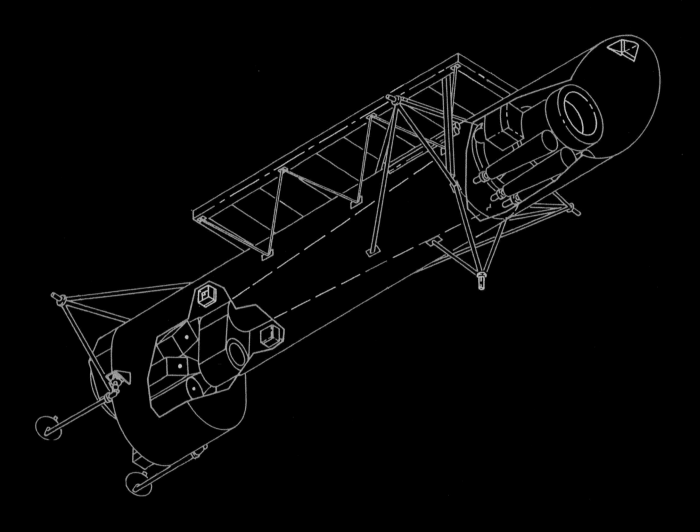

In 1963, Ricardo Giacconi and colleagues outlined a concept for
a large X-ray telescope in a research proposal. A refined concept
became the basis for the 1976 proposal to NASA for the study of
an X-ray telescope called the 1.2 Meter Telescope, later renamed
to the Advanced X-ray Astrophysics Facility (AXAF). It eventually
was named the Chandra X-ray Observatory.

AFTERWORD

HARVEY TANANBAUM

Senior Astrophysicist: Center for Astrophysics | Harvard & Smithsonian
Director (1991–2014): Chandra X-ray Center

IN 1976, RICCARDO GIACCONI and I headed a small team that proposed a study to NASA for a 1.2 Meter X-Ray Telescope National Space Observatory. We optimistically projected a launch in late 1982 with a ten-year mission duration. Readers are invited to do the math required to compare those expectations with the realities of a 1999 launch and a mission whose twentieth anniversary is commemorated with this book of fantastic images from the Chandra X-ray Observatory.

Of course, the math is not so simple as it might first appear. How does one trade off the professional and personal impacts of the twenty-three years from concept proposal to launch versus twenty years of smooth operation on orbit and amazing science, with perhaps another decade or more to come? During the years when our team, drawn from NASA, academia and research centers, and industry, was developing the technology, obtaining the approvals and funding, and then building and testing the hardware and software for the observatory, there were many high points and perhaps comparable numbers of frustrating events.

One highlight that we came to appreciate over the years was the tight bonding of the team, forged through trial by fire. Literally thousands of people and dozens of organizations worked on Chandra, and each contributed to the success of the mission. Through the ups and downs, we all learned to depend upon one another and to appreciate the unique abilities that each brought to the project.

People communicated openly, the team vetted problems, and all of us owned the decisions. Those who built Chandra and those charged with its continuing operations are justifiably proud of what Chandra has achieved and what we share through the spectacular images in this book.

Personally, I was amazed by the Chandra "First Light" image taken a few weeks after launch, which clearly showed the long-sought but previously unseen neutron star created during the Cassiopeia A supernova explosion. I continue to be delighted by daily snapshots of new observations, along with regular press and image releases plus the thousands of scientific papers reporting Chandra discoveries. Chandra studies range from Jupiter's auroras to supermassive black holes in galaxies nearly across the Universe, and they provide unique insights into the working machinery of all types of astronomical objects and systems.

Even with all that we have learned from Chandra, there is so much more of the Universe to explore, with mysteries and puzzles near and far shouting out to be solved. Many of us have been working for several years on a next-generation successor to Chandra with perhaps 100 times greater sensitivity—an even bigger leap in capability than Chandra achieved over its predecessors. The best is yet to be (the motto of my old high school).

We hope that you enjoy these images as much as we enjoy sharing them with you.

ACKNOWLEDGMENTS

The authors are grateful to Harvey Tananbaum, Peter Edmonds, Vinay Kashyap, Andreas Zezas, Kathy Lestition, Mahboubeh Asgari-Targhi, Wallace Tucker, Sara Price, Nancy Wolk, and Kelly Williamson for their invaluable contributions that helped bring this book to life. Chandra is a dream made real by hundreds of people across more than four decades. We thank all of them, including the extraordinary scientists and engineers of the Smithsonian Astrophysical Observatory, NASA Marshall Space Flight Center, Northrup Grumman, and the innumerable other centers of discovery around the world that have helped build Chandra's legacy. A special thanks to the staff at Smithsonian Books—including Jaime Schwender, Christina Wiginton, Carolyn Gleason, Gary Tooth, and Gregory McNamee—who demonstrated incredible expertise, skill, and patience in making this book a reality. Chandra is a NASA mission and would not be possible without the vision of this remarkable agency. To the brave crew of STS-93, including Eileen Collins, Jeffrey Ashby, Michael Tognini, Steven Hawley, and Cady Coleman: you are, and always will be, part of the Chandra family. Thank you.

INDEX

Page numbers in *italics* refer to images.

telescopes, 18–19, 141. *See also individual telescopes*

theory of general relativity, 141, 145

thermonuclear explosions, 91, 103

time, 17–18, 23

TMA-2. *See* Technology Mirror Assembly

Tognini, Michel, 10, 15

Toothbrush Cluster. *See* RX J0603.3-4214

Townsend, Marjorie, *14*

Triangulum Galaxy. *See* Messier 33

Trumpler 14, 28, *29*

Tycho's Supernova Remnant, 95, *95*

Uhuru satellite, 14, *14*

ultraluminous X-ray sources (ULXs), 128

Universe, expansion of, 91, 141, 171

V-2 rocket, 14

Vela pulsar, 56, *56*, *57*

Very Large Array (VLA), 18, 148, 161

Virgo cluster, 148

VLA. *See* Very Large Array

VLA J2130-12, *186*, 187, *187*

VV 340, 132, *132*

W49B, 92, *93*

wavelengths, 18, 26, 53, 111

Westerlund 2, 24, *25*

Whirlpool Galaxy, 130, *130*

white dwarfs, 13, 14, 40, 82, 85, *85*, 89, 91, 103, 105, *105*, 172, *173*

XMM-Newton observatory, 70, 71, 190

X-ray observatories, 14–15, 18–19. *See also individual observatories*

X-rays, 8, 9, 13, 14, 18–19, 24, 28; auroras and, 178, 188; black holes and, 111, 119; magnetic activity and, 23, 48, 178, 190; Moon and, 176; stellar birth and, 23; stellar death and, 53. *See also* binary systems: X-ray

XTE J1118-480, 175, *175*

ILLUSTRATION CREDITS

2-3, 38-39: X-ray: NASA/CXC/PSU/L. Townsley et al.; Optical: NASA/STScI; Infrared: NASA/JPL/PSU/L. Townsley et al.; 5, 88: NASA/CXC/Middlebury College/F. Winkler; 6-7, 166-167: X-ray: NASA/CXC/IoA/A. Fabian et al.; Radio: NRAO/VLA/G. Taylor; Optical: NASA/ESA/Hubble Heritage (STScI/AURA) & Univ. of Cambridge/IoA/A. Fabian; 8-9, 106-107: NASA/CXC/SAO; 10: NASA; 13-14: Seán Doran/NASA; 14*l*: R. Giacconi; 14*m*: NASA; 14*tr*: NASA/SAO/Einstein Observatory; 14*br*: NASA/SAO/Einstein Observatory; 15*l*: NASA; 15*m*: NASA; 15*r*: NASA/CXC/SAO; 16-17: NASA/CXC & J. Vaughan; 19: NASA; 20-21, 45: X-ray: NASA/CXC/PSU/L. Townsley et al.; Optical: UKIRT; Infrared: NASA/JPL-Caltech; 22, 32: X-ray: NASA/CXC/Univ. Potsdam/L. Oskinova et al.; Optical: NASA/STScI; Infrared: NASA/JPLCaltech; 24-25: X-ray: NASA/CXC/SAO/Sejong Univ./Hur et al.; Optical: NASA/STScI; 26-27: X-ray: NASA/CXC/Northwestern/F. Zadeh et al.; Infrared: NASA/HST/NICMOS, Radio: NRAO/VLA/C. Lang; 28-29: NASA/CXC/PSU/L. Townsley et al.; 30: X-ray: NASA/CXC/Penn State/E. Feigelson & K. Getman et al.; Optical: NASA/ESA/STScI/M. Robberto et al.; 31: X-ray: NASA/CXC/CfA/J. Forbrich et al.; Infrared: NASA/SSC/CfA/IRAC GTO Team; 33: X-ray: NASA/CXC/CfA/R. Tuellmann et al.; Optical: NASA/AURA/STScI; 34-35: X-ray: NASA/CXC/SAO/J. Wang et al.; Optical: DSS & NOAO/AURA/NSF/KPNO 0.9-m/T. Rector et al.; 36-37: X-ray: NASA/CXC/SAO/J. Drake et al.; Optical: Univ. of Hertfordshire/INT/IPHAS; Infrared: NASA/JPL-Caltech; 40-41: NASA/CXC/Michigan State/A. Steiner et al.; 42-43: X-ray: NASA/CXC/PSU/K. Getman, E. Feigelson, M. Kuhn & the MYStIX team; Infrared: NASA/JPL-Caltech; 44: X-ray: NASA ICXC/SAO/S. Wolk et al.; Optical: DSS &NOAO/AURA/NSF; Infrared: NASAIJPL Caltech; 46-47: X-ray: NASA/CXC/SAO; Optical: NASA/STScI; 48-49: X-ray: NASA/CXC/Univ. of Valparaiso/M. Kuhn et al.; Infrared: NASA/JPL/WISE; 50-51, 80-81: X-ray: NASA/CXC/SAO/J.Hughes et al., Optical: NASA/ESA/Hubble Heritage Team STScI/AURA; 52, 60-61: X-ray: NASA/SAO/CXC; Optical: NASA/ESA/Hubble Heritage Team/STScI/AURA; 54-55: NASA/CXC/SAO; 56-57: NASA/CXC/SAO; 58-59: X-ray: NASA/CXC/U. Illinois/R. Williams & Y.H. Chu; Optical: NOAO/CTIO/U. Illinois/R. Williams & MCELS Coll.; 62-63: Chandra X-ray: NASA/CXC/B. Gaensler et al., ROSAT X-ray: NASA/ROSAT/Asaoka & Aschenbach; Radio Wide: NRC/DRAO/D. Leahy; Radio Detail: NRAO/VLA; Optical: DSS; 64-65: X-ray: NASA/CXC/RIT/J. Kastner et al.; Optical/Infrared: NASA/STScI/Univ. Washington/B. Balick; 66-67: X-ray: NASA/CXC/RIT/J. Kastner et al.; Optical/Infrared: NASA/STScI/Univ. MD/J. P. Harrington; 68: X-ray: NASA/CXC/RIT/J. Kastner et al.; Optical/Infrared: NASA/STScI/Univ. MD/J. P. Harrington; 69: X-ray: NASA/CXC/RIT/J.Kastner et al.; Optical/Infrared: NASA/STScI/Caltech/J. Westphal & W. Latter; 70, 71: Chandra: NASA/CXC/SAO/P. Slane et al.; XMM-Newton: ESA/RIKEN/J. Hiraga et al.; 72-73: X-ray: NASA/CXC/GSFC/M. Corcoran et al.; Optical: NASA/STScI; 74-75: Illustration: NASA/CXC/M. Weiss; X-ray: NASA/CXC/UC Berkeley/N. Smith et al.; Infrared: Lick/UC Berkeley/J. Bloom & C. Hansen; 76-77: X-ray: NASA/CXC/MIT/D. Dewey et al. & NASA/CXC/SAO/J. DePasquale; Optical: NASA/STScI; 78-79: NASA/CXC/SAO/P. Slane et al.; 82-83, 84, 85, 86: X-ray: NASA/CXC/RIT/J. Kastner et al.; Optical: NASA/STScI; 87: X-ray: NASA/CXC/IAA-CSIC/N. Ruiz et al.; Optical: NASA/STScI; 90-91: X-ray: NASA/CXC/SAO/D. Patnaude, Optical: DSS; 92-93: X-ray: NASA/CXC/MIT/L. Lopez et al.; Infrared: Palomar; Radio: NSF/NRAO/VLA; 94: X-ray: NASA/CXC/IAFE/G. Dubner et al. & ESA/XMM-Newton; 95: NASA/CXC/SAO; 96-97: NASA/CXC/SAO; 98-99: X-ray: NASA/CXC/SAO; Optical: NASA/STScI; Infrared: NASA-JPL-Caltech; 100: NASA/CXC/SAO; 101: X-ray: NASA/CXC/PUS/E. Helder et al.; Optical: NASA/STScI; 102: X-ray: NASA/CXC/Univ. of Wisconsin-Madison/S. Heinz et al.; Optical: DSS; 103: X-ray: NASA/CXC/U. Texas/S. Post et al., Infrared: 2MASS/UMass/IPAC-Caltech/NASA/NSF; 104: X-ray: NASA/CXC/MIT/D. Castro et al., Optical: NOAO/AURA/NSF/CTIO; 105: X-ray: NASA/CXC/SAO/R. Montez et al.; Optical: Adam Block/Mt. Lemmon SkyCenter/U. Arizona; 108-109, 122-123: X-ray: NASA/CXC/UMass/D. Wang et al.; Optical: NASA/ESA/STScI/D. Wang et al.; Infrared: NASA/JPL-Caltech/SSC/S. Stolovy; 110, 137: NASA/UMass/D. Wang et al.; 112: X-ray: NASA/CXC/UAH/M. Sun et al; Optical: NASA, ESA, & Hubble Heritage Team/STScI/AURA; 113: NASA/CXC/Univ. of Wisconsin/Y. Bai. et al.; 114-115: X-ray: NASA/CXC/JHU/D. Strickland; Optical: NASA/ESA/STScI/AURA/The Hubble Heritage Team; Infrared: NASA/JPL-Caltech/Univ. of AZ/C. Engelbracht; 116: X-ray: NASA/UMass/D. Wang et al., Optical: NASA/HST/D. Wang et al.; 117: Composite: NASA/JPL/Caltech/P. Appleton et al.; X-ray: NASA/CXC/A. Wolter & G. Trinchieri et al.; 118-119: X-ray: NASA/CXC/CfA/D. Evans et al.; Optical/UV: NASA/STScI; Radio: NSF/VLA/CfA/D. Evans et al., STFC/JBO/MERLIN; 120-121: X-ray: NASA/UMass/Q. D. Wang et al.; Optical: NASA/STScI/AURA/Hubble Heritage; Infrared: NASA/JPL-Caltech/Univ. AZ/R. Kennicutt/SINGS Team; 124: X-ray: NASA/CXC/MIT/C. Canizares, M. Nowak; Optical: NASA/STScI; 125: X-ray: NASA/CXC/CfA/E.O'Sullivan; Optical: Canada-France-Hawaii-Telescope/Coelum; 126: X-ray: NASA/CXC/SAO/J. DePasquale; Infrared: NASA/JPL-Caltech; Optical: NASA/STScI; 127: X-ray: NASA/CXC/MIT/S. Rappaport et al.; Optical: NASA/STScI; 128: X-ray: NASA/CXC/SAO/S. Mineo et al.; Optical: NASA/STScI; Infrared: NASA/JPL-Caltech; 129: X-ray: NASA/CXC/Caltech/P. Ogle et al.; Optical: NASA/STScI & R. Gendler; Infrared: NASA/JPLCaltech; Radio: NSF/NRAO/VLA; 130: X-ray: NASA/CXC/Wesleyan Univ./R. Kilgard, et al.; Optical: NASA/STScI; 131: X-ray: NASA/CXC/U. Birmingham/M. Burke et al.; 132: X-ray NASA/CXC/IfA/D. Sanders et al.; Optical NASA/STScI/NRAO/A. Evans et al.; 133: X-ray: NASA/CXC/University of Michigan/J-T Li et al.; Optical: NASA/STScI; 134-135: X-ray: NASA/CXC/JHU/K. Kuntz et al.; Optical: NASA/ESA/STScI/JHU/K. Kuntz et al.; Infrared: NASA/JPL-Caltech/STScI/K. Gordon; 136: X-ray: NASA/CXC/INAF/A. Wolter et al.; Optical: NASA/STScI; 138-139, 154-159: NASA, ESA, J. Jee (Univ. of California, Davis), J. Hughes (Rutgers Univ.), F. Menanteau (Rutgers Univ. & Univ. of Illinois, Urbana-Champaign), C. Sifon (Leiden Obs.), R. Mandelbum (Carnegie Mellon Univ.), L. Barrientos (Univ. Catolica de Chile), and K. Ng (Univ. of California, Davis); 140, 165: X-ray: NASA/CXC/SAO/R. van Weeren et al.; Radio: LOFAR/ASTRON; Optical: NAOJ/Subaru; 142-143: NASA/CXC/SAO; 144-145: X-ray: NASA/CXC/CfA/M. Markevitch et al.; Optical: NASA/STScI; Magellan/U. Arizona/D. Clowe et al.; Lensing Map: NASA/STScI; ESO WFI; Magellan/U. Arizona/D. Clowe et al.; 146: X-ray: NASA/CXC/MIT/E.-H Peng et al.; Optical: NASA/STScI; 147: X-ray: NASA/CXC/Columbia Univ./A. Johnson et al.; Optical: NASA/STScI; 148-149: X-ray: NASA/CXC/KIPAC/N. Werner et al.; Radio: NRAO/AUI/NSF/W. Cotton; 150-151: NASA, ESA, CFHT, CXO, M. J. Jee (University of California, Davis), and A. Mahdavi (San Francisco State University); 152-153: X-ray: NASA/CXC/SAO; Optical: NASA/STScI; Radio: NSF/NRAO/VLA; 156-157: X-ray: NASA/CXC/UA/J. Irwin et al.; Optical: NASA/STScI; 158-159: X-ray: NASA/CXC/Univ. of Waterloo/A. Vantyghem et al.; Optical: NASA/STScI; Radio: NRAO/VLA; 160, 161: X-ray: NASA/CXC/SAO/G. Ogrean et al.; Optical: NASA/STScI; Radio: NRAO/AUI/NSF; 162-163: X-ray: NASA/CXC/MPE/J. Sanders et al.; Optical: NASA/STScI; Radio: NSF/NRAO/VLA; 164: X-ray: NASA/CXC/SAO/R. van Weeren et al.; Optical: NAOJ/Subaru; Radio: NCRA/TIFR/GMRT; 168-169, 189: X-ray: NASA/CXC/UCL/W. Dunn et al.; Optical: South Pole: NASA/JPL-Caltech/SwRI/MSSS/Gerald Eichstädt/Seán Doran; 170, 188: X-ray: NASA/CXC/UCL/W. Dunn et al.; Optical: North Pole: NASA/JPL-Caltech/SwRI/MSSS; 172-173: NASA/SAO/CXC; 174: NASA/SRON/MPE; 175: NASA/CfA/J. McClintock & M. Garcia; 176-177: Optical: Robert Gendler; X-ray: NASA/CXC/SAO/J. Drake et al.; 178-179: NASA/MSFC/CXC/A. Bhardwaj & R. Elsner, et al.; Earth model: NASA/GSFC/L. Perkins & G. Shirah; 180-181: X-ray: NASA/CXC; Optical: DSS; Illustration: NASA/CXC/M. Weiss; 182-183: X-ray: NASA/CXC/Univ of Hamburg/S. Schröter et al.; Optical: NASA/NSF/IPAC-Caltech/UMass/2MASS, UNC/CTIO/PROMPT; Illustration: NASA/CXC/M. Weiss; 184-185: X-ray: NASA/CXC/SAO/K. Poppenhaeger et al.; Illustration: NASA/CXC/M.Weiss; 186-187: X-ray: NASA/CXC/Univ. of Alberta/B. Tetarenko et al; Optical: NASA/STScI; Radio: NRAO/AUI/NSF; 190-191: X-ray: NASA/CXC/Queens Univ. of Belfast/R. Booth, et al., Illustration: NASA/CXC/M.Weiss; 192-193: Illustration: NASA/CXC/M.Weiss; X-ray spectrum: NASA/CXC/MIT/H. M. Günther; 194-195: X-ray: NASA/CXC/ICE/M. Mezcua et al.; Infrared: NASA/JPL-Caltech; Illustration: NASA/CXC /A. Hobart; 196-197: NASA/CXC/Trinity University/D. Pooley et al.; Illustration:NASA/CXC/M. Weiss; 198: Harvey Tananbaum.